Conceptual art in the Netherlands and Belgium 1965 — 1975

artists, collectors, galleries, documents,

exhibitions, events

edited by

Suzanna Héman

Jurrie Poot

Hripsimé Visser

with contributions by

Carel Blotkamp

Rudi Fuchs

Camiel van Winkel

Stedelijk Museum Amsterdam

NAi Publishers Rotterdam

This publication appears on the
occasion of the exhibition
'Conceptual art 1965-1975 from
Dutch and Belgian collections' in
the Stedelijk Museum Amsterdam,
20 April – 23 June 2002.
Concept exhibition and publication
Rudi Fuchs, Suzanna Héman,
Jurrie Poot, Hripsimé Visser,
with thanks to Jan van Adrichem
and Leontine Coelewij
Organization exhibition and publication
Saar Groenevelt, Suzanna Héman,
Jurrie Poot, Hripsimé Visser,
with the assistance of
Maria Hendriks, Piet van Orsouw,
Jennifer Steetskamp
Foreword
Rudi Fuchs
Texts
Carel Blotkamp, Camiel van Winkel
Biographies
Saar Groenevelt (SG),
Suzanna Héman (SH),
Jurrie Poot (JP),
Hripsimé Visser (HV)
Chronicle and bibliography
Jennifer Steetskamp

Form and typography
Wigger Bierma, Werkplaats Typografie
Ingo Offermanns, Cologne
Copy editing
Els Brinkman, Amsterdam
Production
Astrid Vorstermans,
NAi Uitgevers/Publishers,
Rotterdam
Publisher
Stedelijk Museum Amsterdam;
NAi Uitgevers/Publishers,
Rotterdam
Printing and lithography
Drukkerij Mart. Spruijt, Amsterdam

English edition:
Stedelijk Museum cat.no. 865

ISBN 90 5662 247 1

This publication is also available
in a Dutch edition: 90 5662 246 3
SMA cat.no. 864

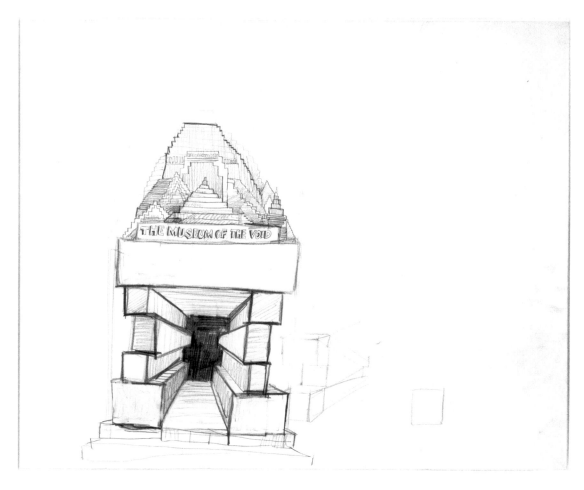

252. Robert Smithson, *The Museum of the Void*, 1967

Foreword

Rudi Fuchs

The abstractness of minimal art, hard and clear as a diamond, was the conclusion of a long modernist project. That was in the early 1960s. The formulation indicated once again that in the twentieth century abstract art had meant the great liberation, and that it was at that time still the measure of things. The most radical steps had been taken. Of course, there are other artists who sought their path in expressionist figuration, or other variants of realism, but a careful examination of the strategies used shows that even there all kinds of abstract impulses played a large part. But when minimal art had presented the most dedicated and serious form of abstractness, other, sometimes younger artists had to find a place somewhere. In the crystal-clear relations and precise contours of minimal art, as if art had been stripped of redundancies and cleaned up, they discovered the potential for deconstruction and how to rearrange the elements. The start of conceptual art was one of those great moments (as the early Renaissance had been) when art literally seemed to be able to start anew. That moment also coincided with the availability of new material and the media. The essence of the conceptual strategy enabled narrative and realism, and even anecdotes, to return to art. The new principles were received with remarkable enthusiasm in the Netherlands and Belgium, and that is what this exhibition and publication are about.

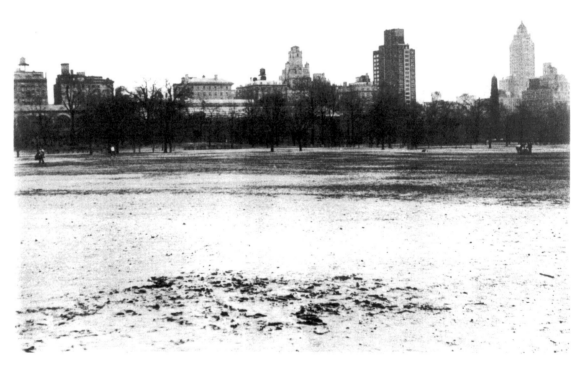

34. Robert Barry, *Radiation Piece*, barium 33, 1968-1969

Introduction

Suzanna Héman / Jurrie Poot / Hripsimé Visser

In 1969 the exhibition 'Op Losse Schroeven, situaties en cryptostructuren' (rendered in the English catalogue of the time as 'square pegs in round holes') was held in the Stedelijk Museum Amsterdam. It was the first time that a Dutch museum gave large coverage to an art that curator Wim Beeren described as 'working discordantly on static relations. It prefers to adopt change and contrast as a stylistic principle.'[1] The thirty-four artists whose work was on show included both European and North American artists; the work of some of them was regarded as conceptual art, that of others was considered to be land art or arte povera. What they had in common was that in their work 'the old notion of art, in the sense of a central ordering and sublimation (…) becomes unsettled.'[2]

Now, thirty-three years on, the time seems ripe to reassess in particular the 'historical' conceptual art among what was shown on that occasion – not exactly the same objects, but examples of tendencies and mentalities that played a key role at the time. There were various reasons to undertake a project of this kind. During the last few years there has been a general increase in interest in the art of the 1960s and 1970s: the exhibition 'Reconsidering the Object of Art' was held in Los Angeles in 1996, the Whitechapel Art Gallery in London presented an exhibition on conceptual art in England two years ago, and last year the Tate Modern put on a retrospective of arte povera while an exhibition on 'Conceptual Documents' was shown in Norwich. This interest in the most progressive and experimental art of the 1960s and 1970s has certain relations with current artistic practice. Reviews of present-day art often point, positively or negatively, to a striking, interesting or brazen affinity with work from the heyday of conceptual art. What is noteworthy in those reviews is the frankly complex and problematic character of the notion of 'conceptual art'. In one way or another the term has become common property without a clear definition of exactly what it refers to. Moreover, the suggested kinship with work from the 'historical' conceptual art often raises more questions rather

1. Wim A.L. Beeren, 'De Tentoonstelling.' In: *Op losse schroeven, situaties en cryptostructuren*, exh. cat. Stedelijk Museum Amsterdam, 1969, n.p.

2. Ibid.

than positioning contemporary work in a clear setting or interpreting it. These are the aspects that lay behind the organization of the exhibition 'Conceptual art 1965-1975 from Dutch and Belgian collections'.

Rather than trying to present an exhaustive retrospective, the inherent polemic of the notion of conceptual art and its interpretations was our starting point for the exhibition. The book – to which we shall return in a moment – offers the best platform for an analysis. To come to grips with an extremely complex period, we decided to focus on a period of ten years, the 'creative phase', when experiments were at their peak and not all of the positions had fully crystallized. It soon became clear to us that the Netherlands, and in particular Amsterdam, had played an important role in the discovery and presentation of the 'new' art at the end of the 1960s. In fact, together with Cologne/Düsseldorf and Antwerp/Brussels, it proved to have formed part of a 'magical' triangle along which contacts were maintained, artists exchanged, and exhibitions held.

The movements, contacts and innovatory character of forms of artistic expression in the period 1965-1975 constituted our starting point. The exhibition and the book concentrate on a selection of artists whose work was pioneering at the time and maintained its importance later on. We are aware that these principles exclude many Dutch and other artists who were active at the time, but neither the exhibition nor the book aims to provide exhaustive coverage. In making our selection, we have endeavoured to accentuate individual positions each time. This seemed more sensible than to group works of art under headings like 'language as medium' or 'dematerialization'. For instance, Kosuth, Barry and Baldessari all emphasized language, but the differences between their work are greater than the extent to which they shared this fascination. Those differences between artists can also be seen in the wide range of materials, methods and techniques that were applied. The artists are represented with films, videos, photographs, paintings, drawings, installations, sculptures, prints and artists' books. A very crucial element that played a role among various artists is the importance that was attached to

documenting a work or a project, especially those works without any physical implementation, such as Ian Wilson's discussions and some of Robert Barry's projects. Attention has been paid to these documents where possible. The artist's book is a phenomenon that was at least as important in the same period. The idea was that books could be made simply, but above all that they represented a radically new artistic medium that everyone could afford.

During the preparations for the exhibition and the book it became clear that the first to come into contact with conceptual art were the galleries and private collectors. The main ones were Galerie Swart and Art & Project and the collectors Mia and Martin Visser and Herman and Henriëtte van Eelen in the Netherlands, and the galleries MTL and Wide White Space and the collectors Herman Daled and Nicole Verstraeten and Annick and Anton Herbert in Belgium. The museums, above all the Gemeentemuseum Den Haag and the Stedelijk Van Abbemuseum as well as the Stedelijk Museum, responded from a suitable distance. The reflection on and presentation of larger group and individual exhibitions was concentrated in the early 1970s.

We referred above to this book as a 'platform for analysis'. We hope that it will provoke discussions on the significance and position of both historical and (alleged) contemporary 'conceptual' art. The instruments provided for that purpose are essays, brief introductions to the work of artists, and a chronological survey that sets the art in its wider social context.

Camiel van Winkel's article looks at historical conceptual art from a modern perspective. Among other things, this polemical essay raises awkward questions about the effect of the 'primacy of the idea', as it was formulated by a number of artists at the time. He also discusses the consequences – by no means all positive – of this stance for current artistic practice, particularly with regard to the lack of a reformulation of the criteria by which conceptual art can be approached and discussed.

Carel Blotkamp writes from a very different perspective about his view of a number of important events during that period. Starting out from the exhibitions 'Op losse schroeven' and 'When Attitudes Become Form', both of which were held in 1969, he draws on his personal involvement to sketch a picture of that period and its art-historical significance.

Many publications on conceptual art take Sol LeWitt's 'Sentences' as one of the major theoretical texts on conceptual art. Thanks to collector Herman Daled, we are now able to publish the different manuscript versions of this text here for the first time, making it possible to follow the development of LeWitt's ideas down to the definitive shape they took in 1969.

We would like to thank a number of people for their generous and invaluable support. The exhibition and publication would not have been possible without the many inspiring and informative discussions with artists, gallery owners, collectors and colleagues. The hours spent discussing his collection with Herman Daled in Brussels are unforgettable. The 1960s and 1970s seemed to come back to life above all the documentation that has been lovingly collected and kept by Nicole Verstraeten. Jan Dibbets and Ger van Elk gave us their personal view of the developments of the early years that so appeal to the imagination. Adriaan van Ravesteijn and Geert van Beijeren deserve admiration for the courage they showed in opening (the gallery) Art & Project in the Netherlands. The collection of Herman and Henriëtte van Eelen is a wonderful example of a collection that could only be achieved by great passion for the art of that moment. The same is true of Annick and Anton Herbert, who lent us a number of very special works and provided us with copious information. The radical nature of that new art, the importance of the discussions that were held, the astonishment at the new, and the enjoyable meetings and friendships with artists played a key role in all those contacts. We hope that something of that atmosphere and enthusiasm can be seen in the exhibition. We are also grateful to Frits Becht, Marja Bloem, Marinus Boezem, Caldic Collection, Michelangelo Cardenas, Rini Dippel, Luca Dosi

Delfini, Michiel Nijhoff, Ad Petersen, Jan Hein Sassen, Seth Siegelaub, The Over Holland Collection, Stedelijk Van Abbemuseum Eindhoven, Rijksmuseum Twenthe Enschede, Stedelijk Museum voor Aktuele Kunst Ghent, Bonnefantenmuseum Maastricht, De Vleeshal Middelburg, Kröller-Müller Museum Otterlo and Museum Boijmans Van Beuningen Rotterdam.

Carel Blotkamp

History is a personal matter. For me, the emergence of conceptual art is connected with the memory of an evening in Bern with plenty to drink. It must have been Saturday, 2 November 1968.

That afternoon the exhibition 'Junge Kunst aus Holland' had opened in the Kunsthalle, where Harald Szeemann was director. It introduced a new batch of Dutch artists after the Cobra generation, characterized by Szeemann in the introduction to the catalogue as situated between two extremes: 'the systematic art that is still alive in Mondrian's country, and a New Realism extending from pithy Pop via all kinds of forms of assemblages to the direct application of "forces of nature"'. The oldest of the group of 21 artists was Jan Schoonhoven (54). Mathieu Ficheroux and Ferdi (Tajiri) were in their early forties – and Ferdi was the only woman – while all the other participants were around thirty, with a few exceptions on either side: Jacob Zekveld, for instance, was only 23. There is often something perfunctory about national exhibitions, but this was a fresh and exciting one that was highly appreciated by the many Dutch who had travelled to Bern and by the Swiss.

A strikingly large number of those young artists had been chosen from two venues in Amsterdam, Galerie 20 and Galerie Swart. Galerie 20 represented New Realism with Pieter Engels, Daan van Golden, Jeroen Henneman and Wim Schippers, while Galerie Swart was associated with the opposite extreme: systematic art in the work of Bob Bonies, Ad Dekkers and Peter Struycken. However, Galerie Swart's contribution also included work by Marinus Boezem, Jan Dibbets and Ger van Elk, and that was the topic of conversation at the well-attended opening. Accustomed as it was to the concrete art of Max Bill and R.P. Lohse, the Swiss public had no difficulty with the strict geometric abstraction of a Dekkers or a Struycken, but what was it supposed to make of that strange tent that Van Elk had erected in one of the rooms, the grass-covered table by Dibbets, or the huge pile of sand that Boezem had tipped onto the black and white chequered

floor and planted with a forest of cat's tails? Lohse, who had come from Zurich, just stood there shaking his head (years later, at the opening of the 1982 documenta, in which Rudi Fuchs had included Lohse as well, the artist was to tell me in deadly earnest that he was 'the only light in this irrationalism'). He was not the only visitor to have difficulties with these unusual interventions in the dignified Kunsthalle. After the opening, the lively debates were continued in a restaurant, but the artists concerned hardly took part in them. As I recall, they spent most of the evening huddled around a table with Szeemann.

That must have been the occasion when 'When Attitudes Become Form', Szeemann's controversial exhibition that opened in Bern on 22 March 1969, was finally settled. Wim Beeren's twin exhibition 'Op losse schroeven' [square pegs in round holes], with Boezem, Dibbets and Van Elk as its driving forces again, had opened in the Stedelijk Museum in Amsterdam a week earlier on 15 March. In combination, the exhibitions presented a panorama of the new conceptual trends in European and American art for the first time. Those trends had already been visible here and there for some time – in artist's publications and events, in galleries and in small group exhibitions in museums, usually confined to a single country, and specialist art journals had devoted some attention to them – but now they were elevated to the level of special exhibitions that set out to present a Zeitgeist. The intuitions of a small circle now reached a large audience: the realization that a kind of earthquake – less figuratively, a change of paradigm – was taking place in art.

Szeemann was remarkably reticent on the background to 'When Attitudes Become Form' in the exhibition catalogue. He merely printed two sheets of paper in facsimile with the names of the artists and gallery owners whom he had visited during a trip to the United States in December 1968. On the other hand, the extensive account that he, curiously enough, published in the catalogue of the exhibition organized by his friend and rival Beeren in Amsterdam was highly informative.

So you have to read the 'Op losse schroeven' catalogue to find out that 'When Attitudes Become Form' was more or less the result of the visits that Szeemann made to the studios of Dibbets, Van Elk and Boezem in the summer of 1968, and of the discussions that he later held with them, in preparation for 'Junge Kunst aus Holland'. Although his account does not mention the discussion in early November 1968 in Bern nor the subsequent one in late November in Amsterdam where the Italian artist Piero Gilardi was also present, they must have played a decisive part.

Szeemann's text, entitled 'Account of the journey, and only that, to prepare the exhibition When Attitudes Become Form (works, concepts, processes, situations, information)' opens like a paraphrase of the Gospel according to St John: 'In the beginning was Dibbets' activity of watering a piece of turf on top of a table. Now you can't exhibit activities. But Dibbets told me in July about other people. There were two more in the Netherlands: Van Elk and Boezem. There was a very good one in England: Long. And in Italy there was an artist who was known for his foam plastic carpets and who had decided to stop work and in a certain sense to turn the new artists into his art by providing information about them: Piero Gilardi.' This is followed by a telegram-style diary of the months December 1968 – some of it wrongly dated in January – to February 1969, documenting Szeemann's many visits to galleries and artists' studios in the United States, Italy, England and Germany. By the way, embedded in all that dry information are a few good examples of his sense of the absurd, such as the note that over Christmas he visited the memorial to the death of Kennedy in Dallas: 'Checked the angle of the shot. The thesis of the Warren report is wrong.'

This account shows that 'When Attitudes Become Form', a comprehensive and complicated exhibition, was put together in record time. What can only be read between the lines or deduced from other sources is the fact that the plans were considerably altered in the course of that brief period of preparation. Szeemann himself mentions in the diary that during a visit to Arakawa's studio in New York on 11 December

1968, he abandoned his original idea of staging a confrontation between 'the artists of the "Cold Poetic Image" [like Arakawa and artists connected with Galerie Schwarz in Milan such as Simonetti] with the "nature crowd" because there are so many of them.' That certainly would have been a very different, probably rather confusing confrontation. What is much more striking, however, is the reduction of Gilardi's part in the exhibition.

An interesting, though hardly objective source for this is a letter that Gilardi sent to a number of European participants shortly before the opening of the exhibition in Bern. It is printed in German in Boezem's catalogue raisonné published in 1999 (p. 539). In the two previous years Gilardi had played an important role in the contacts between artists in the various European countries, as well as being well informed about the situation in the United States. His letter called upon the participants to protest against the exhibition because Szeemann had depoliticized the exhibition concept. Gilardi's proposal had been to bring all of the participants to Bern a month before the opening of the exhibition and to conceive and carry out their work on the spot in a fruitful exchange of ideas, as had been done, for example, in the Italian city of Amalfi in October 1968. (Ger van Elk published a full report on that artistic event in *Museumjournaal* 14 (1969) no. 1.) In terms of cultural politics, this idea would be an example of 'self-criticism of the museum as an institute' and of the artists' 'right to self-determination'. But although Szeemann was supposed by Gilardi to have initially agreed to the latter's proposal, he gave in under pressure from US galleries and the sponsor Philip Morris, who was not keen on supporting an anarchic enterprise of that kind. The exhibition had become 'an élitist, anti-democratic, bourgeois and Americanophile cultural event'.

It is questionable whether Gilardi gained much support from his fellow artists. To the best of my knowledge, there was no protest demonstration by the participants at the opening of 'When Attitudes Become Form', despite his intentions. It would have made a strange impression to exhibit and

demonstrate at the same time. At any rate, Gilardi himself did not take part in the exhibition. That is logical, since he had stopped work as an artist. But in the catalogue he is only mentioned very incidentally in the acknowledgements among a long list of names of gallery owners and other informants, which seems rather meagre to me.

This is where a subtle but not insignificant difference begins to appear between the exhibition in Bern and 'Op losse schroeven' in Amsterdam. Gilardi did not participate in the Amsterdam exhibition as an artist either, but he is personally thanked, along with Boezem and Van Elk, in a short foreword by director De Wilde ('Piero Gilardi, who supplied us with detailed information and gave us countless valuable suggestions and introductions'), followed by a prominent role in the introduction written by the curator Beeren: 'It was Piero Gilardi who has involved the Dutch artists Van Elk, Boezem and Dibbets in an international activity. And who has also inspired this exhibition to a large extent. (...) But in the milieu of what he has called "micro-emotive" art (...) Gilardi has circulated, propagated and discussed his creation. That creation has undeniably inspired and provoked us. It could be regarded as the "work" by Gilardi that we have included in the exhibition.' And so on for a few more lines.

Finally, Gilardi himself was given ample room to have his say. The catalogue includes one of his texts on red paper ('the red of struggle', as Beeren described it) under the programmatic title 'Politics and the avant-garde', in which he sets the latest developments in art in the context of the cultural revolution manifested, for instance, in the underground movement and in the student actions of 1968 in Europe and the US. He concludes: 'Between to-day and the achievement of the "global continuum" of art-life lies a series of "economic" actions that must be undertaken: participation in the revolutionary praxis, demystification of the cultural dialogue, and "epidermic contact" between artists all over the world'. His deep mistrust of the established political and cultural powers can also be seen from the short letter that he had sent with his article and which is also published in the catalogue; he

expresses the hope that Beeren's trip to New York in January 1969 in connection with the preparations for the exhibition 'should not change your wide perspective about "really" integration art-life,' [sic] in other words, that he had not given in to the Americans.

The difference between Beeren and Szeemann lies not only in the extent to which they credit Gilardi for his part in their respective exhibitions, but also in their interpretation of the new art on show. In Szeemann's catalogue introduction, he emphasizes artistic thought – 'live in your head' was the revealing subtitle of 'When Attitudes Become Form' – and the importance of the mental and physical processes that lead to art. Beeren, on the other hand, concentrates in his catalogue introduction on the possible effect: that this art undermines the status quo and may provide models for new structures. He does not go as far as Gilardi in politicising art, but he does relate its undermining activity to the established ideas and institutions within the art world, especially the museum. A large part of his text, as I wrote in 1969 in my review of 'Op losse schroeven', is about 'the masochistic question of whether the museum is still the most appropriate place to show modern art'.

That difference in perspective and approach to the new art also explains the following stages in their careers as exhibition curators. Although Beeren still considered the museum to be a suitable venue in 1969, soon afterwards he drew his conclusions and resigned as curator of the Stedelijk Museum to concentrate on the organization of 'Sonsbeek buiten de perken' [Sonsbeek beyond the pale]. The 1971 exhibition was centred in Sonsbeek Park in Arnhem, including an impressive programme of artists' films, but it extended over the whole of the Netherlands, from the Waddenmuseum in Pieterburen, where Richard Long showed a single photograph of a sculpture that he had completed on the island of Schiermonnikoog, to a barn in the village of Vlake, Zealand, where you could sit on bales of straw and listen to an interview about Joseph Beuys on the headphones. It would have taken at least a week to visit every location and event. Partly as a

result of all kinds of local contributions, the exhibition was of uneven quality and extremely diffuse in character with regard to content as well as space, a reflection of Beeren's view of the art situation at the time.

Szeemann also resigned his post as director of the Kunsthalle in Bern and set up his own consultancy under the original name Agentur für geistige Gastarbeit [Agency for Intellectual Guest Labour]. In 1972 he organized the documenta in Kassel, which I regard as the best documenta ever. With sections devoted to 'individual mythologies', devotional objects, artists' museums, science fiction and the art of the mentally ill, it offered a kaleidoscope of forms of imagination that was not confined to the present or to official art. I shall never forget Paul Thek's astonishingly beautiful installation, the reconstruction of Adolf Wölfli's asylum cell with piles of drawings almost 2 metres tall, Broodthaers' annex of his Musée d'Art Moderne, Département des Aigles, and many other works in the exhibition. Nevertheless, this documenta still retained the museum framework. Looking back, we can see how Szeemann has extended that framework; while Beeren's Sonsbeek exhibition blew up the museum.

Back to the magical year 1969, to 'Op losse schroeven' and 'When Attitudes Become Form'. Actually, I did not see the latter exhibition in its original form in Bern, but the somewhat modified version shown at the ICA (Institute of Contemporary Art) in London. What I remember best of the opening is the presence of Gilbert & George in their stereotype old-fashioned suits, their hands and faces painted bronze. They had not been invited to participate in the exhibition – they were not taken seriously in the English art world at that time – and this was how they had gatecrashed. Their appearance as a living work of art was a complete novelty to me. A few months later, on 22 November, they were to pose unannounced for more than four hours on the staircase of the Stedelijk Museum. Photographs of the event were published to accompany an article that Ger van Elk wrote for *Museumjournaal* (vol. 14, no. 5, October 1969, though issued

slightly later), the first substantial article to appear on them in print.

In Bern the exhibition had to be fitted into the classical arangement of the rooms of the Kunsthalle; the unusual feature of the London version was that the flexible space of the ICA was kept as open as possible, which meant that the works were visible in dozens at a time. All kinds of works were lying, standing or hanging every which way. It was exciting, this confrontation between very different artistic personalities, though rather tough on the more modest and subtle works, sometimes no more than some documentation on sheets of A4 pinned to the walls. The sculptural works attracted the most attention, with Italian arte povera and US post-minimalism vying with one another in the use of unusual materials. I remember that Eva Hesse's sculptures of layers of latex as thin as folds of skin made a very striking, vulnerable and calm impact amid that welter of visual impressions.

The exhibition in Amsterdam, like its counterpart in Bern, was spread out among a number of rooms, in each of which the work of several artists was combined; a memorable room, for instance, was the one with work by Mario Merz and Anselmo. However, the exhibition continued elsewhere. Van Elk had divided the large museum staircase in two from bottom to top with a strange piece of fabric, hanging from a rope, that followed the profile of the stairs, and above a table in the restaurant he had suspended an intrusive object, a brick wall hanging from the ceiling by steel cables. Michael Heizer had created a 'negative sculpture' – a kind of pit fenced off with grids – in the pavement in front of the museum, and Dibbets had dug up the four corners of the building. The exhibition expanded even further. Dennis Oppenheim had the land belonging to farmer Waalkens in Finsterwolde ploughed and sown according to certain patterns. Even the catalogue was an exhibition site: it included a number of collotypes with projects by artists of whom some were and others were not represented in the regular exhibition. With this scattering of locations and media in 'Op losse schroeven', Beeren was already anticipating 'Sonsbeek buiten de perken'.

The recollections of the exhibitions of 1969 have inevitably grown rather vague and have become coloured by later experiences in the course of thirty-three years. Catalogues and photographs of the shows can serve as an aide-mémoire, but they are still no more than that. What I remember above all is the excitement generated by experiencing all those new phenomena in a short period of time. As mentioned above, in 1967 and 1968 there were already certain signs that profound changes were imminent in art. Boezem, Van Elk and Dibbets had profiled themselves in 'Beeld en route' [Sculpture en route] in the city and province of Groningen in 1967, '248 objecten' in Leiden and 'Project Katshoek' in Rotterdam, both in 1968, and in other group exhibitions and presentations at Galerie Swart. Dibbets had publicly abandoned painting with piles of canvases and had begun to work with natural materials, for several years Van Elk had been making whimsical sculptures from gaily coloured plastic and foam and hanging strange rope sculptures in the air, while Boezem stacked tyres and designed spaces where the weather and the wind played a role.

At an exhibition at Galerie Swart in the autumn of 1968, Boezem hung washing to dry above a tub (the critic Hans Redeker earned a slap in the face for knocking his pipe out in it during the opening), and Dibbets installed a tape recorder that produced the sound of waves breaking on the shore behind a fence of poles with barbed wire. The exhibition included other laconic references to the clichés about Dutch propriety and the Dutch landscape. At this stage their work was still funky and full of irony, soon to be followed by a more formal elaboration of their themes. In the course of 1969 the three of them moved to a new gallery, Art & Project, that had opened in August 1968 in the modest space of the hall of the home of Adriaan van Ravesteijn's parents in Amsterdam. Art & Project, as well as other venues, presented the work of artists displaying a new mentality, such as Stanley Brouwn, and it became the major platform for this art. Those who were interested also followed what was going on abroad in galleries such as Wide White Space in Antwerp,

Konrad Fischer in Düsseldorf and Ricke in Cologne and in the museums of Krefeld and Mönchengladbach, as well as gleaning information from artists' publications, catalogues and journals, among which *Museumjournaal* deserves a special mention.

All the same, the exhibitions held in March 1969 in Amsterdam and Bern were especially newsworthy. In the case of most of the artists, their work had never been seen before in the Netherlands or Switzerland. This was true not only of the Americans but also of English artists like Long and of the Italian arte povera artists. 'Op losse schroeven' and 'When Attitudes Become Form' were fairly chaotic and unstructured. The organizers were aware of the fact: the different parallel developments taking place in art at the time had not yet crystallised clearly, and all kinds of terms were used indiscriminately to refer to them. Moreover, some artists were absent who are assigned an important position in that art from the vantage-point of today (Marcel Broodthaers, Stanley Brouwn), and some artists were represented who would now be deleted (Edward Kienholz, Yves Klein and Claes Oldenburg in the exhibition in Bern, though the last two featured mainly as precursors). Nevertheless, this in no way affects the historical importance of the two exhibitions.

There was so much else going on in 1969 as well. German television broadcast the film *Land Art* on 15 April. It was made by Gerry Schum, who had set up a Fernsehgalerie and thereby opened up a new medium for artists interested in film and video. The first issue of *Art-Language* was published in May. In various constellations, the Anglo-American group of the same name was to play an important role in stimulating the intellectual debate among artists and theoreticians of art in the following years, despite its very dogmatic stance (Joseph Kosuth and Charles Harrison still bicker about who was first at many a conference, no matter what its subject may be). The critic Germano Celant published *Arte Povera*, which – in spite of what the title suggests – presented work by not only Italians but also artists from many other countries, as a kind of exhibition in book form. The exhibition

'Konzeption/Conception', which was held in the museum in Leverkusen in November-December, was an attempt to define conceptual art more precisely and to distinguish it from other, more material-orientated art forms. And in the course of the same year exhibitions were held in various locations that concentrated on a particular theme or medium, such as 'Earth Art' (Ithaca, N.Y.), 'Street Works' (New York), 'Letters' (Long Beach, N.J.), and 'Art by Telephone' (Chicago).

Towards the end of 1969, on the eve of a new decennium, the positions of the different artists had become reasonably clear for anyone who had taken the trouble to follow the developments. Something of a hierarchy began to emerge, to which a number of galleries and influential curators, critics and collectors made an important contribution. This inevitably heralded the institutionalization and museumification of this art, a trend that took definitive shape in the course of the 1970s. Despite the fact that much of it had arisen in opposition to the institutions, or at any rate had called their existence and functioning into question, as Beeren had stressed in 'Op losse schroeven', most of the artists turned out to be no less receptive to official attention and recognition than their more traditional colleagues. Temporary materials, one-off actions were all prepared for the market and the museum by making them more permanent or through documentation. Gilardi's ideal of an art that not only reflects social life but can also serve as a means of bringing about change was far out of sight by now.

There is no need to end a retrospective of those early years in a minor key. It was a fantastic time and produced a lot to be pleased about; in the first place, a lot of good and very good art, because there was a concentration of talent. Besides, the developments that began then have had an extremely stimulating influence on the theory and practice of the exhibition, both inside and outside the museum, which has lost none of its relevance today. Still, some critical reflection is called for on the less positive side-effects: the megalomania that later seized many of the artists involved, the

affected aesthetic of display that has spread its tentacles widely, the proliferation of exhibitions on the wildest sites, and the unworldliness that often characterizes the debate on the social function of modern art. But that is a subject for a different story.

Carel Blotkamp (1945) is
Professor of Art History at the
Vrije Universiteit Amsterdam.
He has been a critic for the weekly
review *Vrij Nederland*.

Camiel van Winkel

For a variety of reasons I don't like the term 'conceptual art'.
Connotations of an easy dichotomy with perception are
obvious and inappropriate. The unfortunate implication is of
a somewhat magical/mystical leap from one mode of exist-
ence to another. The problem is the confusion of idealism
and intention. By creating an original fiction, 'conceptualism'
posits its special non-empirical existence as a positive
(transcendent) value. But no amount of qualification (or doc-
umentation) can change the situation. Outside the spoken
word, no thought can exist without a sustaining support.
 Mel Bochner (1970)[1]

A spectre flits through the chronicles of modern art: the
unachievable yet insistently recurring obsession with a work
of art that consists of nothing but an idea. In 1961, Henry
Flynt talked about 'an art of which the material is "con-
cepts," as the material of e.g. music is sound'.[2] The move-
ment that is termed 'conceptual art' is simply the result of
the premature historicization of this fantasy.

The impossibility of concept art is already implicit in
Flynt's formulation. The analogy between sound as the raw
material of music and concepts as the raw material of 'con-
ceptual art' comes unstuck, given that sounds are percept-
ible whereas concepts are not. Without a material medium,
nobody can become aware of any concept. 'Conceptual
artists' – I will abandon the inverted commas in the rest of
this article – have tackled this impasse in an impossible
way: they have treated it as conceptual material with which
they would surely once again be able to make art. Owing to
a combination of circumstances, the second half of the
1960s witnessed a whole series of these paradoxical at-
tempts. Obvious examples are Mel Ramsden's *Secret Paint-*
ing from 1967-1968 ('The content of this painting is invisible;
the character and dimension of the content are to be kept
permanently secret, known only to the artist') and Robert
Barry's *Telepathic Piece* from 1969 ('During the exhibition
I will try to communicate telepathically a work of art, the

nature of which is a series of thoughts that are not applicable to language or image'). These examples are already strong enough to suggest that artists who want to purify the content of their work by eliminating everything that is not content are in danger of ending up with straightforward formalism. If Barry and Ramsden were wanting to make an ironic comment about the work of painters such as Frank Stella, in retrospect they seem to have become the butt of their own joke. Barry's recourse to paranormal methods only corroborates the esotericism of Ramsden's secret painting. That also seems to be the only 'content' that these works still convey.

Because it is hardly possible to re-stage such extreme positions, the conceptual art fantasy has often adopted the guise of a rigourous uncoupling of mental and physical effort, of conception and execution. This strategy was not limited to the illustrious 1966 to 1972 period. A history of conceptual art would not be complete without László Moholy-Nagy's telephone paintings from 1922 or Jeff Koons's polychrome sculptures from 1988, even though both these cases are somewhat contentious.

'In 1922 I ordered by telephone from a sign factory five paintings in porcelain enamel. I had the factory's color chart

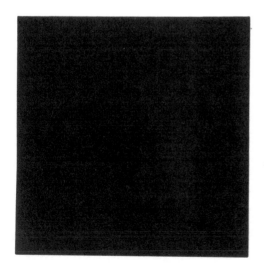

The content of this painting is invisible; the character and dimension of the content are to be kept permanently secret, known only to the artist.

before me and I sketched my paintings on graph paper. At the other end of the telephone the factory supervisor had the same kind of paper, divided into squares. He took down the dictated shapes in the correct position.'[3] Witnesses later alleged that Moholy-Nagy had not given his instructions over the telephone but delivered them in person; it seems more important, however, that by then it was already technically and artistically thinkable for an artist to leave the realization of his or her work to some third party, and therefore translate the 'concept' of the work into 'information' that could be communicated using a modern technological medium such as the telephone. The *Dada-Almanach* from 1920 similarly extols the virtues of telephonic instructions for the manufacture of paintings.[4]

At the other end of the 20th century we find the life-size wood and porcelain sculptures by Jeff Koons, executed by German and Italian craftspeople to the artist's specifications. The vulgar and backward connotations of the mass-production workplaces where Koons sought his recourse are at odds with Moholy-Nagy's forward-looking vision. The fact that the conceptual art fantasy was subjected to all kinds of contradictory impulses during the 66 intervening years is borne out in Koons's ambiguous position as regards the authorship of these works. He had the wood-carver or ceramicist responsible for the work sign the plinth, but he placed his own signature as well – out of sight on the underside. 'I have them sign it because I want them to give me 100%, to exploit themselves. I also like not being physically involved because I feel that, if I am, I become lost in my own physicality. I get misdirected toward my true initiative so that it becomes masturbative.'[5] Although Koons did not entrust himself with the manual work and wanted to get the very best from the artisans, he also felt that he could not leave anything in their hands: '... I could not give these people that freedom. I mean, how can I let them do it; these people aren't artists. So, I had to do the creating. I did everything. I directed every color; I made color charts. This

has to be pink, this has to be blue. Everything! Every leaf, every flower, every stripe, every aspect.'[6]

To think of these works as conceptual pieces has not been evident to all of Koons's commentators. The reasons for this are clear: the works are overly visual and extravagant, and contain too many Pop and kitsch elements. By the 1980s 'conceptual art' had clearly already changed from a procedural category into a stylistic qualification. It had come to stand for difficult, austere, frugal and disciplined, for a sloppy or rather stiff form of visual poverty. Moreover, Koons the cynical populist is far removed from the ideology and the lifestyle that we now tend to associate with conceptual artists. Conceptual art is supposed to be historically connected with the spirit of '68, with the protest against the war in Vietnam and rebellion against paternalistic authorities.

Chinese walls

The interpretation of conceptual art as an historic phenomenon has to a large extent been guided by one single book from 1973: Lucy Lippard's *Six Years: The Dematerialization of the Art Object from 1966 to 1972*. The success of this publication resulted in the obsession with dematerialization –

Christine Kozlov, *A mostly painting (red)*, 1969, private collection

Joseph Kosuth, *Five words in blue neon*, 1965, collection Herbert, Ghent

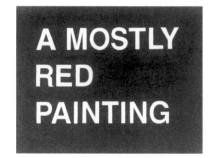

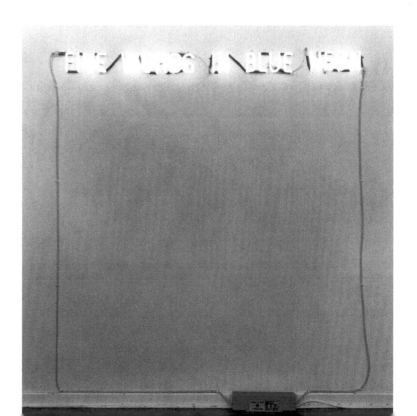

the reduction of the artwork to nothing more than an idea –
being spread far and wide. As a consequence, there has
never been much consideration for indications that the
strictest conceptual artists arrived at the very opposite:
instead of dematerializing the object, they seemed to hypo-
stasize the concept – represent it as a concrete thing.
Christine Kozlov painted the text 'A MOSTLY RED PAINT-
ING' with white paint on a red canvas. Joseph Kosuth had
the words 'FIVE WORDS IN BLUE NEON' realized in blue
neon lights. 'Frozen' concepts like these constitute the most
straightforward interpretation of conceptual art.

The dematerialization of the art object is an idée-fixe in
the reception of conceptual art. The examples by Kozlov
and Kosuth demonstrate that the uncoupling of conception
and execution did not make the latter into something less
important – on the contrary, it became the chief issue.
Looking back, many of the artists concerned seem to have
been obsessed by the manual processing of physical mater-
ial. In response to a question about what his work was
about, Lawrence Weiner once replied: materials.[7] Although
he asserted that he was more interested 'in the *idea* of the
material than in the material itself',[8] that too points to a
heightened rather than a reduced consideration for the
material. It seems appropriate here to talk of the *idealiza-
tion* of the art object rather than its *dematerialization*.

The works that Lawrence Weiner is still making to this
day essentially stem from the inversion of the relationship
between his early sculptures and their titles. This reversal
initially occurred in 1968, during an exhibition in the grounds
of Windham College in Putney, Vermont. Weiner's 'sculptural'
contribution to the exhibition was exhaustively described in
its title: *A SERIES OF STAKES SET IN THE GROUND AT
REGULAR INTERVALS TO FORM A RECTANGLE – TWINE
STRUNG FROM STAKE TO STAKE TO DEMARK A GRID – A
RECTANGLE REMOVED FROM THIS RECTANGLE*. After
the work had been damaged by students who needed
space to play sports, Weiner realized that repair was unne-
cessary, because the title held all the essential information

for the work to be able to survive.[9] Since this turning-point in his development, all of Lawrence Weiner's works have the character of 'linguistic constructions' that do not necessarily have to lead to a material interpretation. In his view, everyone is free to realize the 'sculpture' described at any given moment – such as *A TWO INCH WIDE ONE INCH DEEP TRENCH CUT ACROSS A STANDARD ONE-CAR DRIVEWAY* or *ONE QUART EXTERIOR GREEN INDUSTRIAL ENAMEL THROWN ON A BRICK WALL*. In some cases Weiner realized a material version himself on the request of exhibition organizers, but usually a sculpture only existed as text. In an interview from 1969 he emphasized the fundamental importance of the possibility of a material execution: 'If [the works] were not possible to be built, they would negate the choice of the receiver as to whether they were built or not.' But the work remains the same: 'Whether [people] build it or not in no way affects the work.'[10]

Weiner's linguistic constructions are always intrinsically complete; they describe the material result of an action rather than the action itself. He categorically does not want to give instructions and therefore avoids the use of the imperative. 'My own art never gives directions, only states the work as an accomplished fact.'[11] And further, 'To use the

Lawrence Weiner, *Lower density photo with sky*, 1968, photo: Siegelaub Collection & Archives at the Egress Foundation, Amsterdam

Lawrence Weiner, 1000 GERMAN MARKS WORTH MEDIUM BULK MATERIAL TRANSFERRED FROM ONE COUNTRY TO ANOTHER, 1979, Stedelijk Van Abbemuseum, Eindhoven

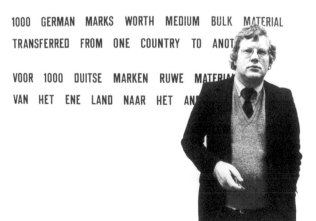

imperative would be for me fascistic... The tone of command is the tone of tyranny.'[12] Without their corresponding state of completion, the text version and the material version of a particular work could never be equally valid nor function in a parallel way.

Although the political context of conceptual art was permeated by anti-authoritarian notions, Weiner stood relatively alone in his rejection of the instructional form. It was that form which was often employed – at various levels – in the conceptual art of the 1960s. At that time the instruction must have seemed like the ideal means to separate physical 'labour' from mental effort. Although that was already the case when Moholy-Nagy telephoned a sign factory in 1922, the conceptual artists of the 1960s emancipated the instruction and took it to the extreme. In certain cases the instruction took the place of the realized work of art. This turned the division of labour between inventor and implementor into the most important thing.

Between 1966 and 1968, John Baldessari called on a sign painter to make a series of paintings that consisted of a text or a text with a photograph. The sign painter was given precise instructions; Baldessari dictated exactly what was to be done. 'Important was that I was the strategist. Someone else built and primed the canvases and took them to the sign painter, the texts are quotations from art books, and the sign painter was instructed not to attempt to make attractive artful lettering but to letter the information in the most simple way.'[13] In many cases the text fragments used also have the character of instructions themselves – instructions which, once transferred to the canvas, seem to be directed at the person viewing the painting. The work *Composing on a Canvas* instructs the viewer to study paintings in a systematic fashion: 'Study the composition of paintings. Ask yourself questions when standing in front of a well-composed picture. What format is used? What is the proportion of width to height?' and so on. In other works Baldessari presents a textual analogy of a 'compelling' painting – 'The spectator is compelled to look directly down

the road and into the middle of the picture' – or of a minimal, reductionist painting: 'A work with only one property.' The last example makes it clear that Baldessari was driving at something impossible: a painting executed as the material evidence of a concept that amounts to the negation of the painting.

Baldessari instructed his public in a disturbing, ironizing manner. Lawrence Weiner probably overlooked that possibility when he dismissed the instructional form. Nonetheless, Baldessari's paintings are no less serious as art proposals than the linguistic constructions by Weiner. What they have in common is that their obsession with manufacture – the manual processing of physical material – is still framed within a given medium, whether painting or sculpture. There was evidently a tendency in 'historic' conceptual art to seek out a radical method with which a credible result could still be achieved *within* those traditional art media, instead of rejecting them. This method therefore often involved a proposal in the form of a descriptive text related to the handling of materials or objects. Whereas Weiner used this form to renounce his authority as an artist while still being able to make art, Baldessari used it to reformulate his authority as an artist, namely as a strategist who

John Baldessari, *Everything is purged from this painting...*, 1967-1968, The Sonnabend Collection

John Baldessari, *The spectator is compelled...*, 1967-1968, collection Robert Shapazian, Los Angeles

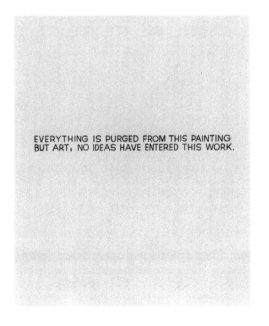

EVERYTHING IS PURGED FROM THIS PAINTING BUT ART, NO IDEAS HAVE ENTERED THIS WORK.

THE SPECTATOR IS COMPELLED TO LOOK DIRECTLY DOWN THE ROAD AND INTO THE MIDDLE OF THE PICTURE.

hires in and organizes the capacity of third parties. (He also called in a number of amateur painters for his 1969 *Commissioned Paintings*.)

On the other hand, some artists working in this period gave instructions to *themselves*, but essentially with the same goal: to salvage the sense of their work as artists. Some of them phrased instructions explicitly, while others allowed them to remain implicit; one artist formulated a new instruction for every work, another made do with one single instruction for years. When Carl Andre was asked to contribute to 'Sonsbeek buiten de perken' (1971), he instructed himself to satisfy two conditions: 'no materials or fabrication cost' and 'no harm to any living thing'.[14] In his *Today Paintings* (1966-), On Kawara applied the rule that they had to be completed within a day; if he did not succeed then he would destroy them immediately. The basis for Vito Acconci's *Following Piece* (1969) was the assignment that the artist set himself to follow a random person on the street until he or she entered into a private space. Douglas Huebler's *Variable Piece #111* (1974) was based on the artist's self-instruction to make a series of close-up shots of mannequins while standing in front of a shop window, and then photograph the passer-by who most re-

Carl Andre, *Light Wire Circuit*, 1971, Park Sonsbeek, photo: Judith Cahen, Amsterdam

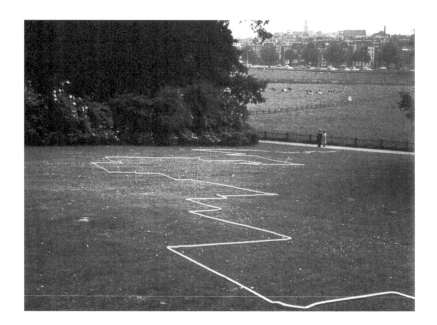

sembled that mannequin within ten seconds. In these examples it is still a matter of the division of labour between inventor and implementor, even though the same person plays both roles. The artist splits himself in two, to the extent that the instructions cannot be changed from the moment that the process of execution has begun. The interim evaluation of the result can no longer lead to adaptation of the plan. There is in fact no evaluation whatsoever by the artist: every result or outcome is a good result. The instruction would be performed to the best of the artist's abilities, and the result presented as clinically as possible. In 1967, Sol LeWitt described this 'Chinese Wall' as follows: 'In conceptual art the idea of concept is the most important aspect of the work. When an artist uses a conceptual form of art, it means that all of the planning and decisions are made beforehand and the execution is a perfunctory affair. The idea becomes a machine that makes the art. This kind of art… is usually free from the dependence on the skill of the artist as a craftsman.'[15]

A straight line

Sol LeWitt wrote his manifesto on conceptual art in 1967. Thirty-five years have passed since then, but there are still

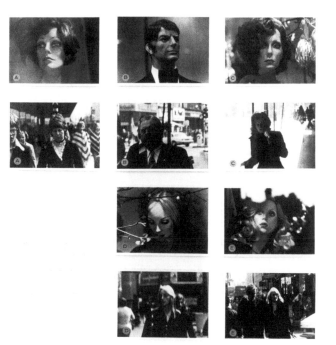

Douglas Huebler, *Variable Piece #111*, 1974, Stedelijk Van Abbemuseum, Eindhoven

During a ten minute period of time a number of mannequins were photographed through the windows of clothing stores on Oxford Street. The artist allowed no more than ten seconds to pass before making a photograph of a passer-by whom he felt, more than anyother seen during that time, most closely resembled the mannequin thereby juxtaposing one mode of reality with another.

Ten photographs join with this statement to constitute the form of this piece.

March, 1974

young artists appearing on the scene whose work is presented as 'conceptual'. What makes this qualification so attractive nowadays? What is the success of conceptual art based on?

As early as 1973, Seth Siegelaub and Lucy Lippard, two important agents of the first generation, expressed their disappointment and frustration with what conceptual art had managed to achieve. At that point it was obvious to them that the intended transformation of the art system had failed. The desire to eliminate commercialism and the art market had proven to be no more than wishful thinking: people were still dealing, even in 'dematerialized' art, and often with the endorsement of the artists themselves. The radical ideas developed by conceptual artists concerning the relationship between the work of art and its audience went largely unnoticed beyond a small, well-informed elite, and they certainly failed to find general acceptance; the breakthrough to a wider public failed completely.[16] The large-scale popular breakthrough also failed to materialize in the Netherlands. 'Sonsbeek buiten de perken' was seen as a failure by organizers and sympathizers alike; the work of conceptual artists met for the large part with ridicule and incomprehension. Afterwards, a disappointed Wim Beeren withdrew from the museum world for a number of years.[17]

The 'success' of conceptual art can thus primarily be regarded as an internal success. Its body of ideas was spread in an efficient manner at academies and art schools in Europe and America. Since the 1960s, Michael Asher, Stanley Brouwn, Daniel Buren, Jan Dibbets, Bernd Becher, John Baldessari and other pioneers of conceptual art have trained many art students at these institutions. It is perhaps no coincidence that conceptual artists often turned out to be strong teachers: they were in a sense already specialized in the detached analysis of the fundamental issues of art production and the artist's expertise. If uncoupling mental labour from physical labour and giving preference to the instructional form were to have an impact anywhere, then it was in the training of young artists.

The transformation of conceptual art into an academic curriculum has contributed to the fact that the label identifying a contemporary work of art as 'conceptual' no longer has any real meaning – a vague sense of intellectual merit aside. During their training, artists learn how to present their work in a correct fashion – i.e. in terms of self-reflection and contextual analysis. The following passage is taken from a subsidy application by Maziar Afrassiabi, born in 1973 in Tehran and educated at the Hogeschool voor de Kunsten (College for the Arts) in Utrecht from 1993 to 1997: 'My work process is characterized by the quest for expressive styles in order to problematize the "creative" activity and the relevance of "meaning", and thus devise images that are a solution for the problematized object/subject relationship in visual art and, in general, in the recognition of the "Identity". The a-chronological broaching of (art) history in order to temporarily mark my position within or outside it. In this way I can move freely from context to content and vice versa…. For me it is very important that my work should be a result of encounters between different levels of experience and the thought within the representation.'[18]

A statement like this suggests that any well-educated artist today can pass for conceptual. The separation of conception and execution has, so it seems, spread into a general precondition for artists to articulate their position in the art system successfully. Nowadays, the representation (and promotion) of art is what makes it crucial for artists to reflect about the context of their practice. The complete or partial contracting out of the execution of a work has become a standard option which in many cases makes little difference to the content of that work.

The impossibility of still attributing a specific meaning to the label 'conceptual' with regards to modern-day art production has a retroactive effect on the historic interpretation of conceptual art. If there ever was a meaningful foundation for the delineation of this movement, this now seems to have definitively disappeared. On reflection, Sol LeWitt's stipulation that all the decisions must have been

made before realization can begin could also be applied to the work of minimalists such as Donald Judd and Tony Smith. (It is known that Smith had his work *Die*, a six-foot steel cube from 1962, executed using telephonic instructions: 'I didn't make a drawing; I just picked up the phone and ordered it.'[19]) The elusive position of Carl Andre and Robert Morris once again suggests that the categorical distinction – and even antagonism – between minimalism and conceptual art must have been construed after the fact. Early works by Morris, such as his *Cardfile* (1962), anticipate typical conceptual procedures.[20] The rigid boundary between art for the eye and art for the brain starts to give a little in the knowledge that mental and physical work were separated even in so-called 'op art': Bridget Riley has been having her paintings realized by assistants since 1961.[21] The same holds for the systematic distinction between conceptual art and the *instruction pieces* of the Fluxus movement. La Monte Young wrote 'compositions' around 1960 that consisted of a short, one-line instruction, such as 'Draw a straight line and follow it' (*Composition 1960 #10*) or 'Turn a butterfly (or any number of butterflies) loose in the performance area' (*Composition 1960 #5*). George Brecht took this further with his 'word pieces' and 'event scores'. The kinship

Tony Smith, *Die*, 1962, Wadsworth Atheneum, Hartford

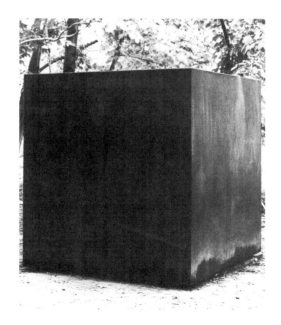

of conceptual art and Fluxus is partly founded on the fact that in post-serial music practice the fixed division of labour between inventor and implementer – composer and performer – was seized on for experiments with chance and unpredictability. The interaction and collaboration between composers, choreographers, performers and artists such as Young, Brecht, Yoko Ono, Yvonne Rainer and Robert Morris in the early 1960s generated important procedural models for the (official) conceptual art that was to follow. The substitution of a completed work with an open instruction, to be executed by a random person at a random time and place, is possibly the most important of these models. John Cage, whose composition lessons were followed by Brecht and various other Fluxus artists in the late 1950s, gave a crucial impetus to this development. His composition *4'33"* from 1952 might be regarded as the *Ur*-model of the maxim 'any result is a good result'.[22]

Non-events

Meanwhile, the obsessive fantasy of a work of art that consists of nothing but ideas has not been thwarted by considerations of an historical or art historical nature. Artists who want to share this fantasy with their audience, and for whom

La Monte Young, *Composition 1960 #10*, 1960, from: *An Anthology* (1963)

George Brecht, *Water Yam*, 1963, collection Harry Ruhé, Amsterdam

Composition 1960 #10
to Bob Morris

Draw a straight line
and follow it.

October 1960

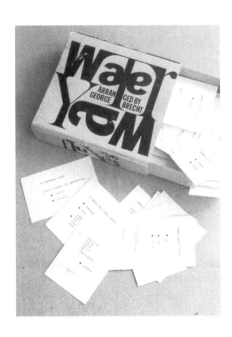

the designation 'conceptual artist' is a sobriquet, keep on popping up again and again. Sometimes they are good for a little fracas and some publicity, witness the recent *brouhaha* about *The Lights Going On and Off*, the work for which the 33-year-old Martin Creed won the British Turner Prize in December 2001. The work consisted of an empty room in which the lights went on and off. Other artists protested against the jury's decision to award the prestigious prize for this 'gimmick' at the expense of 'painters and sculptors with real creative talent'.[23] Creed had given his opponents ammunition with the memorable statement: 'It's true, anyone can do it…. It's just I'm better than anyone else at it.'[24]

One of the 'event scores' by George Brecht from 1961 bears the title *THREE LAMP EVENTS*. The complete text reads:

THREE LAMP EVENTS.
* on. off.
* lamp.
* off. on.

Martin Creed, *The Lights Going On and Off*, Tate Modern/Turner Prize London, December 2001, photo: Reuters

Martin Creed's prize-winning work could in theory be understood as a realization or interpretation of Brecht's 'score' of 40 years earlier. However, what makes this connection less credible – apart from the fact that the name of the inventor was kept silent – was most notably the aura of 'new, hip and unique' that emanated from Creed's presentation. Press photos of *The Lights Going On and Off* showed the artist standing in an empty museum space, dressed in a dandyish outfit, with his gaze fixed on the ceiling lights.

Since the historic failure of conceptual art, ascertained by Siegelaub and Lippard in 1973, the phantom of a completely dematerialized work of art can no longer show itself without a backdrop of deception and fraud. Martin Creed's stunt is only the umpteenth version of it. Scandals small and large relating to rip-offs and plagiarism often involve artists who, explicitly or not, have recourse to a conceptual status, such as Damien Hirst and Rob Scholte: the irritation

among colleagues and the public is only magnified by the idea that 'untalented' artists know how to make a lot of money by doing almost nothing.

Affairs such as these illustrate today's great unease in dealing with the conceptual heritage. The historic effect of conceptual art splits into two conflicting tendencies. Its characteristic forms – such as text panels, photographic documentation, temporary 'situations', performances, etc. – have evolved into the most natural and constantly available instrumentarium of the modern-day artist. On the other hand, the criteria for the judgment of art works have never been transformed in the spirit of conceptual art. That explains why since the mid-1970s visual art seems to have become so much more prone to accusations of plagiarism and a lack of originality.

The efforts of artists like Lawrence Weiner were still explicitly aimed at enabling art to transcend value judgements in terms of creativity, originality and innovation. He and his colleagues wanted to permanently dismantle the normalizing effect of such criteria. In its place, the reception of art works would have to be determined to a much greater extent by the personal input and initiative of those on the receiving end of the production line. 'People, buying my stuff, can take it wherever they go and rebuild it if they choose. If they keep it in their heads, that's fine too. They don't have to buy it to have it – they can have it just by knowing it. Anyone making a reproduction of my art is making art just as valid as art as if I had made it. (…) If art has a general aspect to it and if someone receives a work in 1968 and chooses to have it built, then either tires of looking at it or needs the space for a new television set, he can erase it. If – in 1975 – he chooses to have it built again – he has a piece of 1975 art. As materials change, the person who may think about the art, as well as the person who has it built, approach the material itself in a contemporary sense and help to negate the preciousness of 1968 materials….'[25]

Whoever considers the uproar around Martin Creed and the Turner Prize against this background, must acknow-

ledge that the supposed failure of historic conceptual art has had a much wider reach than the predictable detail that it failed to blow up the art market. In essence, *all* the institutions ranged behind the professional quality judgment – art criticism, the museum, the discipline of art history – have successfully managed to shield themselves from the implications of conceptual art. The intended uncoupling of conception and execution – the replacement of a realized work of art with an open description or instruction – specifically threatened to pull away the very foundation of every well-reasoned quality judgement. When every execution is a good execution, and any result a good result, what else is there to say about it? The disregard of conceptual artists for the accepted modernist quality criteria undermined and ridiculed the function of everyone involved in professional critical judgment.

However, this threat endured only briefly; around the middle of the 1970s the status quo already seemed to have been restored. The only place that conceptual artists successfully propagated their ideas was within the academy – the protectorate of institutionalized art instruction. There they had direct and unconditional influence.

Gillian Wearing, *Signs That Say What You Want Them To Say, And Not Signs That Say What Someone Else Wants You To Say*, 1992-1993

The periodical recurrence of the fantasy of the completely dematerialized work of art can change nothing about the fact that conceptual art is an historical phenomenon. As one movement among many, conceptual art has entered the annals of 20th-century art, without its implications for the judgement of quality having had a lasting impact on the way that the history of that 20th-century art is written. This two-pronged effect has created an impasse for the critical formation of judgements about contemporary works of art. In the 1990s, well-educated young artists such as Douglas Gordon and Gillian Wearing came up with variations on historic examples of conceptual art (including work by Douglas Huebler). In most cases these new works were too innocent to be considered plagiarism and too shallow to be considered commentary. At the same time, the heroes of yesterday also continued to make work themselves – some of them endlessly embroidering on a 35-year-old pattern, others knitting on an equally endless chain of retro-innovations, the consistency of which is only obvious to the artists themselves. What these young and old artists have in common is that they can easily shrug off any criticism of their work as a symptom of nostalgia for the 1960s. The task that critics, theoreticians and historians should set themselves – to

Douglas Huebler, *Variable Piece #70*, 1970-1977, Stedelijk Van Abbemuseum, Eindhoven

develop 'post-conceptual' criteria with which it is possible to judge individual contemporary works of art in a convincing way – is all the more pressing.

Camiel van Winkel (1964) is an arts critic, writer and editor of *De Witte Raaf*.
In 1999 he published *Moderne leegte. Over kunst en openbaarheid* (SUN publishers).

1. Mel Bochner, 'Excerpts from Speculation (1967-1970)'. In: Alexander Alberro and Blake Stimson (eds.), *Conceptual Art: A Critical Anthology*, MIT Press, Cambridge, Mass./London 1999, p. 192.
2. Henry Flynt, 'Concept Art' [1961]. In: Jackson MacLow and La Monte Young (eds.), *An Anthology*, New York 1963 and http://www.henryflynt.org/aesthetics/conart.html.
3. László Moholy-Nagy, *The New Vision*, Wittenborn, New York 1947, p. 79.
4. Richard Huelsenbeck, (ed.), *DADA Almanach* [1920], Edition Nautilus, Hamburg 1987, p. 89.
5. Jeff Koons interviewed by Burke & Hare, 'From Full Fathom Five', *Parkett*, no. 19 (1989), p. 47.
6. Ibid.
7. Lucy R. Lippard (ed.), *Six Years: The Dematerialization of the Art Object from 1966 to 1972* [1973], University of California Press, Berkeley 1997, p. 73.

8. Lawrence Weiner, 'Statement' [1972]. In: Charles Harrison and Paul Wood (eds.), *Art in Theory 1900-1990. An Anthology of Changing Ideas*, Blackwell, Oxford/Cambridge, Mass. 1992, p. 882.
9. Ann Goldstein and Anne Rorimer (eds.), *Reconsidering the Object of Art: 1965-1975*, MIT Press, Cambridge, Mass./London 1995, p. 222.
10. Lippard (ed.), *Six Years: The Dematerialization of the Art Object*, p. 115.
11. Weiner, 'Statement', p. 882.
12. John Anthony Thwaites, 'Lawrence Weiner: An Interview and an Interpretation', *Art and Artists*, no. 5 (August 1972), p. 23. Cf. Alexander Alberro, 'Reconsidering Conceptual Art, 1966-1977'. In: Alberro and Stimson (eds.), *Conceptual Art: A Critical Anthology*, pp. xvi-xxxvii.
13. *John Baldessari*, exh. cat. Van Abbemuseum, Eindhoven/Museum Folkwang, Essen 1981, p. 6.

14. *Sonsbeek 71*, exh. cat. Arnhem 1971, pt. 2, p. 5.
15. Sol LeWitt, 'Paragraphs on Conceptual Art' [1967]. In: Alberro and Stimson (eds.), *Conceptual Art: A Critical Anthology*, p. 12.
16. Blake Stimson, 'The Promise of Conceptual Art'. In: ibid., pp. xlii-xliii.
17. Cf. Camiel van Winkel, 'Dertig jaar buiten de perken. Gesprek over Sonsbeek 71 met Cor Blok, Judith Cahen and Lambert Tegenbosch', *De Witte Raaf*, no. 91 (May-June 2001), pp. 19-21; and ibid., 'Informatie ervaren – ervaring vergaren'. In: Jeroen Boomgaard et al. (eds.), *Als de kunst er om vraagt. De Sonsbeektentoonstellingen 1971, 1986, 1993*, Stichting Tentoonstellingsinitiatieven, Amsterdam 2001, pp. 89-106.
18. Application for Development and Stimulation Subsidy, CBK 2001. Quoted with the permission of the artist.

19. *Tony Smith. Two Exhibitions of Sculpture*, exh. cat. Wadsworth Atheneum, Hartford/ICA, Philadelphia 1966, n.p.
20. Cf. 'Round Table: Conceptual Art and the Reception of Duchamp', *October*, no. 70 (1994), pp. 127-146.
21. Frances Spalding, 'The Poetics of Instability'. In: *Bridget Riley: Paintings from the 60s and 70s*, exh. cat. Serpentine Gallery, London 1999.
22. Liz Kotz, 'Post-Cagean Aesthetics and the "Event" Score', *October*, no. 95 (2001), pp. 55-89.
23. 'Tate egg protester faces life ban', BBC News Online, 12 December 2001 (http://news.bbc.co.uk/hi/english/entertainment/arts/newsid_1706000/1706637.stm).
24. 'Judges switched on as Turner Prize goes to the Creed of nothingness', *The Guardian*, 10 December 2001.
25. Weiner, 'Statement', p. 882.

Suzanna Héman

'Sol is our Spinoza' (Carl Andre)[1]

1. In: *Sol LeWitt*, exh. cat. Gemeentemuseum Den Haag, The Hague 1970.

A number of conceptual artists theorized and wrote extensively about the role and importance of visual art. From the very start, Sol LeWitt belonged to this 'literary' group, along with artists like Joseph Kosuth, Art & Language and Daniel Buren.

In the discussions we held with collectors, artists, gallery owners and curators in preparation for this exhibition, LeWitt's 'binding' and social character came up explicitly again and again. His skill in rallying other people together and sparking their enthusiasm for certain projects was exceptional. But LeWitt was not only socially active, he was also the intellectual, or the philosopher, as Carl Andre suggested: he realized the importance of analysis and reflection. In the same way as Spinoza stood up for the freedom of speech in the 17th century, LeWitt campaigned in the 20th century for a new freedom in the visual arts. Spinoza was excommunicated and outlawed because he dared to repudiate the immortality of the soul and was too vocal a proponent of religious tolerance. LeWitt, who was happily not subjected to excommunication, is in a certain sense that same kind of autonomous freedom thinker. He also refused to accept the theories that were posited as ostensible certainties. The statements that he published in 1969 under the title 'Sentences on Conceptual Art' is one example of the texts in which he formulated his thoughts,[2] and since then the text has been cited widely in periodicals, exhibition catalogues and anthologies about conceptual art. Nobody now disputes the importance or quality of this text. It has frequently been used by artists as well as critics, by supporters as well as opponents, in order to evaluate their thoughts with regards to the value and significance of conceptual art.

2. In: *0-9*, January 1969, pp. 3-5 en *Art-Language*, 1 (1969) no. 1 (May).

3. Daled acquired the manuscipt in 1973 at a benefit auction for the French periodical *Libération*. Daled's collection also includes two pages with concepts and sentences or sentence fragments, which seem to have formed the basis for *Paragraphs on Conceptual Art*.

That is why we were delighted to discover the manuscript of the 'Sentences' in the collection of Herman Daled, including various draft versions.[3] The material, which has never previously been published in this form, offers an insight into the genesis of this renowned text. The first version, for example, lacks the first 'Sentence' of the definitive version that is so often

cited: 'Conceptual artists are mystics rather than rationalists. They leap to conclusions that logic cannot read.' This 'Sentence' first appears in the second version, and even then it is not directly followed by the 'Sentences' about rationale and logic as in the definitive version. The drafts reveal LeWitt's methodology in writing this text: he sensitively sought out the best balance. Analytical, but also deeply personally involved, he investigated the possibilities for other, novel ways of approaching the visual arts. For LeWitt this was not so much a case of rejecting previous art forms and movements, but more a question of attempting to define his own position, and that of his contemporaries of a similar mind, regarding what visual art should be.

LeWitt certainly did not see it as simply being the value of the concept that forms the basis for a work of art. The physical realization had always been essential and necessary in order to be able to speak in terms of a work of art for him too. But for him it was incontrovertible that a sound concept was a *conditio sine qua non* for every good work of art. LeWitt elaborated what he considered the artistic significance of all this in the 'Sentences'. Comparing the different versions reveals where components have been combined or dropped, where the sequence and thus the relative position of the various statements was altered radically, and where the text has been elaborated (the first version had 23 'Sentences', while the published version has 35). In writing the 'Sentences', LeWitt managed to clarify a number of important aspects of visual art in words, for example the difference between concept and idea (the concept necessarily precedes the idea), perception (there is no *a priori* perception; it is only possible once there actually is something to be perceived), the duality of language, which is not merely a functional instrument that can be employed to reflect on visual art. Language itself can be visual art in its own right, since concepts and ideas are initially formed in thoughts and words; language has in itself become an integral element of conceptual art.

Over the years, LeWitt's 'Sentences' have provided a framework for the many discussions about the significance and role of conceptual art.

1 *The artist is interested in the conception of the work. He per-cieves it only when there is something to percieve.*
2 *A successful work alters the viewers (and artists) perception.*
3 *When an artist's perception is altered it allows and suggests new concepts.*
4 *If an artist changes his work while in process he risks fulfil-ment of the concept.*
5 *Ones (rational) judgements can only lead nowhere. They only repeat past results.*
6 *To leave oneself open to new experience ones mind must be open to make an illogical choice and then to follow it through to its conclusion*
7 *The value of the work of conceptual art is in its unpredictability*
8 *The total process must be followed blindly. The result is the result of the pre-planed process.*
9 *Decisions would be left to a minimum and should be solved in termes of the initial premise.*

191. Sol LeWitt, *Sentences on Conceptual Art*, 1968

1. The artist is interested in the conception of the work – He percieves it only when there is something to perceive.

2. A successful work alters the viewers (and artists) perception.

3. When an artists perception is altered it ~~for find its~~ allows and ~~suggest~~ new concepts.

4. If an artist changes his work while in process he risks fulfilment of the concept ~~prints~~ ~~conclusion.~~

5. One's ~~ex~~ judgements (rational) can only lead nowhere. They only repeat past results.

6. To leave oneself open to new experience ~~ones mind~~ must be open to make an illogical ~~decision~~ ~~choice~~ and then to follow it through to its conclusion

7. The value of the work of conceptual art is ~~it~~ in its unpredictability

8. The total process must be followed blindly – The result is the result of the pre-planed process.

9. Decisions would be left to a minimum and should be solved in terms of the initial premise.

10 *The direction of the concept allows the artist complete freedom – nothing is preordained*

11 *It has neither to do with materialism or non-materialism but can deal with either (or formal and anti-formal directions)*

12 *No form is inherently superior or inferior. It is possible that the thought alone would suffice as the work of art, if the thought were in terms of art.*

13 *The inner-vision should be followed.*

14 *A successful work of art changes the idea of what art is (definition) or what the artist does.*

15 *The artist works within the convention of his time but this convention is constantly changed, slowly.*

16 *The artist reacts to the dominant art of his time either by doing the opposite (which means the same terms are used, – upside-down inside-out) or improving on the same (the improvement is usually worse than the original).*

10. The direction of the concept allows the artist complete freedom - nothing is pre-ordained

11. It has neither to do with materialism or non-materialism but can deal with either (or formal and anti-formal directions)

12. No form is inherently superior or inferior. It is possible that the thought alone would suffice as the work of art; if the thought were in terms of art.

13. The inner-vision should be followed - ~~The conventions of art are basis of the new vision~~ ~~making new conventions~~.

14. A successful work of art changes the idea of what art is (definition) or what the artist does.

15. The artist works within the convention of his time but this convention is constantly changed, slowly.

16. The artist reacts to the dominant art of his time either by doing the opposite (which means the same terms are used, - upside-down inside-out) or improving on the same (usually the improvement is ~~the opposite~~ worse than the original

17 —

18 *It need not do anything except follow its own way, whether it is understood in that way is not the problem of the artist.*

19 *Each viewer approaches a work of art with a total history of understanding*

20 *Conceptual arts is not good art or bad art.*

21 *The artist's understanding of his own work is no better than anyone elses – sometimes worse.*

22 *The conceptual artist does not need to know what he is doing.*

23 *The conceptual artist would deal with what the artist himself would not expect.*

17. ~~Conceptual art is often didactic~~

18. It need not do anything except follow its own way. whether it is understood in that way is not the problem of the artist.

19. Each viewer approaches a work of art with a total history of understanding

20. Conceptual arts is not good art nor bad art.

21. The artists understanding of his own work is no better than anyone elses – sometimes worse.

22. The conceptual artist does not need to know what he is doing.

23. The conceptual artist would deal with what the artist himself would not expect.

1. *Conceptual artists are mystics rather than rationalists. They leap to conclusions that logic cannot reach.*
2. *The concept of a work may involve the matter of the piece*
3. *The piece cannot be percieved until it has been completed. The artist decides when the work is complete. He is a perciever, then, of his own art.*
4. *A priori perception is impossible. It implies imagining the piece as it will not exist.*
5. *Perception alters the mind and may change further concepts*
6. *Rational judgements repeat rational judgements*
7. *Illogical judgements lead to new experience.*
8. *All judgements are art if they are concerned with art, and fall within the conventions of art.*
9. *The conventions of art are altered by changing perceptions of art.*
10. *Banal ideas cannot be saved by beautiful execution.*

✓ 1. Conceptual artists are mystics rather than rationalists. They leap to conclusions that logic cannot reach.

✓ 2. The concept of a work may involve the matter of the piece

3. The piece cannot be perceived until it
✓ has been completed. The artist ~~becomes~~ decides when the ~~viewer~~. The work is complete. He is a perceiver, then, of his own art.

4. A priori perception is impossible. It
✓ implies imagining the piece as it will not exist.

✓ 5. Perception alters the mind and may changes further concepts

✓ 6. Rational judgements repeat rational judgements

✓ 7. Illogical judgements lead to new experience.

✓ 8. All judgements are art if they are concerned with art, and fall within the conventions of art.

✓ 9. The conventions of art are altered by changing perceptions of art.

10. Banal ideas cannot be saved by beautiful execution.

11 *Works of art can only be judged by results no matter what the idea.*

12 *Whatever form a work may take, it may only be taken (understood) in the terms that were intended. It may not be distorted by the viewers perception so that it is totally misconstrued. All perception is subjective, but must not be made perverse.*

13 *No form is inherently superior or inferior.*

14 *The artists concept will alter the viewers perception if the work is successful, but it may take time.*

15 *If the artist changes his mind midway through the execution of the piece he compromises the result and repeats past results.*

16 *Irrational thoughts should be followed absolutely and logically.*

17 *Formal art is essentially rational.*

18 *Conceptual art is not good art, or bad art.*

19 *The artist does not necessarily understand his own art. His perception is sometimes (often) worse than others.*

20 *Artists can often understand (percieve) other works than their own better than their own.*

11. Works of art can only be judged by results no matter what the idea.

12. Whatever form a work may take, it may only be taken (understood) in the terms that were intended. It may not be distorted by the viewers perception so that it is totally misconstrued. All perception is ~~any~~ subjective, but must not be made perverse.

13. No form is inherently superior or inferior.

14. The artists concept will alter the viewers perception of the work is successful, but it may take time.

15. If the artist changes his mind midway through the execution of the piece he compromises the result and repeats past results.

16. Irrational thoughts should be followed absolutly and logically.

17. Formal art is essentially rational.

18. Conceptual art is not good art, or bad art.

19. The artist does not necessarily understand his own art. His perception is sometimes (often) worse than others.

20. Artists can often understand (perceive) other works than their own better than their own.

The words of one artist to another may induce an idea chain, if they share the same concept.

The process of making art could possibly stop anywhere during the process and produce a work of art.

A work of art is about art.

If words are the medium used and the words are about art, they are not literature but are art.

If numbers are the medium used and the numbers are used as abstract quantities they may be art and not mathematics. Letters or symbols might be used as a substitute in this case, art is not philosophy.
When words such as painting and sculpture are used they connote a whole tradition and imply a rigid acceptance of this tradition intact.

√ The words of one artist to another
may induce an idea chain, if
they share the same concept.

The process of making art could
√ possibly stop stop anywhere during
the process and produce a work of
art.

A work of art is about art.

√ If words are the medium used
and the words are about art, they
are not literature but are art.

√ If numbers are the medium used
and the numbers are used as abstract
quantities they may be art and not
mathematics. Letters or symbols might
be used as a substitute in this
case.
art is not philosophy
When words such as painting and
√ sculpture are used they connote a
whole tradition and imply a rigid
acceptance of this tradition intact.

There are always many elements involved in any work of art. The most important are obvious, especially when a group of works by one artist are percieved.

If an artist uses the same form in [a] group of works and changes the material in each, then one would assume the artist's concept involved the material.

A work of art may be understood as a conductor from the artist's mind to the viewers. But it may never reach the viewers, or it may never leave the artist's mind.

The artists will is secondary to the process he initiates from idea to completion. His willfulness may be only ego.

To think of the artist as one with superior sensitivity implies he has little intelligence or daring.

There are always many elements
involved in any work of art. The
most important are obvious especially
by one artist
when a group of works, are percieved.

If an artist uses The same form
in group of works and changes
The material in each, Then one would
assume The artist's concept involved
The material.

A work of art may be understood as
a conductor from The artist's mind to
The viewers. But it may never
reach The viewers, or it may never
leave The artists' mind.

The artists will is secondary to
The process he initiates from idea
to completion. His willfulness
may be only ego.
To Think of The artist as one with
superior sensitivity implies he has
little intelligence or daring.

Idea and concept are different. The concept is a general overall direction while ideas are the components.

Ideas alone can be works of art; they are a chain of development that may eventually produce an object or physical entity. All ideas need not be made physical (even as words spoken) but the succeeding ideas depend on the completion of each, in its order.

If a work of art is made there are many variations that are not made. These may be as important.

√ Idea and concept are different.
√ The concept is a general over-all
direction while ideas are The components.

Ideas alone can be works of art; They
are a chain of development That
may eventually produce an object
√ or physical entity. All ideas need
not be made physical (even as words
spoken) but The succeeding ideas depend
on The completion of each, in its order.

√ If a work of art is made There are many
variations that are not made. These
may be as important.

Sentences on Conceptual Art

1 *Conceptual artists are mystics rather than rationalists. They leap to conclusions that logic cannot reach.*
2 *Rational judgements repeat rational judgements.*
3 *Illogical judgements lead to new experience.*
4 *Formal art is essentially rational.*
5 *Irrational thoughts should be followed absolutely and logically.*
6 *If the artist changes his mind midway through the execution of the piece he compromises the result and repeats past results.*
7 *The artists' will is secondary to the process he initiates from idea to completion. His wilfulness may be only ego.*
8 *When words such as painting and sculpture are used, they connote a whole tradition and imply a consequent acceptance of this tradition, thus placing limitations on the artist who would be reluctant to make art that goes beyond the limitations.*
9 *The concept and idea are different. The former implies a general direction while the latter are the components. Ideas implement the concept.*

Sentences on Conceptual Art

1. Conceptual artists are mystics rather than rationalists. They leap to conclusions that logic cannot reach

2. Rational judgements repeat rational judgements.

3. Illogical judgements lead to new experience

4. Formal Art is essentially rational

5. Irrational thoughts should be followed absolutely and logically.

6. If the artist changes his mind midway through the execution of the piece he compromises the result and repeats past results.

7. The artists' will is secondary to the process he initiates from idea to completion. His wilfulness may be only ego.

8. When words such as painting and sculpture are used, they connote a whole tradition and imply a consequent acceptance of this tradition, thus placing limitations on the artist who would be reluctant to make art that goes beyond the limitations.

9. The concept and idea are different. The former implies a general overall direction while the later are the components. Ideas implement the concept.

10 *Ideas alone can be works of art; they are in a chain of development that may eventually find some form. All ideas need not be made physical.*

11 *Ideas do not necessarily proceed in logical order. They may set one off in unexpected directions but an idea must necessarily be completed in the mind before the next one is formed.*

12 *For each work of art that becomes physical there are many variations that do not.*

13 *A work of art may be understood as a conductor from the artists' mind to the viewers. But it may never reach the viewer, or it may never leave the artists' mind.*

14 *The word[s] of one artist to another may induce an idea[s] chain, if they share the same concept.*

15 *Since no form is intrinsically superior to another, the artist may use any form, from an expression of words (written or spoken), to physical reality, equally.*

16 *If words are used, and they proceed from the ideas about art, then they are art and not literature; numbers are not mathematics.*

10. Ideas alone can be works of art; They are in a chain of development that may eventually find some form. All ideas need not be made physical.

11. Ideas do not necessarily proceed in logical order. They may set one off in unexpected directions but an idea must necessarily be completed in The mind before The next one is formed. ~~They There may be a~~

12. For each work of art That becomes physical There are many variations That do not.

13. A work of art may be understood as a conductor from The artists' mind to The viewers. But it may never reach The viewer, or it may never leave The artists mind.

14. The words of one artist to another may induce an idea chain, if they share the same concept.

15. Since no form is intrinsically superior to another, The artist may use any form, from an expression of words, (written or spoken) to physical reality, equally.

16. If words are used, and They proceed from ideas about art, Then they are art and not literature. ~~This goes for numbers symbols or any Thing else.~~ numbers are not mathematics

17 *All ideas are art if they are concerned with art, and fall within the conventions of art*

18 *One usually understands the art of the past by applying the conventions of the present thus misunderstanding the art of the past.*

19 *The conventions of art are altered by works of art.*

20 *Successfull art changes our understanding of the conventions by altering our perceptions*

21 *Perception of ideas leads to new ideas.*

22 *The artist cannot imagine his art, and cannot percieve it until it is complete.*

23 *One artist may mis-percieve (understand it differently than the artist) a work of art but still be set off in his own chain of thought by that misconstrual.*

24 *Perception is subjective*

25 *The artist may not necessarily understand his own art. His perception is neither better or worse than that of others.*

26 *An artist may percieve the art of others better than his own.*

27 *The concept of a work of art may involve the matter of the piece or the process in which it is made*

17. All ~~judgements~~ ideas are art if they are concerned with art, and fall within the conventions of art

18. One usually understands the art of the past by applying the conventions of the present, thus misunderstanding the art of the past.

19. The conventions of ~~the~~ art ~~of one's time~~ are altered by works of art.

20. Successful art changes our understanding of the conventions by altering our perceptions

21. Perception of ~~new~~ ideas leads to new ideas, ~~and change of concepts~~.

22. The artist cannot imagine his art, and cannot perceive it until it is complete.

23. One artist may mis-perceive (understand it differently than the artist) a work of art but ~~will~~ still be set off on his own chain of thought by that misconstrual.

24. Perception is subjective

25. The artist may not necessarily understand his own art. His perception is neither better or worse ~~that~~ than that of others.

26. An artist may perceive the art of others better than his own.

27. The concept of a work of art may involve the matter of the piece or the process in which it is made

28 *Once the idea of the piece is established in the artists'*
mind and the final form is decided, the process is carried
out blindly. There are many side effects that the artist cannot
imagine. These may be used as ideas for new works.

29 *The process is mechanical and should not be tampered with.*
It should run its course.

30 *There are many elements involved in a work of art. The most*
important are the most obvious.

31 *If an artist uses the same form in a group of works, and*
changes the material, one would assume the artists' concept
involved the material.

32 *Banal ideas cannot be rescued by beautiful execution.*

33 *It is difficult to bungle a good idea.*

34 *When an artist learns his craft too well he makes slick art.*

35 *These sentences comment on art, but are not art.*

Sol LeWitt

28. Once the idea of the piece is established in the artists' mind and the final form is decided, the process is carried out blindly. There are many side effects that the artist cannot imagine. These may be used as ideas for new works.

29. The process is mechanical and should not be tampered with. It should run its course.

30. There are many elements involved in a work of art. The most important are the most obvious.

31. If an artist uses the same form in a group of works, and changes the material, one would assume the artists' concept involved the material.

32. Banal ideas cannot be rescued by beautiful execution.

33. It is difficult to bungle a good idea.

34. When an artists learns his craft too well he makes slick art.

35. These sentences comment on art, but are not art.

Sol LeWitt

The newspaper *Provo* appears for the first time, under the management of the Amsterdam student Roel van Duyn. The Provo movement is established. In the summer well attended happenings take place by the statue *Het Lieverdje* in Amsterdam's Spui, particularly on Saturday evenings. The police come into action repeatedly and carry out numerous arrests amongst the Provos. (1) The 'anti-smoking magician' Robert Jasper Grootveld, a leading protagonist of the happenings, aims to make Amsterdam a 'Magical Centre'. During the action 'Stoned in the Streets', Bart Huges, a fellow combatant, shows the mind-expanding 'third eye' that he had drilled into his skull.
Internationally a number of cultural events raise people's eyebrows. Richard Wolheim speaks about 'minimal art', in reference to 'art with minimal content' and Allen Ginsberg introduces the expression 'flower power'. The Rolling Stones bring out *Satisfaction*. The Beatles come up with *Yesterday* and visit the Netherlands for the first time, while Bob Dylan also makes musical history with his LP *Highway 61 Revisited* and his famous song *Like a Rolling Stone*. Jean-Luc Godard's *Alphaville* succeeds in producing a convincing sketch of a futuristically inhuman world.

1965

———— The Mickery project starts in Loenersloot. The initiator is Ritsaert ten Cate, whose main interest is experimental theatre. From 1969 onwards works of art can be exhibited on this site.
———— In Amsterdam Stanley Brouwn asks passers-by to show him the way to a particular spot in the city using pen and paper. The project is called *This way Brouwn* and has been carried out repeatedly since 1961. (2) Brouwn has already organized a similar event, *View of a city in 24 hours*, in 1963. The event involved putting sheets of paper on the ground and allowing people to walk over them for 24 hours, leaving behind their footprints. The result was shown in the TV programme 'Signalement' on 29 December 1963.

In 1966, artists become involved in the Provo protest in Antwerp. Panamarenko, Hugo Heyrman and Bernd Lohaus organize happenings on the Groenplaats which are regularly broken up by the police. The same artists also stage a happening at the opening of Wide White Space Gallery. In Amsterdam the Provos win a seat on the city council. Gerard Reve publishes his novel *Nader tot U*. He is charged with blasphemy but later acquitted.
The Provo movement also starts to exercise influence outside the Benelux. In London Gustav Metzger organizes the 'Destruction in Art Symposium', explicitly requesting participation by Dutch Provo activists. John Latham and his students undertake an action in London in which they eat Clement Greenberg's *Art and Culture*. The publication

1966

…elgium the language conflict between the
 Flemish and the Walloons becomes
 increasingly violent, leading to actions
 around the University of Leuven.
…ary United States. Democrat Lyndon B.
 Johnson is sworn in as president for the
 second time.
…uary Vietnam. Beginning of the American
 bombing of North Vietnam.
…uary United States. Murder of the black
 militant leader Malcolm X.
…ch United States. In Selma, Alabama,
 demonstrators against racial discrimina-
 tion are shot down in an attempted
 march to Montgomery. After this 'Bloody
 Sunday', eight thousand demonstrators
 under the leadership of Martin Luther
 King finally succeed in completing the
 protest march at the end of March. 3
…United States. Artists protest against
 America's Vietnam policy at a reception
 at the White House in connection with
 the White House Festival of Arts.
…ber/november Great Britain, United
 States. Mass protests against the war
 in Vietnam.

…e. The Vatican officially abolishes the
 inquisition and the index of forbidden
 books.
…ed States. Founding of the Black Panthers.
…ch The Netherlands. Twenty people
 are arrested at incidents during and
 after the celebration of the marriage
 between Princess Beatrix and Claus
 von Amsberg. 4
…ch North America, Europe and Australia.
 Protest demonstrations against America's
 Vietnam policy in dozens of large cities.
…The Netherlands. VARA's controversial
 satirical TV programme 'Zo is het

photo: Cor Jaring

1

2

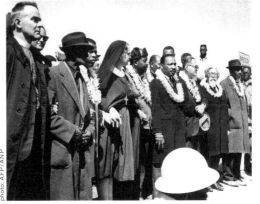

photo: AFP/ANP

3

75

of Michel Foucault's *Les mots et les choses* ushers in a new era of philosophy. Jean-Luc Godard makes film history with his *Masculin Féminin*, as does Michelangelo Antonioni with *Blow up* and Andy Warhol with *Chelsea Girls*. In the US Stokeley Carmichael calls for 'Black Power'.

—— *Working Drawings and other visible things on paper not necessarily meant to be viewed as Art*, organized by Mel Bochner at the School of Visual Arts Gallery, New York, including works by Carl Andre, Sol LeWitt and Robert Smithson.

—— *Primary Structures. Younger American and British Sculptors*, organized by Kynaston McShine at the Jewish Museum, New York, including works by Carl Andre.

—— Anny De Decker and Bernd Lohaus set up Wide White Space Gallery in Antwerp. One of their first exhibitors is Marcel Broodthaers.

—— On Kawara starts work on his *Date paintings*.

Publication of Bertrand Russell's *War Crimes in Vietnam*, Roland Barthes' essay 'The Death of the Author' and Jacques Derrida's poststructuralist essays *De la Grammatologie* [*Of Grammatology*] and *L'écriture et la différence* [*Writing and Difference*]. A number of different publications appear in the art world, including Michel Fried's 'Art and Objecthood' and Germano Celant's *Arte Povera*. In the Netherlands Wim T. Schippers, Wim van der Linden and Hans Verhagen start up 'Hoepla', a new programme for young people, for VPRO (a Dutch TV station). Phil Bloom causes an outrage when she appears naked in the first edition. 7 Jean-Luc Godard's *Week-end* comes out at the same time as much discussed films like Arthur Penn's *Bonnie and Clyde*, Buñuel's *Belle de Jour* and Pier Paolo Pasolini's magnum opus *Edipo Re*. Michael Snow's film *Wavelength* wins first prize at the fourth International Experimental Film Festival in Knokke, Belgium. The Beatles bring out *Sergeant Pepper's Lonely Hearts Club Band*, and the musical *Hair*, which is put on in Amsterdam three years later, has its premiere in New York. The rock band Mothers of Invention invite the only ten people who turn up to their concert to do the playing themselves. In the Netherlands Harry Mulisch publishes his *Bericht aan de rattenkoning*.

1967

—— Sol LeWitt publishes his 'Paragraphs on Conceptual Art', in which he attempts to define conceptual art, in *Artforum*.

—— *documenta 4* at Kassel, responsibility for which is shared by Jean Leering, director of the Stedelijk Van Abbemuseum, Eindhoven, including works by Carl Andre, Sol LeWitt and Bruce Nauman.

toevallig ook nog eens een keer' is
discontinued after 22 editions.

The Netherlands. Clashes between
building workers and the police in
which one of the workers dies. 5

Vietnam. Hanoi and Haiphong bombed
by the Americans.

The Netherlands. Arrest in Amsterdam
of 85 protesters against America's
Vietnam policy.

st China. Beginning of the Cultural
Revolution (which is to last till 1969)
under the leadership of Mao Zedong. 6

ember The NATO countries decide to
move their European headquarters
from France to Belgium.

ember The Netherlands. Foundation of
D'66, a political party whose aim is to
modernize the democratic system.

nany. Joseph Beuys sets up the German
Students Party.

t Britain. The British parliament
decriminalizes abortion and homo-
sexuality.

The Netherlands. Riots in Amsterdam
in connection with a Vietnam demon-
stration. 8

Greece. Military coup leads to the aboli-
tion of the monarchy and parliament.

Germany. At a demonstration against
the visit of the Shah of Persia, a
student, Benno Ohnesorg, is shot
dead by a policeman.

Middle East. Six-day war between Israel
and its Arab neighbours, in the course
of which 700,000 Palestinians flee to
Jordan and Lebanon.

China. The first Chinese hydrogen
bomb is set off.

he Netherlands enters into a cultural
treaty with the Soviet Union. In the
same year treaties of cooperation are
entered into with Poland, Romania
and Czechoslovakia.

st In Geneva the United States and
the Soviet Union propose similar
treaties banning the proliferation of
nuclear weapons.

ember The Netherlands. First transmis-
sion of colour television.

photo: Pieter Boersma

4

photo: Cor Jaring

5

photo: AFP/ANP

6

7

photo: Cor Jaring

77

—— *Junge Kunst aus Holland*, organized by Harald Szeemann at the Kunsthalle Bern, including works by Marinus Boezem, Jan Dibbets and Ger van Elk.

—— *19:45-21:55: September 9th, 1967: Frankfurt, Germany: Dies alles Herzchen wird einmal Dir gehören* organized by Paul Maenz at the Galerie Loehr, Frankfurt, including works by Jan Dibbets and Richard Long. Jan Dibbets is responsible for the choice of English artists, Paul Maenz for the Germans. 9 Gerry Schum films the event and furthermore decides to put his 'Fernsehgalerie' on German television.

—— *Signalement 67*, organized by the Liga Nieuw Beelden at the Stedelijk Museum, Amsterdam, including works by Jan Dibbets and Ger van Elk, with the help of which the term 'environment', previously unknown in the Netherlands, is introduced.

—— Galerie Konrad Fischer opens in Dusseldorf, Germany, with Carl Andre's first European solo exhibition. He is followed by artists including Douglas Huebler, Sol LeWitt, Bruce Nauman, Robert Smithson, Lawrence Weiner, Ian Wilson, Hanne Darboven, Daniel Buren and Jan Dibbets.

—— Jan Dibbets gives up painting and starts making more immaterial, conceptual projects. His new work goes on show at places like the Galerie Swart in Amsterdam. During the year he goes to London and visits St. Martin's School of Art.

—— Founding of the Internationaal Instituut voor herscholing van Kunstenaars [International Institute for retraining of Artists] by Jan Dibbets, Ger van Elk and Reinier Lucassen. Courses are given with titles such as 'Pop Art', 'Hard Edge', 'How do I get to be a trendy gallery owner' and 'How do I get to be the kind of modern collector who commands respect'. 10

—— Ger van Elk produces his Plestiek Plastieken (Plastic Sculptures), which include the National Monument: three little mounds in red, white and blue, with orange pennants.

—— The Professional Association of Visual Artists (Beroepsvereniging Beeldende Kunstenaars – BBK) becomes active in the artists' protest movement. In the first instance the issue is mainly a critical reaction to the government's policy on art, as laid down in the BKR [Visual Artist Regulation, a piece of Dutch legislation that provides for the payment of allowances to artists.]

Death of Marcel Duchamp. Edward Kienholz builds his Portable War Memorial in reaction to the war in Vietnam 11 and Stanley Kubrick conquers space with his famous film 2001: A Space Odyssey. Mike Nichols' 'alternative' Hollywood film The Graduate becomes a major box office hit. Andy Warhol's Lonesome Cowboys and Pasolini's Teorema come out. In the Netherlands the artist Frans Zwartjes makes his first underground films. An important event for theorists and artists is the appearance in an English translation of Walter Benjamin's Das Kunstwerk im Zeitalter seiner technischen Reproduzierbarkeit' ('The Work of Art in the Age of Mechanical

1968

...ber Bolivia. Che Guevara, revolutionary and guerrilla fighter, is murdered by Bolivian troops.

...mber South Africa. In Cape Town the surgeon Christian Barnard carries out the first human heart transplant.

...mber Romania. Party leader Nicolae Ceauscescu is appointed president.

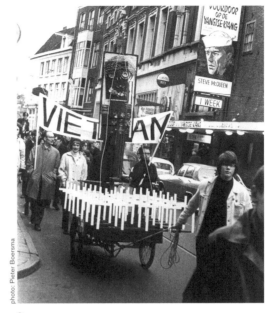

photo: Pieter Boersma

8

PARTICIPATING:

**JAN DIBBETS
BARRY FLANAGAN
BERNHARD HÖKE
JOHN JOHNSON
RICHARD LONG
KONRAD LUEG
CH. POSENENSKE
PETER ROEHR**

Arranged by Paul Maenz

source: Stedelijk Museum Amsterdam

9

source: Stedelijk Museum Amsterdam

10

...co. Olympic Games. During the award ceremony, the American sprinters Tommy Smith and John Carlos give the Black Power salute to draw attention to race relations in their country.

...ary Czechoslovakia. The moderate politician Alexander Dubček becomes leader of the Communist Party and follows a path of democratisation and liberation that comes to be known as the 'Prague spring'.

photo: Ad Petersen

11

Reproduction'; originally published in 1936). Timothy Leary's *Politics of Ecstasy* becomes the manifesto of the psychedelic movement and Jean Baudrillard publishes *Le système des objets*. In Amsterdam the pop shrine Paradiso opens its doors.

—— Lucy R. Lippard and John Chandler's article 'The Dematerialization of Art' appears in *Art International*.

—— *Minimal Art*, organized by Enno Develing at the Gemeentemuseum Den Haag, The Hague and at the Städtische Kunsthalle, Dusseldorf at the beginning of 1969, including works by Carl Andre and Robert Smithson. The exhibition catalogue includes pieces by Lucy R. Lippard and Enno Develing.

—— *Prospect 68*, organized by Konrad Fischer and Hans Strelow at the Städtische Kunsthalle, Dusseldorf. Participants include Marcel Broodthaers, Daniel Buren and Bruce Nauman.

—— *Carl Andre, Robert Barry, Douglas Huebler, Joseph Kosuth, Sol LeWitt, Lawrence Weiner (Xeroxbook)*, organized by the New York gallery owner Seth Siegelaub. The exhibition only exists in the form of a catalogue.

—— *3 Blind Mice/de collecties Visser, Peeters, Becht*, organized by Jean Leering at the Stedelijk Van Abbemuseum, Eindhoven, including works by Carl Andre, Marcel Broodthaers and Hanne Darboven.

—— Foundation of Galerie Art & Project by Adriaan van Ravesteijn and Geert van Beijeren. First exhibition bulletin sent out on 16 September. The gallery aims to maintain close international contacts with other galleries which exhibit conceptual art.

—— In May Terry Atkinson, Michael Baldwin and Harold Hurrell set up *Art & Language* Press in Coventry, England.

—— Mia Visser (Editions Bergeyck-Bergeyck), Wies Smals (Galerie Wies Smals, Amsterdam) and Ritsaert ten Cate (Galerie Mickery, Loenersloot) combine to set up Galerie Seriaal in Amsterdam as 'The Dutch sales centre for mass-produced works of art'.

—— Marcel Broodthaers opens his Musée d'Art Moderne in Brussels, which he subsequently exhibits in different variations in various places including Antwerp and Dusseldorf, and which continues to exist until 1972.

—— In parallel with *documenta 4*, Wide White Space Gallery organizes an alternative exhibition in hotel Hessenland in Kassel, exhibiting works including films by Marcel Broodthaers.

—— First exhibition of works by Carl Andre at Wide White Space Gallery, Antwerp.

—— The artist Bob Bonies organizes *Project Katshoek* in a newly completed office building. Various artists from Galerie Swart, including Marinus Boezem, Jan Dibbets and Ger van Elk, construct works of art using left behind building material.

—— Jan Dibbets and Ger van Elk take part in the exhibition

in the news

ry Vietnam. North Vietnamese troops
 and the National Liberation Front begin
 the Tet offensive, an all-out attack on
 forty towns in South Vietnam.

ary The Netherlands. The lower house
 approves a motion calling for an end
 to American bombing in Vietnam.

h Poland. Beginning of student demon-
 strations in Warsaw in favour of intellec-
 tual freedom.

h Vietnam. American mass murders in
 Son My.

United States. Martin Luther King
 killed in Memphis and buried in
 Atlanta. 12 Riots in a number of
 American cities

West Germany. Student leader Rudi
 Dutschke seriously wounded in a
 murder attempt.

France. Rebellious students occupy
 the Sorbonne. Demonstrations and
 violent skirmishes reach their climax
 on 11 May. 13 Subsequently mass
 strikes are held in protest against
 police behaviour.

Rome. Papal encyclical against birth
 control.

st Czechoslovakia is occupied by
 troops from the Soviet Union, the GDR,
 Poland, Hungary and Bulgaria. 14
 Leading politicians of the 'Prague
 spring' are arrested.

st France. The first French hydrogen
 bomb is set off.

ember West Germany. Formation of a
 new German Communist Party.

ber Vietnam. President Johnson
 announces the complete suspension
 of American bombing in North Vietnam.

mber Republican Richard Nixon is
 elected as America's president.

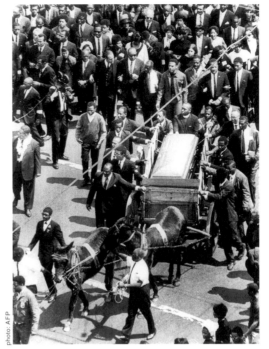

photo: AFP

12

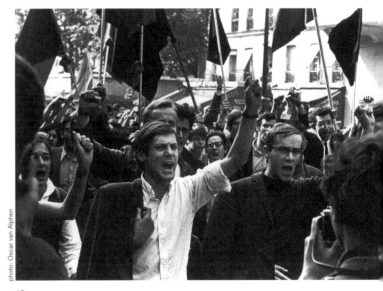

photo: Oscar van Alphen

13

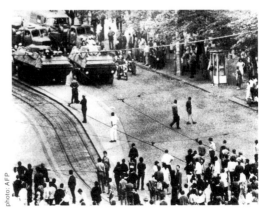

photo: AFP

14

81

Arte Povera + Azioni Povere in Amalfi, Italy, organized by Germano Celant.

———— At the opening of the academic year 1968/69 Amsterdam's Rijksacademie is occupied in protest against the 19th-century style of teaching which makes the Rijksacademie a stronghold of conservatism.

After the student uprisings in Paris and elsewhere the artists' protest movement gets under way. In New York the Art Workers Coalition protest against the war in Vietnam and the misuse of their art in the Museum of Modern Art. The Guerrilla Art Action Group goes so far as to demand that the Rockefellers leave the board. The Dutch artists' protest is less concerned with demonstrations against the war in Vietnam but more with a general criticism of cultural policy in the Netherlands, as is made clear by the occupation of the Night Watch room in the Rijksmuseum.

Jan Wolkers' book *Turks fruit* [*Turkish delight*] appears and shocks the public. Dennis Hopper's *Easy Rider* and John Schlesinger's *Midnight Cowboy* come out and Luchino Visconti makes an impression with his film *La caduta degli dei*. Fassbinder's first four long films, including *Der Katzelmacher* and *Liebe ist kälter als der Tod*, come out in West Germany. British humour shows its subversive side when *Monty Pythons Flying Circus* has a triumph on TV. Gilles Deleuze and Felix Guattari publish their influential megawork *L'Anti-Oedipe*.

1969

———— Sol LeWitt publishes his 'Sentences on Conceptual Art' in the journal *0-9*.

———— Joseph Kosuth's 'Art after Philosophy' appears in *Studio International*.

———— *January 5-31, 1969*, organized by Seth Siegelaub in rented office space at 44 East 52nd Street, New York, including works by Robert Barry, Douglas Huebler, Joseph Kosuth and Lawrence Weiner.

———— *Op losse schroeven: situaties en cryptostructuren*, ('Square pegs in round holes: situations and cryptostructures'), organized by Wim Beeren at the Stedelijk Museum, Amsterdam 15 and later in Museum Folkwang, Essen as 'Verborgene Strukturen', including works by Carl Andre, Jan Dibbets, Ger van Elk 16, Douglas Huebler, Richard Long, Bruce Nauman, Robert Smithson and Lawrence Weiner.

———— *When Attitudes Become Form: Works – Concepts – Processes – Situations – Information: Live in Your Head*, organized by Harald Szeemann at the Kunsthalle, Bern and other locations; including works by Carl Andre, Robert Barry, Hanne Darboven, Jan Dibbets, Joseph Kosuth, Sol LeWitt, Richard Long, Robert Smithson and Lawrence Weiner.

———— *July, August, September 1969*, organized by Seth Siegelaub at various locations around the world; including works by Carl Andre (The Hague), Robert Barry (Baltimore),

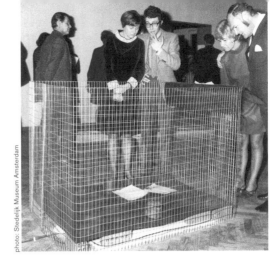

15

Netherlands. Founding of the feminist
action group Dolle Mina, with the
ultimate aim of liberating mankind.
dation of the Kabouter movement in
Amsterdam by Roel van Duyn, a former
Provo. One of this alternative group's
guiding slogans is 'Back to nature!'
Lennon and Yoko Ono hold a 'bed-in'
in the Hilton hotel in Amsterdam
to demonstrate against the violence
in the world.**17**

ary Czechoslovakia. Student Jan Palach
and thirteen fellow demonstrators burn
themselves alive in protest against
Russian interference in Czech politics.
The funeral is attended by more than
one million people.

ary Palestine. Yasser Arafat becomes
leader of the PLO.

France. President de Gaulle resigns
and is succeeded by Georges
Pompidou.

The Netherlands. Students occupy the
Maagdenhuis, the administrative centre
of the University of Amsterdam, because
of the way their demand for the right
to be consulted is disregarded. At the
beginning of June the start of legal
proceedings against the occupying
students leads to clashes between
students and police.**18** Later the
temporary premises of Amsterdam's
Vrije Universiteit are also occupied.

The Netherlands. Artists occupy the Night
Watch room at the Rijksmuseum, mainly
as a criticism of Dutch cultural policy.

mer The Netherlands. Amsterdam's Dam
square is occupied each night by 'Dam
sleepers', young visitors to the city sleep-
ing rough.**19**

Neil Armstrong becomes the first human
being to set foot on the moon.

ust Northern Ireland. Fierce fighting
between Protestants and Catholics. On
15 August British troops land in Ulster.

16

17

83

Daniel Buren (Paris), Jan Dibbets (Amsterdam), Douglas Huebler (Los Angeles), Joseph Kosuth (Portales, New Mexico), Sol LeWitt (Dusseldorf), Richard Long (Clifton Down, Bristol, England), Robert Smithson (Uxmal, Yucatan, Mexico) and Lawrence Weiner (Niagara Falls, New York and Ontario).

—— *557,087*, organized by Lucy R. Lippard at the Seattle Art Museum Pavilion, Seattle Art Museum and as *955,000* at the Vancouver Art Gallery, University of British Columbia, in 1970; including works by Carl Andre, John Baldessari, Robert Barry, Daniel Buren, Hanne Darboven, Jan Dibbets, On Kawara, Joseph Kosuth, Sol LeWitt, Bruce Nauman, Edward Ruscha, Gerry Schum and Lawrence Weiner.

—— *Prospect 69*, organized by Konrad Fischer and Hans Strelow at the Städtische Kunsthalle, Dusseldorf, including works by Marcel Broodthaers, Stanley Brouwn, Daniel Buren, Hanne Darboven, Jan Dibbets, Sol LeWitt en Robert Smithson.

—— *Konzeption – Conception: Dokumentation einer heutigen Kunstrichtung/Documentation of a Today's Art Tendency*, organized by Rolf Wedewer at the Städtisches Museum, Leverkusen, including works by John Baldessari, Robert Barry, Marcel Broodthaers, Stanley Brouwn, Daniel Buren, Hanne Darboven, Jan Dibbets, Gilbert & George, Douglas Huebler, On Kawara, Joseph Kosuth, Sol LeWitt, Bruce Nauman, Edward Ruscha, Robert Smithson and Lawrence Weiner.

—— The first issue of *Art-Language* is published in Coventry, England. *The Journal of conceptual art*, the journal of Art & Language (Terry Atkinson, David Bainbridge, Michael Baldwin and Harold Hurrell). Contributors include Sol LeWitt and Lawrence Weiner.

—— 'A 379089' is set up in Antwerp on 2 May as a kind of alternative art institute. Those involved include James Lee Byars, Marcel Broodthaers, Kaspar Daled, Anny De Decker, Bernd Lohaus and Martin Visser.

—— On 20 January a discussion on and exhibition of contemporary art is held at castle Drakensteyn under the direction of Princess Beatrix and Prince Claus. At the same time a performance is given of *Symfonie voor zeven obers* [Symphony for seven waiters], in which Prince Claus, his secretary, Wim Beeren, Marinus Boezem, Michel Cardena, Ad Dekkers, Jan Dibbets and Peter Struycken all take part. 20

—— Stanley Brouwn becomes involved in imaginary projects such as an idea to use holograms to project an image of a different part of the earth over Amsterdam every minute of the day.

—— Gilbert & George turn up for the first time, in London with their Singing Sculpture and in Amsterdam with their *Pose Sculpture* on the staircase of the Stedelijk Museum, which involves them spending four and a half hours in the same position with their faces and hands covered in metallic paint. 21

—— On 6 December On Kawara sends his first telegram, which says: 'I am not going to commit suicide. Don't worry.' A second telegram follows on 8 December: 'I am not going to commit suicide. Worry.' On 11 December his closing words

ust Woodstock. The Woodstock Music and
Art Fair in the American state of New
York attracts half a million visitors and
becomes a legend.

ember Vietnam. Death of the Communist
leader Ho Chi Min.

ember United States. *Life* magazine pub-
lishes an article showing photographs of
the mass murders by American soldiers
in the Vietnamese village of Son Mai. As
a result, in October fifteen million people
demonstrate against the war on 'Vietnam
moratorium day'.

ber West Germany. Willy Brandt becomes
Chancellor of the Federal Republic of
Germany.

mber Great Britain. Abolition of the death
penalty.

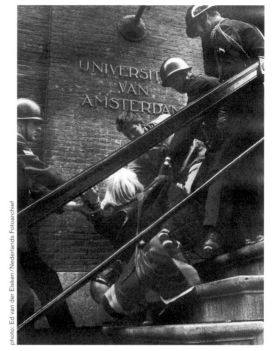

18

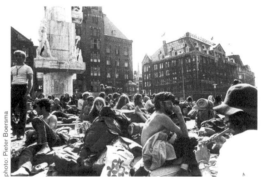

19

20

are: 'I am going to sleep. Forget it.' Subsequent telegrams contain the message: 'I am still alive.'

—— Jan Dibbets sends a card round the world in which he announces his intention to make a gesture (sticking up his thumb and winking) on a balcony in Amsterdam at three p.m. on three different days (9, 12 and 30 May).

Another project involving the transmission of information is *Jan Dibbets. Art and project Bulletin 15*, 26 November-16 December: 'Send the right page of this bulletin by returning post to Art and Project; each returned bulletin will be marked on the world map by straight line from your home to Amsterdam.' The results are published in *Studio International*, July/August 1970.

—— Robert Barry, Stanley Brouwn, Jan Dibbets, Joseph Kosuth and Lawrence Weiner exhibit at Art & Project, Amsterdam.

—— 21 June: In an interview in the *Haagse Post* Carl Andre calls on Dutch artists to protest against the misuse of their art. He comes up with a proposal, later withdrawn, that all of Rembrandt's paintings should be thrown out of the windows of the Rijksmuseum.

—— 23 August-5 October: solo exhibition of works by Carl Andre in the Gemeentemuseum Den Haag.

—— In the same year Carl Andre, like Daniel Buren, Lawrence Weiner, Marcel Broodthaers and others, exhibit at Wide White Space Gallery, Antwerp.

—— Gerry Schum's television exhibition 'Land Art' on German television (15 April), including works by Marinus Boezem, Jan Dibbets, Richard Long and Robert Smithson.

—— Jan Dibbets, *24 minutes. TV as a Fireplace* on German television in connection with the activities of Gerry Schum, 24-31 December. Every evening between Christmas Eve and New Year's Eve an open fire is lit at the end of the WDR programme.

—— Galerie Mickery: *(Pr)o(b)ject* with artists from 'Op losse schroeven', including works by Robert Smithson and Sol LeWitt.

—— Ger van Elk organizes *Micro Emotive Art*, a kind of sequel to 'Op losse schroeven', at Galerie Swart; including works by Marinus Boezem, Pier Paolo Calzolari, Jan Dibbets, Ger van Elk, Richard Long, Mario Merz and Emilio Prini.

—— The BBK organizes a conference of artists, students and lecturers from the Rijksacademie to oppose the reduction in the number of options offered. Art and artists are defined as modernizers of the social order.

Death of Jimi Hendrix. The Dutch beat band Shocking Blue achieves international success for the first time. Miles Davis creates 'fusion', a completely new musical genre, with his LP *Bitches' Brew*. Germaine Greer publishes *The Female Eunuch* and Dario Fo *Morte accidentale di un anarchio*. Bernardo Bertolucci's *Il Conformista* becomes one of the key films of the 1970's. In the Netherlands it becomes possible to sell

1970

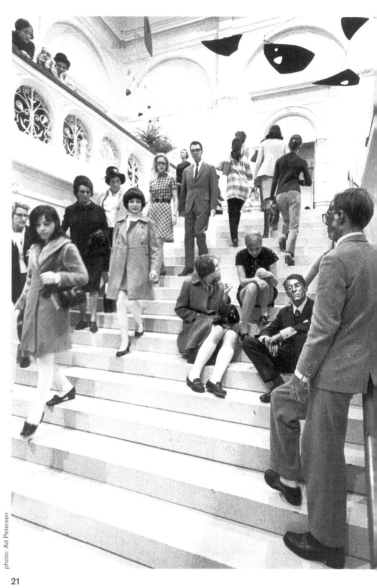

photo: Ad Petersen

21

dwide terrorist actions by the Palestinian
PLO, including hijacking of aircraft.
ary The Netherlands. The 'Kabouters' set
up the anti-authoritarian 'Orange Free
State' in Amsterdam as an 'alternative
state within a state'. Its national anthem
is *De Uil zat in de olmen*.

87

contraceptives to minors. Harry Mulisch publishes his novel
De verteller.

—— *Conceptual Art, Arte Povera, Land Art*, organized by
Germano Celant at the Galleria Civica d'Arte Moderna, Turin,
including works by Carl Andre, John Baldessari, Robert Barry,
Hanne Darboven, Jan Dibbets, Gilbert & George, Bruce Nau-
man, Robert Smithson and Lawrence Weiner.
—— *July-August 1970*, organized by Seth Siegelaub in the
form of a catalogue only, for which six critics selected a
number of artists including Art & Language, John Baldessari,
Hanne Darboven, Jan Dibbets, Douglas Huebler, On Kawara,
Joseph Kosuth and Sol LeWitt.
—— *Information*, organized by Kynaston L. McShine at The
Museum of Modern Art, New York, including works by Carl
Andre, Art & Language, Art & Project, John Baldessari, Robert
Barry, Stanley Brouwn, Daniel Buren, Hanne Darboven, Jan
Dibbets, Gilbert & George, Douglas Huebler, On Kawara, Sol
LeWitt, Richard Long, Edward Ruscha, Robert Smithson, Law-
rence Weiner and Ian Wilson. The exhibition is accompanied
by a demand by various artists that museums should close
temporarily as a gesture of protest against the attack on
Cambodia. The MOMA stays closed on 22 May.
—— *The New York Times* reports that at least a hundred
foreign artists are working in Amsterdam.
—— In September, to mark the occasion of the 75th anni-
versary of the opening of Amsterdam's Stedelijk Museum, a
week of special events is organized in and around the mu-
seum. The idea is to display art which takes place outside
the confines of the museum. A feature is Ellen Edinoff and
Koert Stuyf's *Verend trottoir*, which is held in Amsterdam's
Kalverstraat and elsewhere.
—— Sol LeWitt exhibits in the Gemeentemuseum Den
Haag, (25 July-30 August). The exhibition is organized by
Enno Develing. The catalogue includes pieces by Carl Andre,
Terry Atkinson Lawrence Weiner and others.
—— *Identifications*, a televised exhibition by Gerry Schum
on German television (30 November), includes works by
Stanley Brouwn, Ger van Elk, Gilbert & George and Lawrence
Weiner. Bas Jan Ader's performance *Fall* takes place in Los
Angeles and Amsterdam. The year marks the beginning of
Bas Jan Ader's involvement in Art & Project, but he has to
wait until 1972 for his own exhibition.
—— Gilbert & George have their first exhibition at Art &
Project. A two-hour showing of *Living Sculpture* is held on
12 May.
Ger van Elk and Jan Dibbets leave Galerie Swart to join Art &
Project, as do Marinus Boezem, Hanne Darboven, Douglas
Huebler, Sol LeWitt and Ian Wilson.
—— In a joint project, Jan Dibbets ploughs furrows some-
where in the country, Ger van Elk fills them with polyure-
thane and Reinier Lucassen colours them in.

h Germany. First official meeting between representatives of the two German states since the official partition of Germany in 1949.

Cambodia. Invasion by American and South Vietnamese troops after the takeover by Lon Nol and his military actions against North Vietnamese troops in his country.

✓may United States. The National Guard shoots down students at Ohio State University and Kent State University taking part in demonstrations against the invasion of Cambodia.

The Netherlands. Holland's first large-scale pop festival is held in Rotterdam's Kralingse Bos.

st The Soviet Union. German Chancellor Willy Brandt and Russian premier Kosygin sign a non-aggression treaty between West Germany and the Soviet Union.

st The Netherlands. The coming into force of the ban on sleeping rough on the Dam Square, announced on 21 August, results in clashes between 'Dam sleepers' and the police.

st Great Britain. The Isle of White Music Festival becomes the British equivalent of Woodstock.

st The Netherlands. Ambonese youths occupy the Wassenaar residence of the Indonesian ambassador.

mber Poland. The West German Chancellor Willy Brandt kneels at the monument on the site of the former Jewish ghetto in Warsaw, a memorial to the residents' revolt in 1943.

———— Robert Smithson constructs his monumental earth-work *Spiral Jetty* in Utah.

———— Stanley Brouwn performs *100 stappen richting La Paz* in Amsterdam's Kinkerstraat.

———— Lawrence Weiner buys the houseboat *Joma* in Amsterdam. (22)

———— In June Daniel Buren sticks up strips in various places in Amsterdam, e.g. above a shoe shop, on a series of advertising hoardings and by the entrance to a house.

The aftermath of the sexual revolution becomes clearly visible. The sex musical *Oh Calcutta* has its premiere in Amsterdam and makes the eight o'clock news programme, causing protests from conservative viewers. In England Princess Anne wears hot pants and in *ArtNews* Linda Nochlin wonders 'Why Have There Been No Great Women Artists?'. Greenpeace, the global environmental protection organization, is founded, the American engineer Ted Hoff invents the microchip, and the first Walt Disney World opens in Florida. Stanley Kubrick's A *Clockwork Orange* is the first film to use the Dolby sound system, heightening the film's shock effect. Visconti's *Morte a Venezia* comes out and the Belgian and Dutch film industry bring out classics like Fons Rademakers' *Mira*. The Rolling Stones finally set up their own record company (R.S. Records) and bring out the album *Sticky Fingers*, which includes *Brown Sugar*.

1971

———— *Guggenheim International Exhibition*, organized by Diane Waldman and Edward F. Fry at the Solomon R. Guggenheim Museum, New York, including works by Carl Andre, Hanne Darboven, Jan Dibbets, On Kawara, Joseph Kosuth, Sol Lewitt, Richard Long, Bruce Nauman, Robert Ryman and Lawrence Weiner. Work by Daniel Buren is rejected at the request of Donald Judd, Dan Flavin and Michael Heizer, whereupon Carl Andre withdraws his own work.

———— *Sonsbeek 71: buiten de perken* [beyond the pale], organized by Wim Beeren at Park Sonsbeek, Arnhem, including works by Bas Jan Ader, Carl Andre, Marinus Boezem, Stanley Brouwn, Daniel Buren, Hanne Darboven, Jan Dibbets, Ger van Elk, Douglas Huebler, On Kawara, Sol LeWitt, Richard Long, Bruce Nauman, Edward Ruscha, Robert Smithson and Lawrence Weiner. Local artists protest. (23)

———— *Prospect 71: Projection*, organized by Konrad Fischer, Jürgen Harten and Hans Strelow at the Städtische Kunsthalle, Dusseldorf, and other locations, including works by Bas Jan Ader, John Baldessari, Robert Barry, Marcel Broodthaers, Stanley Brouwn, Hanne Darboven, Jan Dibbets, Ger van Elk, Gilbert & George, Bruce Nauman and Lawrence Weiner.

———— Daniel Buren exhibits at Wide White Space Gallery, Antwerp, and Art & Project.

Netherlands. The influence of 'Nieuw
 Links' [New Left] on the Partij van
 de Arbeid.[The Dutch Labour
 Party] increases steadily.

centre for alternative youth tourism
 moves from the Dam to the Vondelpark.

ch The Netherlands. The fourteenth
 compulsory census arouses violent
 protests.

ember Middle East. Formation of the
 Union of Arabic Republics by Egypt,
 Syria and Libya.

ber China becomes a member of the
 United Nations and from November
 onwards has a seat in the Security
 Council, while Taiwan has to leave
 the UN.

ember Vietnam. The United States
 resumes bombing in North Vietnam.

22

23

——— Bas Jan Ader, John Baldessari and Richard Long exhibit at Art & Project.

——— Douglas Huebler's work for Art & Project *Variable Piece 1* is carried out in the Netherlands, United States, Italy, France and Germany. Eight people are photographed at the moment of being told 'You have a beautiful face'.

——— Stanley Brouwn and Gilbert & George have solo exhibitions at Amsterdam's Stedelijk Museum and Jan Dibbets has a solo exhibition at the Stedelijk Van Abbemuseum, Eindhoven.

——— In 1963 Jan Dibbets stuck on his letterbox in Antwerp 'Jan Dibbets, Metallurgist And Dematerialisator'. In 1971 in a letter to Lucy R. Lippard he writes 'That dematerialization you are speaking about is going to be for me (in contrast to many other artists) more and more visual.'

In his essay 'Other Criteria', Leo Steinberg refers to Rauschenberg's style of painting as 'post-modernist', indicating the difference with 'modernist' painting and abstract expressionism. Much discussed films include Gerard Damiano's sex film *Deep Throat*, with Linda Lovelace, and Pasolini's *I Raconti di Canterbury*. Buñuel's equally provocative film *Le Charme Discret de la Bourgeoisie* comes out. Francis Ford Coppola's *The Godfather* is the most financially successful film so far. Rainer Werner Fassbinder directs a number of films, including *Die bitteren Tränen der Petra von Kant*.

1972

——— *'Konzept'-Kunst*, organized by Konrad Fischer at the Kunstmuseum, Basel, including works by Art & Language, John Baldessari, Robert Barry, Stanley Brouwn, Daniel Buren, Hanne Darboven, Jan Dibbets, Gilbert & George, Douglas Huebler, On Kawara and Lawrence Weiner.

——— *Book as Artwork 1960/72*, organized by Germano Celant for Nigel Greenwood, London, including works by Carl Andre, the artists of Art & Language, John Baldessari, Robert Barry, Marcel Broodthaers, Stanley Brouwn, Daniel Buren, Hanne Darboven, Jan Dibbets, Ger van Elk, Gilbert & George, Douglas Huebler, Joseph Kosuth, Sol LeWitt, Richard Long, Bruce Nauman, Edward Ruscha and Lawrence Weiner.

——— *documenta 5*, organized by Harald Szeemann in Kassel, including works by Art & Language, John Baldessari, Robert Barry, Marcel Broodthaers, Daniel Buren, Hanne Darboven, Jan Dibbets, Ger van Elk, Gilbert & George, Douglas Huebler, Sol LeWitt, Richard Long, Bruce Nauman, Edward Ruscha, Robert Ryman, Robert Smithson and Lawrence Weiner.

——— Jan Dibbets represents the Netherlands at the Venice Biennial and has a solo exhibition in Amsterdam's Stedelijk Museum.

24

am. Intensification of American bombing
of cities in North Vietnam.

ary Northern Ireland. 'Bloody Sunday.'
British soldiers open fire on a banned
Catholic demonstration.

ary United States, China. President
Nixon visits China.

United States, Soviet Union. President
Nixon visits the Soviet Union and signs
the SALT I treaties to limit nuclear
weapons.

West Germany. Arrest of the leaders of
the extreme left Red Army Fraction
(RAF), including Andreas Baader and
Ulrike Meinhof.

Vietnam. Americans bomb the village of
Trang Bang with napalm. 24

United States. Five intruders are arrested
in the Watergate complex, the
Washington headquarters of the Demo-
cratic party, in the middle of an attempt
to install bugging devices. It later
appears that they were acting on the
orders of President Nixon's top advisers.

Northern Ireland. 'Bloody Friday.' The
IRA explode 21 bombs in Belfast.

ember West Germany. During the Olympic
Games a group of Israeli athletes
meet their deaths in the course of a
Palestinian hostage-taking action.
The games continue nonetheless.

mber United States. Nixon is re-elected
as president.

mber West Germany. Chancellor
Brandt is re-elected.

——— Lawrence Weiner exhibits at Wide White Space Gallery, Antwerp.

——— Establishment of the 'Galerie in het Goethe-Instituut/ Provisorium' in Amsterdam by Johannes Gachnang.

The Dutch film-going public is confronted with Paul Verhoeven's film version of *Turks fruit*, which becomes almost better known than the book. William Friedkin's *The Exorcist* triggers a revival of the horror genre, which from now on is not exclusively represented by cheap productions. Marco Ferreri's *La Grande Bouffe* causes an outrage at the Cannes film festival.

1973

——— Lucy R. Lippard publishes her book *Six Years: The Dematerialization of the Art Object*, in which she gives a summary of activities in the field of conceptual art between 1962 and 1972.

——— *Contemporanea*, organized by Incontri Internazionale d'Arte (Achille Bonito Oliva, Michel Claura and Yvon Lambert) at the Parcheggio di Villa Borghese, Rome. A separate section is called *Artists' Books*. The exhibition includes works by Carl Andre, Art & Language, John Baldessari, Robert Barry, Marcel Broodthaers, Daniel Buren, André Cadere, Hanne Darboven, Jan Dibbets, Ger van Elk, Gilbert & George, Douglas Huebler, On Kawara, Joseph Kosuth, Sol LeWitt, Richard Long, Bruce Nauman, Edward Ruscha, Robert Ryman, Lawrence Weiner and Ian Wilson.

——— Robert Smithson dies in a plane crash.

——— Marcel Broodthaers exhibits at Galerie Seriaal and Art & Project.

——— Robert Ryman has an exhibition at Art & Project.

——— Solo exhibition of works by Stanley Brouwn and Richard Long in the Stedelijk Museum, Amsterdam.

——— Ger van Elk and Bruce Nauman have an exhibition in the Stedelijk Van Abbemuseum, Eindhoven.

——— Ger van Elk and Richard Long exhibit at Wide White Space Gallery, Antwerp.

——— Jan Dibbets, Ger van Elk and Reinier Lucassen record in the portfolio *Morandi olé* how Morandi's 'cans' and 'tins' were bowled over in the bowling alley at the Rembrandtplein.

um and the Netherlands both get
Socialist prime ministers, Edmond
Leburton and Joop den Uyl respect-
ively. Den Uyl and his cabinet are
seen as symbolizing a political
watershed.

ary France, Vietnam. The Paris Accord,
signed by representatives of North
and South Vietnam, the United States
and the provisional revolutionary
government of South Vietnam, lays
down measures intended to lead to
a peaceful united Vietnam.

Greece. George Papadopoulos,
leader of the fascist junta, declares
a republic, but the military regime
returns to power at the end of the
year.

Vietnam. The second Vietnam Accord
urges South Vietnam to comply with
its agreements.

United States, Soviet Union. Party
leader Brezhnev and President Nixon
sign a new disarmament treaty.

ember Chile. In a violent military
coup, Augusto Pinochet, supported
by the CIA and others, takes power
from the democratically elected
president Salvador Allende, who
subsequently commits suicide.
Political opponents are held impris-
oned in the football stadium
in Santiago de Chile. 25

ber Middle East. Fourth war between
Israel and the Arab world. The
resulting 'oil boycott' by the Arab
states leads to an acute energy
crisis in the West at the end
of 1973.

ber Nobel peace prize awarded to
Le Duc Tho, representative of North
Vietnam, and Henry Kissinger, the
American secretary of state for
foreign affairs. Le Duc Tho refuses
the prize in protest against the
violation of the treaty by the South
Vietnamese.

photo: Koen Wessing

25

95

A number of ideologically critical books are published, including Alexander Solshenitsin's *The Gulag Archipelago*, brought out by a Paris publisher, giving an account of the barbarity of prison camps inside the Soviet Union. *All the President's Men*, by the American journalists Bob Woodward and Carl Bernstein, documents the disclosure of the Watergate affair. Jacques Derrida publishes his *Glas* and Pasolini's film *Il fiore delle mille e una notte*, later censored, comes out. Rainer Werner Fassbinder produces his film version of Fontane's *Effi Briest*.

1974

—— *Carl Andre, Marcel Broodthaers, Daniel Buren, Victor Burgin, Gilbert & George, On Kawara, Richard Long, Gerhard Richter*, at the Palais des Beaux-Arts, Brussels.
—— *Kunst bleibt Kunst: Projekt '74: Aspekte internationaler Kunst am Anfang der 70er Jahre*, at the Wallraff-Richartz Museum, Kölnischer Kunstverein und Kunsthalle, Cologne, including works by Robert Barry, Marcel Broodthaers, Daniel Buren, Hanne Darboven, Jan Dibbets, Gilbert & George, Joseph Kosuth, Bruce Nauman and Lawrence Weiner.
—— Bas Jan Ader, Daniel Buren, Hanne Darboven, Ger van Elk and Gilbert & George exhibit at Art & Project.
—— Robert Barry, Ger van Elk, Sol LeWitt and Robert Ryman have solo exhibitions in the Stedelijk Museum, Amsterdam.
—— Bruce Nauman exhibits at Wide White Space Gallery, Antwerp.

The film *Die verlorene Ehre der Katharina Blum*, from Heinrich Böll's novel of the same name, comes out and Rainer Werner Fassbinder directs films like *Faustrecht der Freiheit*. Amongst the year's other more or less discussed films are Jean-Luc Godard's *Numéro Deux*, Milos Forman's *One Flew Over the Cuckoo's Nest*, Jim Sherman's *The Rocky Horror Picture Show* and Pasolini's *Salò o le 120 giornate di Sodoma*. Carlos Fuentes publishes his *Terra Nostra* and Michel Foucault his *Surveiller et Punir*.

1975

nber The Netherlands. The first
 car-free Sunday is held as a result
 of the energy crisis.

tests its first atom bomb.
-scale starvation in Bangladesh and
 Ethiopia attracts worldwide media
 attention for the first time.
tance to the new atomic power station
 at Kalkar, on the border between
 Germany and Holland, develops into a
 huge German-Dutch protest.
Portugal. A non-violent military coup,
 which comes to be known as the
 Carnation Revolution, brings to an end
 almost forty years of dictatorship.
West Germany. Willy Brandt resigns as
 Chancellor because of a spy scandal.
 He is succeeded by Helmut Schmidt.
Greece. End of the military dictatorship.
 Ex Premier Konstantios Karamanlis
 returns to Athens.
st United States. President Nixon
 resigns over the Watergate affair. Vice-
 president Gerald Ford is sworn in as
 the new president.
mber West Germany. Holger Meins, 26
 a member of the Baader-Meinhof gang,
 dies in prison after a seven-week hunger
 strike, as a result of which the judge,
 Günther von Drenkmann, is shot by
 members of the RAF. Shortly afterwards
 Ulrike Meinhof is sentenced to eight years
 imprisonment for attempted murder during
 the freeing of Andreas Baader in 1970.
mber The United Nations decide to exclude
 South Africa from the General Assembly
 because of its apartheid policy. The
 country does however retain its member-
 ship thanks to a veto by the United
 Kingdom, France and the United States.

stance to the laying of the new metro
 line in the Nieuwmarkt district of
 Amsterdam. 27 Scuffles take place
 between police and residents trying
 to save their homes from demolition.
PvdA (the Dutch Labour Party), the VARA
 (a Dutch TV station) and the NVV (the
 Netherlands Federation of Trade Unions)
 organize the action 'Houd Portugal vrij'

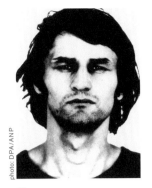

photo: DPA/ANP

26

photo: Pieter Boersma

27

—— For his project *In Search of the Miraculous* Bas Jan Ader sets sail from Cape Cod, Massachusetts, in an attempt to cross the Atlantic in a small sailing boat. He disappears without trace before reaching his intended destination in Cornwall, England.

—— The foundation De Appel is officially opened in Amsterdam with a performance by James Lee Byars and becomes a leading centre for performance and video art. The initiators include Wies Smals, previously co-founder of Galerie Seriaal, which is taken over by Helen van der Meij in 1975.

—— Carl Andre exhibits at Art & Project.

—— John Baldessari and Hanne Darboven have solo exhibitions in the Stedelijk Museum, Amsterdam.

—— Sol LeWitt exhibits in the Stedelijk Van Abbemuseum, Eindhoven.

—— From 18 January onwards the psychologist Henk Jurriaans can be seen for one hour each day in Amsterdam's Stedelijk Museum as a work of art. The purchase price paid by the Stedelijk Museum was 2,500 Dutch guilders.

[Keep Portugal free], intended to
provide financial support for the
Portuguese socialists.

JN declares 1975 the Year of the Woman.

Soviet Union and the United States
organize their first joint space mission.

o recorders and PCs are introduced
for home use.

ary Great Britain. Margaret Thatcher
becomes leader of the Conservative
party.

ary The Netherlands. Mass demonstra-
tions against the rising level of unem-
ployment.

h The Netherlands. Preparation of a draft
law recognizing conscientious objection
against compulsory military service.

Cambodia. Pol Pot and the Khmer Rouge
take power in Pnom Penh.

Vietnam. South Vietnam's President
Nguyen Van Thieu leaves office after
North Vietnamese troops besiege
Saigon.

Portugal. First general elections for 20
years followed two months later by
a coup by three generals and finally,
in September, by the installation of a
middle-of-the-road cabinet.

Vietnam. End of the war. Hanoi becomes
the official capital.

ember Spain. Death of Franco, the Spanish
dictator. Democracy finally returns to
Spain under King Juan Carlos, designat-
ed by Franco himself as his successor.

ember Surinam becomes independent.

ember The Netherlands. South Moluccans
hijack the Indonesian consulate in
Amsterdam.

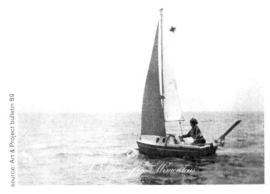

source: Art & Project bulletin 89

28

photo: Pieter Boersma

29

Bas Jan Ader

Carl Andre

Art & Language

John Baldessari

Robert Barry

Marinus Boezem

Marcel Broodthaers

Stanley Brouwn

Daniel Buren

André Cadere

Hanne Darboven

Jan Dibbets

Ger van Elk

Gilbert & George

Douglas Huebler

On Kawara

Joseph Kosuth

Sol LeWitt

Richard Long

Bruce Nauman

Edward Ruscha

Robert Ryman

Robert Smithson

Lawrence Weiner

Ian Wilson

museums

Stedelijk Museum Amsterdam	Stedelijk Van Abbemuseum	Gemeentemuseum Den Haag
	1968	1968, 1969
1975		
1974		
	1970	
	1968	
1971, 1973		
1975	1968	
1972	1971	
1974	1973	
1971		
1974	1975	1968, 1970
1973		
	1969, 1973	
	1969	
1974		
		1968

These listings may be incomplete. The editors would be pleased to receive any additional information.

Op losse schroeven, 1969	When Attitudes Become Form, 1969	Prospect, 1968	Prospect, 1969	
				Bas Jan Ader
■	■	■	■	Carl Andre
				Art & Language
				John Baldessari
	■		■	Robert Barry
■	■			Marinus Boezem
		■		Marcel Broodthaers
			■	Stanley Brouwn
		■	■	Daniel Buren
		■		André Cadere
	■		■	Hanne Darboven
■	■		■	Jan Dibbets
■	■			Ger van Elk
				Gilbert & George
	■		■	Douglas Huebler
				On Kawara
	■		■	Joseph Kosuth
	■	■	■	Sol LeWitt
■	■		■	Richard Long
■	■	■		Bruce Nauman
				Edward Ruscha
■	■		■	Robert Ryman
■	■	■	■	Robert Smithson
■	■		■	Lawrence Weiner
				Ian Wilson

Sonsbeek, 1971	documenta 5, 1972	galleries — Art & Project
■		1971, 1972, 1974, 1975
■		1975
	■	
	■	1971, 1972
	■	1969, 1971, 1972
■		1970
	■	1973
■	■	1969 ——— 1973, 1975
■	■	1971, 1974
	■	
■	■	1970, 1972, 1974
■	■	1969, 1971 ——— 1973, 1975
■	■	1970 ——— 1974
	■	1970 ——— 1972, 1974
■	■	1970 ——— 1973
■		
		1969
■	■	1970 ——— 1972, 1975
■	■	1971, 1973, 1975
■	■	
■	■	
	■	1973
■		
■	■	1969, 1972, 1973
	■	1970, 1972

Galerie Swart	Konrad Fischer	Wide White Space	MTL
	1967, 1969, 1971, 1972 ——— 1974		
	1971, 1973		
			1972, 1973
1968			
		1966 ——— 1975	1972, 1973
	1970, 1973		
	1969	1969 ——— 1974	1970, 1975
			1973, 1975
	1968, 1970, 1971, 1975		1972, 1974
1966 ———1969	1968, 1970, 1971, 1973, 1974		1971, 1975
1968		1973	
	1970, 1972, 1974		1975
	1970, 1971, 1972, 1974		1972, 1975
	1971, 1972, 1975		
	1968, 1969, 1971, 1972, 1975	1969	1972, 1974
	1968 ——— 1970, 1973, 1974	1973, 1975	
	1968, 1970, 1971, 1974, 1975	1969, 1973 ——— 1975	
	1968, 1969, 1973		1975
	1968		
	1969, 1970, 1972, 1975	1969, 1970, 1972 ——— 1974	
	1970, 1972		1974, 1975

Bas Jan Ader

Carl Andre

Art & Language

John Baldessari

Robert Barry

Marinus Boezem

Marcel Broodthaers

Stanley Brouwn

Daniel Buren

André Cadere

Hanne Darboven

Jan Dibbets

Ger van Elk

Gilbert & George

Douglas Huebler

On Kawara

Joseph Kosuth

Sol LeWitt

Richard Long

Bruce Nauman

Edward Ruscha

Robert Ryman

Robert Smithson

Lawrence Weiner

Ian Wilson

On 9 July 1975, Bas Jan Ader sets sail aboard a small yacht from Cape Cod on the east coast of the United States bound for Falmouth, England. A camera and a tape recorder are meant to document his journey, which he expects will take sixty days. In the same month, the Art & Project gallery publishes *In Search of the Miraculous*, a bulletin designed by Ader himself that includes a photograph of the artist in his sailboat at sea and the sheet music for the song 'Life on the Ocean Wave'. Three weeks after his departure, radio contact with the boat is lost; during the next year the sunken boat is recovered off the coast of Ireland.

Ader's unsuccessful voyage across the ocean is the finale, as dramatic as it is romantic, of a career that began at the end of the sixties in Los Angeles. The modest body of work that the artist managed to complete in about six years' time consisted of films, photographs, videos, installations and a performance. Through Ger van Elk, Ader's work became known in Europe in around 1970, where it was shown not only at Art & Project but also at various events such as 'Sonsbeek buiten de perken' and 'Prospect 71'.

A major element of Ader's work consists of a number of films in which he investigates the phenomenon of 'falling'. In 1970, for example, he completed the film *Fall I, Los Angeles*, in which he sits on a chair on the roof of his house in Claremont. This action results in a fall. The same thing happens in *Fall II, Amsterdam* from the same year, in which he rides his bicycle into a canal. The films were recorded in black and white; they have no sound and run only a few seconds. The fall is always at the end. Ader wrote about these works in a Christmas card he sent to Art & Project: 'I'm making a subdued work. On the film I silently state everything which has to do with falling. It's a large task which demands a great deal of difficult thinking. It's going to be poignant. I like that. I'm a Dutch Master.'

Gravity, irony and tragedy strive for prominence, which is typical of his work. The last characteristic, tragedy, is magnified and presented without any further explanation in the 'crying work' *I'm too sad to tell you*, also from 1970.

HV

3. *Fall II (Amsterdam)*, 1970

Literature: Paul Andriesse, *Bas Jan Ader*, Stichting Openbaar Kunstbezit, Amsterdam 1988. | Christopher Müller (ed.), *Bas Jan Ader, Filme, Fotografien, Projektionen, Videos und Zeichnungen aus den Jahren 1967-1975*, Verlag der Buchhandlung Walther König, Cologne 2000.

6. *I'm too sad to tell you*, 1970

1. Transcript of a symposium held at Windham College, Putney, Vermont on 30 April, 1968.

'My works are in a constant state of change. I'm not interested in reaching an ideal state with my works. As people walk on them, as the steel rusts, as the brick crumbles, as the material weather, the work becomes its own record of everything that's happened to it.'[1]

The work of the American artist Carl Andre first appeared on the European exhibition circuit in the late 1960s. His debut in the Netherlands was in 1968 at the celebrated group exhibition 'Minimal Art' in the Gemeentemuseum Den Haag. A year later, a comprehensive solo exhibition of his work was held in the same museum.

Carl Andre makes his sculptures from uniform elements of unprocessed materials such as bricks, wooden beams, plates of lead or other metals, arranged in accordance with a predetermined plan. It therefore has some relation to minimal art. Andre has distinguished three phases of development in his work: sculpture as *form*, sculpture as *structure* and sculpture as *place*. Since 1965, sculpture as place (i.e. the surroundings) has formed the starting point for his work, which he often adapts on site.

10 x 10 Altstadt Lead Square (1967-1976) is composed of 100 lead plates measuring 50 x 50 cm that are assembled into a square 'carpet'. The plates are interchangeable and are covered in scratches because many people have walked across them. The work is not signed, but it does have a certificate signed by the artist which also notes the dimensions and other features.

What we see with Andre is a form of dematerialisation. He wants to eliminate art as material object and replace it with a brief experience. Viewed in isolation, his floors do not exist: they are square or rectangular plates of steel or another material. They only become what one calls art if they are set up in a particular environment.

Running parallel with Andre's interest for elements and components in sculpture is his interest in words as the building blocks of language. In his poems it is language itself that has become the subject, language is cut free from what is represents. The poems do not follow the usual typographic rules, but are composed of words arranged in blocks, in grids, as clusters, in triangles, squares or other quadrangular structures – just like the sculptures. The elements of language gain an important visual value while simultaneously being rendered more abstract.

SG

TITLE OF WORK: 10 X 10 ALTSTADT LEAD SQUARE

DATE OF WORK: 1967 (PROPOSED)/ 1976 (MADE)

MATERIAL: LEAD PLATE

NUMBER AND CONFIGURATION OF ELEMENTS: 100 UNIT SQUARE (10X10)

DIMENSIONS OF EACH ELEMENT: 1 0CM X 50CM X 50CM

OVERALL DIMENSIONS: 1.0 CM X 500CM X 500CM

PLACE OF ORIGIN: DUSSELDORF

DOCUMENTATION/AUTHENTICATION: THIS SHEET

DATE AND PLACE OF ACQUISITION: 1976 DÜSSELDORF

SOURCE OF ACQUISITION: ARTIST, REPRESENTED BY KONRAD FISCHER

METHOD OF ACQUISITION (PURCHASE, TRADE, GIFT, OTHER): PURCHASE

PRESENT LOCATION: STEDELIJK MUSEUM AMSTERDAM

EXHIBITION HISTORY: STEDELIJK MUSEUM AMSTERDAM

THIS WORK
DÜSSELDORF
1967
@

THIS SHEET
NEW YORK
11 MAR 77
@

11. document: *10 x 10 Altstadt Lead Square*, 1977

Literature: David Bourdon, *Carl Andre Sculpture 1959-1977*, Jaap Rietman Inc., New York 1978. | *Carl Andre Sculptor*, Haus Lange und Haus Esters, Krefeld/Kunstmuseum Wolfsburg, Wolfsburg 1996.

11. *10 x 10 Altstadt Lead Square*, 1967/1976

10. *Dutch Poem*, 1967

©CARL ANDRE 1968

9. from: *Words 1958-1972*

1. *Art & Language & Luhman*, Freiburg im Breisgau/Vienna 1977, pp. 113-114.

Art & Language is a conceptual art collective rooted in the collaboration between Terry Atkinson and Michael Baldwin, who met in 1966 at the Coventry College of Art. In 1968 they and other British artists set up the Art & Language Press in Cambridge. The group's ranks were swelled the following year by, among others, a number of American artists. From that time on, they enjoyed contact with Joseph Kosuth and, to a lesser extent, Ian Wilson. Given the occasional hiatus the group has been consistently active to this day and has periodically taken new members on board.

Art & Language defines conceptual art as an analytical investigation into the fundamentals of what is meant by art. Influenced by Marxism and Anglo-Saxon analytical philosophy the group has attained an art criticism that seeks to unmask the mystification in art. As Michael Baldwin and Mel Ramsden write: 'It is when artistic practice turns aggressively back upon itself that it is able to be perforated by the world.'[1] Art & Language concentrated at least until 1977 on the use of 'language' as a way of expressing their ideas. Since then the collective has made more plastic works though these too have an art-critical thrust. The group is responsible for a great many publications, most of which operate in the province of art criticism and art theory, one being the journal *Art-Language*. They have also produced installations using card files and textual wall displays.

JP

22. *Matrix for an Index*, 1972

Literature: Paul Wood & Art & Language, *Art & Language. Now they are*, Brussels 1992. | Michael Baldwin, Charles Harrison and Mel Ramsden, *Art & Language in Practice*, 2 vols., Barcelona 1999.

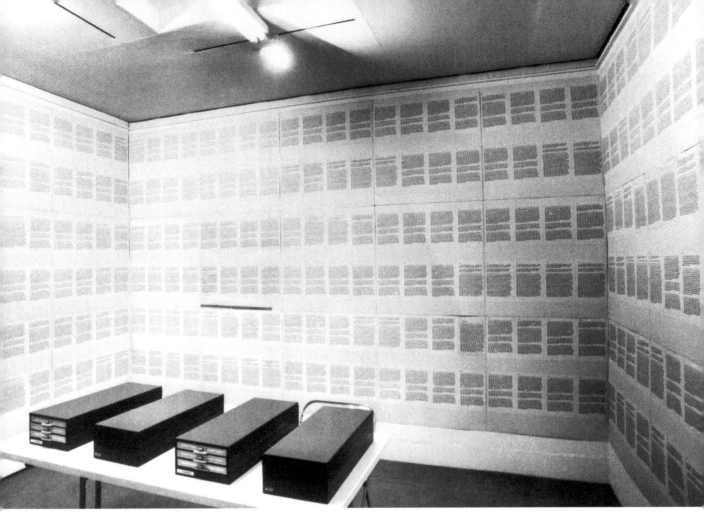

21. *Index 2 (II) (Hayward Index)*, 1972

23. from: *Art-Language. The Journal of conceptual art*

1. 'Interview with John Baldessari.'
In: *John Baldessari, National City*,
p. 87. In: Anne Rorimer, *New Art
in the 60s and 70s, Redefining
Reality*, Thames & Hudson,
London 2001, p. 130.
2. See Coosje van Bruggen, *John
Baldessari*, The Museum of
Contemporary Art, Los Angeles/
New York 1990, p. 121.

Language, texts and words, either isolated or in combination with photos, constituted the new material of the painter John Baldessari in the second half of the sixties. For him the camera was a means of capturing supremely factual, dry information, and language the basis for examining the aesthetic conventions of painting. In 1970, the year his career as a teacher began, he went as far as to burn all his paintings up until then (the *Cremation Project*).

Crucial works from this period include the so-called *Text Paintings*, a great many of which were inspired by *How to teach art* manuals, which he collected. His *Phototext Paintings* were made along comparable lines; these judged the rules for making good photographs on their merits. Behind this humoristic, offbeat approach lay the conviction that a photo shows 'things pretty much as they are', if you don't 'wait for the right light and the best angle' before shooting.[1]

Another key aspect of Baldessari's work during this period was his fascination with the ambivalent and symbolic possibilities of images. One of his early videos, *Folding Hat* (1970), shows the artist's hand folding a hat for a full thirty minutes in a single constant, monomaniacal and exploratory action. The hat is continually changing shape, but somehow manages to keep its original form. The object reminded Baldessari of a remark made by the painter Amédée Ozenfant about what the nature of art might be if this were to have the lifespan of a hat. At the same time he may be referring to Freud, for whom the hat was an obvious symbol of male sexuality.[2]

HV

28. from: *Four Events and Reactions*, 1975

Literature: Marcia Tucker, Robert Pincus-Witten, Nancy Drew, *John Baldessari*, The New Museum, New York/Dayton, Ohio 1982. | Coosje van Bruggen, *John Baldessari*, The Museum of Contemporary Art, Los Angeles/New York 1990.

24. from: *Folding Hat*, 1971

115

1. *Robert Barry*, Stedelijk Museum Amsterdam, 1974.

Something which is very near in place and time, but not yet known to me. [1]

In 1969, on the morning of January 5th, Robert Barry buried three small containers with radioactive Barium-133 at various spots in Central Park in New York. All that remains is the black-and-white photograph, *Radiation Piece*. A few months later Barry sent out invitations for his exhibition at Art & Project with the text: 'During the exhibition the gallery will be closed.' The public finds a locked door and the people who want to attend are left to use their own fantasy.

Barry's work, which initially consisted of 'process' paintings, became increasingly immaterial during the 1960s. In 1968 he investigated physical phenomena that are beyond the sensory perception of human beings. This resulted in a series of dematerialized projects that employed spaces, including galleries, containing electromagnetic fields and imperceptible gases. Barry raises the question of whether visibility is a precondition for visual art.

'Language' has formed a central visual medium in Barry's work since 1971. His works consist of words that he chooses in the same way a painter chooses his colours, to paraphrase the artist himself. He uses everyday language, but selects and combines the words with the utmost care. They often have a double meaning. Barry's aim is to stimulate the thinking and associative processes of the viewer/reader. Barry published his works in booklets, but also presented them in the form of 'slide pieces', such as *16th Century* (1974).

Along with Lawrence Weiner, Douglas Huebler and Joseph Kosuth, Barry is regarded as one of the earliest conceptual artists. These artists, initially grouped around the New York gallery owner, Seth Siegelaub, definitively changed the state of international art at the end of the 1960s. Their works involved hardly any visual elements and often consisted of written instructions, sometimes accompanied by documentary information and photographs. In Europe, Barry's work was included in all the important exhibitions that presented this 'new art' from the start, such as 'When Attitudes Become Form', 'Op losse schroeven', 'Konzeption' and 'Prospect 69'.

SG

36. *Art & Project bulletin 17* (1969): *Robert Barry*

Literature: René Denizot, *It's about time Il est temps*, Yvon Lambert, Paris 1980. | Erich Franz, *Robert Barry*, Karl Kerber Verlag, Bielefeld 1986.

45. *16th Century*, 1974

1. Edna van Duyn, 'Essay'. In: Edna van Duyn and Fransjozef Witteveen, *Boezem*, Uitgeverij TOTH Bussum 1999, p. 111.

Marinus Boezem was already active as a painter and draughtsman at the end of the fifties. In about 1960 his way of working went through changes which the artist regards as the true starting-point of his oeuvre. At that time Boezem extricated himself from the tradition of his métier and began concentrating in his art on appropriating areas and spaces around him. Through this outward gaze the research oriented itself inwards, to the opening up of 'inner spaces'.[1] In the second half of the sixties Boezem played a role in national and international developments in the visual arts. His contribution to conceptual art gained partial expression in his collaboration with Jan Dibbets and Ger van Elk. During the seventies Marinus Boezem's attention gradually shifted to breathing new life into art education, though he has continued to make autonomous work.

At the close of the sixties Boezem incorporated into his work the weather conditions and the ways of recording them. In this long-term focus on a single theme, we can identify a certain similarity with the work of Stanley Brouwn. Unlike Brouwn, however, Boezem did not restrict himself to a style or a particular handwriting; a given manner of execution served him merely as a means of communicating. During an exhibition at the Stedelijk ('Op losse schroeven', 1969) Boezem sought literally and metaphorically to subject that museum to a wind of change by hanging bed linen out of the open museum windows. This strategy had crystallized earlier in his wall installation of 1968, *Window*. Another project of a like ambience involved 500 examples of the weather chart for 26 September 1968 produced by the Dutch meteorological office which the artist stamped with his name and circulated together with the Beaufort scale. Boezem also rendered nature as a changing sculpture in a three-part work of 1969, *Signing the sky above the Port of Amsterdam by an Aeroplane*. Photography was the most appropriate means of capturing the fleeting nature of this work.

JP

50. *Weather map,*
Thursday 26 September 1968, 1968

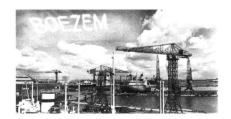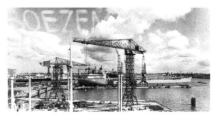

51. *Signing the Sky above the Port of Amsterdam by an Aeroplane*, 1969

Literature: Philip Peters, 'Op losse schroeven: het werk van Marinus Boezem opnieuw bekeken'. In: *Marinus Boezem*, Provinciaal Museum, Hasselt 1982. | Edna van Duyn and Fransjozef Witteveen, *Boezem*, Uitgeverij THOTH, Bussum 1999

1. Anna Hakkens (ed.), Marcel
Broodthaers aan het woord, Ludion,
Ghent/Amsterdam 1998, p. 46.
2. Ibid., p. 78.

Broodthaers began his career as a poet and bookseller. In 1963 he made the transition from poet to visual artist by setting 50 unsold copies of his collection of poems *Pense-Bête* in plaster. The fusion of word and image was to remain a characteristic feature of Broodthaers' work; it showed his great admiration for the work of the painter René Magritte and the poet Stéphane Mallarmé. Broodthaers eventually employed almost every medium; his oeuvre includes installations, sculptures, photographs, films, books, prints and drawings. The external form was only a secondary consideration for him: 'For me the first thing is the idea, and then the visual means. The visual means must be subordinate to the idea… However, I have recently discovered that in order to be able to adequately express an idea I must play with the visual means.'[1] This is also one of the reasons why Broodthaers found it very important to personally install his work at exhibitions; on each occasion he achieved a different harmony thanks to a new assembly or staging.

The work of Broodthaers is permeated by socio-political criticism, and the hypocrisy of the bourgeoisie and corrupt obsession with power by money are frequently exposed and denounced in his work. In one group of works – which consist of nothing except his initials, M.B. – Broodthaers held up a mirror to the art dealers and certain artists, questioning the importance they attach to the signature of the artist. 'The signature of the creator – painter, poet, film director… – seems to me the point where the system of lies begins, the system that every poet, every artist, attempts to construct in order to protect himself… though I am not sure exactly what against.'[2] Broodthaers also brought the position and relevance of museums under discussion. In 1968 he founded a conceptual museum in his own home, using transportation crates and picture postcards. It set the scene for heated debate about the role of the museums. This *Musée d'Art Moderne*, Département des Aigles ended up evolving into one of his biggest projects.

SH

MUSÉE D'ART MODERNE

DÉPARTEMENT DES AIGLES

● 1968 . Bruxelles XIXᵉ siècle
● 1969 . Antwerpen XVIIᵉ siècle
● 1970 . Düsseldorf XIXᵉ siècle (bis)

● SECTION CINEMA

A partir du 12 janvier '71 19 h.
From January '71
Burgplatz 12
4 Düsseldorf

invitation card, archives Nicole Verstraeten, Brussels

Literature: Benjamin H.D. Buchloh (ed.), *Broodthaers. Writings, Interviews, Photographs*, MIT Press, Cambridge, Mass./
London, 1988. | *Marcel Broodthaers*, Walker Art Center, Minneapolis/Rizzoli, New York, 1989.

59. *L'Entrée de l'Exposition*, 1974

53. *Carte du Monde Poétique*, 1968

55. *La Signature Série 1,* 1969

1. *Art & Project bulletin*, no. 11.

In 1957 Stanley Brouwn set himself up as an artist in Amsterdam, where in 1961 he began a long series of works entitled *This way Brouwn*. In these works Brouwn got passers-by in the street to make drawings of the directions he asked of them. He would then stamp each sketch with the above-mentioned title and present it as a work of art. Of a similar order are the works in which the artist once again involved passers-by by asking them to walk across sheets of paper he had placed in the street.

In around 1970 Brouwn began concentrating more on his own footsteps, which he would place in relation to the metric system in a constantly progressing, systematic study. An example of his ideas from that period, which were worked out in writing only: 'Walk during a few moments very consciously in a certain direction; simultaneously a vast number of microbes within the circle are moving in a vast number of directions.'[1]

Brouwn's methodical way of working has something scientific about it, but idea and elaboration are always strictly personal. Brouwn expresses dimensions and distances in terms of series of numbers and words, which are published as 'artist's books' or consist of 'corrections' of city maps, for instance. He also produces austere line drawings, as independent works of art or as parts of installations. Stanley Brouwn is considered part of the conceptual group 'in spirit', especially on account of the work he has produced since about 1970 whose systematic approach is closely aligned with the works (and style) of Hanne Darboven and On Kawara.

JP

100.000 mm
stanley brouwn

80. from: *100.000 mm*

Literature: Ludo van Halem, *Stanley Brouwn: werk 1957-1982* (doctoral thesis, Leiden University), 2 parts, Rotterdam 1988 (in the library of the Stedelijk Museum Amsterdam). | Harry Ruhé, *Stanley Brouwn. A chronology*, Amsterdam 2001.

84. *100 km*, 1976

44641 STEPS	44701 STEPS	44761 STEPS	44821 STEPS	44881 STEPS	4490
44642 STEPS	44702 STEPS	44762 STEPS	44822 STEPS	44882 STEPS	449
44643 STEPS	44703 STEPS	44763 STEPS	44823 STEPS	44883 STEPS	4490
44644 STEPS	44704 STEPS	44764 STEPS	44824 STEPS	44884 STEPS	4490
44645 STEPS	44705 STEPS	44765 STEPS	44825 STEPS	44885 STEPS	449
44646 STEPS	44706 STEPS	44766 STEPS	44826 STEPS	44886 STEPS	449
44647 STEPS	44707 STEPS	44767 STEPS	44827 STEPS	44887 STEPS	449
44648 STEPS	44708 STEPS	44768 STEPS	44828 STEPS	44888 STEPS	449
44649 STEPS	44709 STEPS	44769 STEPS	44829 STEPS	44889 STEPS	449
44650 STEPS	44710 STEPS	44770 STEPS	44830 STEPS	44890 STEPS	449
44651 STEPS	44711 STEPS	44771 STEPS	44831 STEPS	44891 STEPS	449
44652 STEPS	44712 STEPS	44772 STEPS	44832 STEPS	44892 STEPS	449
44653 STEPS	44713 STEPS	44773 STEPS	44833 STEPS	44893 STEPS	449
44654 STEPS	44714 STEPS	44774 STEPS	44834 STEPS	44894 STEPS	449
44655 STEPS	44715 STEPS	44775 STEPS	44835 STEPS	44895 STEPS	449
44656 STEPS	44716 STEPS	44776 STEPS	44836 STEPS	44896 STEPS	449
44657 STEPS	44717 STEPS	44777 STEPS	44837 STEPS	44897 STEPS	4490
44658 STEPS	44718 STEPS	44778 STEPS	44838 STEPS	44898 STEPS	4490
44659 STEPS	44719 STEPS	44779 STEPS	44839 STEPS	44899 STEPS	4490
44660 STEPS	44720 STEPS	44780 STEPS	44840 STEPS	44900 STEPS	449
44661 STEPS	44721 STEPS	44781 STEPS	44841 STEPS	44901 STEPS	4490
44662 STEPS	44722 STEPS	44782 STEPS	44842 STEPS	44902 STEPS	449
44663 STEPS	44723 STEPS	44783 STEPS	44843 STEPS	44903 STEPS	4490
44664 STEPS	44724 STEPS	44784 STEPS	44844 STEPS	44904 STEPS	4490
44665 STEPS	44725 STEPS	44785 STEPS	44845 STEPS	44905 STEPS	4490
44666 STEPS	44726 STEPS	44786 STEPS	44846 STEPS	44906 STEPS	4490
44667 STEPS	44727 STEPS	44787 STEPS	44847 STEPS	44907 STEPS	449
44668 STEPS	44728 STEPS	44788 STEPS	44848 STEPS	44908 STEPS	4490
44669 STEPS	44729 STEPS	44789 STEPS	44849 STEPS	44909 STEPS	4490
44670 STEPS	44730 STEPS	44790 STEPS	44850 STEPS	44910 STEPS	4491
44671 STEPS	44731 STEPS	44791 STEPS	44851 STEPS	44911 STEPS	4491
44672 STEPS	44732 STEPS	44792 STEPS	44852 STEPS	44912 STEPS	4491
44673 STEPS	44733 STEPS	44793 STEPS	44853 STEPS	44913 STEPS	4491
44674 STEPS	44734 STEPS	44794 STEPS	44854 STEPS	44914 STEPS	4491
44675 STEPS	44735 STEPS	44795 STEPS	44855 STEPS	44915 STEPS	4491
44676 STEPS	44736 STEPS	44796 STEPS	44856 STEPS	44916 STEPS	4491
44677 STEPS	44737 STEPS	44797 STEPS	44857 STEPS	44917 STEPS	4491
44678 STEPS	44738 STEPS	44798 STEPS	44858 STEPS	44918 STEPS	4491
44679 STEPS	44739 STEPS	44799 STEPS	44859 STEPS	44919 STEPS	4491
44680 STEPS	44740 STEPS	44800 STEPS	44860 STEPS	44920 STEPS	4491
44681 STEPS	44741 STEPS	44801 STEPS	44861 STEPS	44921 STEPS	4498
44682 STEPS	44742 STEPS	44802 STEPS	44862 STEPS	44922 STEPS	4498
44683 STEPS	44743 STEPS	44803 STEPS	44863 STEPS	44923 STEPS	4498
44684 STEPS	44744 STEPS	44804 STEPS	44864 STEPS	44924 STEPS	4498
44685 STEPS	44745 STEPS	44805 STEPS	44865 STEPS	44925 STEPS	4498
44686 STEPS	44746 STEPS	44806 STEPS	44866 STEPS	44926 STEPS	4498
44687 STEPS	44747 STEPS	44807 STEPS	44867 STEPS	44927 STEPS	4498
44688 STEPS	44748 STEPS	44808 STEPS	44868 STEPS	44928 STEPS	4498
44689 STEPS	44749 STEPS	44809 STEPS	44869 STEPS	44929 STEPS	4498
44690 STEPS	44750 STEPS	44810 STEPS	44870 STEPS	44930 STEPS	4499
44691 STEPS	44751 STEPS	44811 STEPS	44871 STEPS	44931 STEPS	4499
44692 STEPS	44752 STEPS	44812 STEPS	44872 STEPS	44932 STEPS	4499
44693 STEPS	44753 STEPS	44813 STEPS	44873 STEPS	44933 STEPS	4499
44694 STEPS	44754 STEPS	44814 STEPS	44874 STEPS	44934 STEPS	4499
44695 STEPS	44755 STEPS	44815 STEPS	44875 STEPS	44935 STEPS	4499
44696 STEPS	44756 STEPS	44816 STEPS	44876 STEPS	44936 STEPS	4499
44697 STEPS	44757 STEPS	44817 STEPS	44877 STEPS	44937 STEPS	4499
44698 STEPS	44758 STEPS	44818 STEPS	44878 STEPS	44938 STEPS	4499
44699 STEPS	44759 STEPS	44819 STEPS	44879 STEPS	44939 STEPS	4499
44700 STEPS	44760 STEPS	44820 STEPS	44880 STEPS	44940 STEPS	4500

EPS	45061 STEPS	45121 STEPS	45181 STEPS	45241 STEPS	45301 STEPS	
EPS	45062 STEPS	45122 STEPS	45182 STEPS	45242 STEPS	45302 STEPS	
EPS	45063 STEPS	45123 STEPS	45183 STEPS	45243 STEPS	45303 STEPS	
EPS	45064 STEPS	45124 STEPS	45184 STEPS	45244 STEPS	45304 STEPS	
EPS	45065 STEPS	45125 STEPS	45185 STEPS	45245 STEPS	45305 STEPS	
EPS	45066 STEPS	45126 STEPS	45186 STEPS	45246 STEPS	45306 STEPS	
EPS	45067 STEPS	45127 STEPS	45187 STEPS	45247 STEPS	45307 STEPS	
EPS	45068 STEPS	45128 STEPS	45188 STEPS	45248 STEPS	45308 STEPS	
EPS	45069 STEPS	45129 STEPS	45189 STEPS	45249 STEPS	45309 STEPS	
EPS	45070 STEPS	45130 STEPS	45190 STEPS	45250 STEPS	45310 STEPS	
EPS	45071 STEPS	45131 STEPS	45191 STEPS	45251 STEPS	45311 STEPS	
EPS	45072 STEPS	45132 STEPS	45192 STEPS	45252 STEPS	45312 STEPS	
EPS	45073 STEPS	45133 STEPS	45193 STEPS	45253 STEPS	45313 STEPS	
EPS	45074 STEPS	45134 STEPS	45194 STEPS	45254 STEPS	45314 STEPS	
EPS	45075 STEPS	45135 STEPS	45195 STEPS	45255 STEPS	45315 STEPS	
EPS	45076 STEPS	45136 STEPS	45196 STEPS	45256 STEPS	45316 STEPS	
EPS	45077 STEPS	45137 STEPS	45197 STEPS	45257 STEPS	45317 STEPS	
EPS	45078 STEPS	45138 STEPS	45198 STEPS	45258 STEPS	45318 STEPS	
EPS	45079 STEPS	45139 STEPS	45199 STEPS	45259 STEPS	45319 STEPS	
EPS	45080 STEPS	45140 STEPS	45200 STEPS	45260 STEPS	45320 STEPS	
EPS	45081 STEPS	45141 STEPS	45201 STEPS	45261 STEPS	45321 STEPS	
EPS	45082 STEPS	45142 STEPS	45202 STEPS	45262 STEPS	45322 STEPS	
EPS	45083 STEPS	45143 STEPS	45203 STEPS	45263 STEPS	45323 STEPS	
EPS	45084 STEPS	45144 STEPS	45204 STEPS	45264 STEPS	45324 STEPS	
EPS	45085 STEPS	45145 STEPS	45205 STEPS	45265 STEPS	45325 STEPS	
EPS	45086 STEPS	45146 STEPS	45206 STEPS	45266 STEPS	45326 STEPS	
EPS	45087 STEPS	45147 STEPS	45207 STEPS	45267 STEPS	45327 STEPS	
EPS	45088 STEPS	45148 STEPS	45208 STEPS	45268 STEPS	45328 STEPS	
EPS	45089 STEPS	45149 STEPS	45209 STEPS	45269 STEPS	45329 STEPS	
EPS	45090 STEPS	45150 STEPS	45210 STEPS	45270 STEPS	45330 STEPS	
EPS	45091 STEPS	45151 STEPS	45211 STEPS	45271 STEPS	45331 STEPS	
EPS	45092 STEPS	45152 STEPS	45212 STEPS	45272 STEPS	45332 STEPS	
EPS	45093 STEPS	45153 STEPS	45213 STEPS	45273 STEPS	45333 STEPS	
EPS	45094 STEPS	45154 STEPS	45214 STEPS	45274 STEPS	45334 STEPS	
EPS	45095 STEPS	45155 STEPS	45215 STEPS	45275 STEPS	45335 STEPS	
EPS	45096 STEPS	45156 STEPS	45216 STEPS	45276 STEPS	45336 STEPS	
EPS	45097 STEPS	45157 STEPS	45217 STEPS	45277 STEPS	45337 STEPS	
EPS	45098 STEPS	45158 STEPS	45218 STEPS	45278 STEPS	45338 STEPS	
EPS	45099 STEPS	45159 STEPS	45219 STEPS	45279 STEPS	45339 STEPS	
EPS	45100 STEPS	45160 STEPS	45220 STEPS	45280 STEPS	45340 STEPS	
EPS	45101 STEPS	45161 STEPS	45221 STEPS	45281 STEPS	45341 STEPS	
PS	45102 STEPS	45162 STEPS	45222 STEPS	45282 STEPS	45342 STEPS	
PS	45103 STEPS	45163 STEPS	45223 STEPS	45283 STEPS	45343 STEPS	
PS	45104 STEPS	45164 STEPS	45224 STEPS	45284 STEPS	45344 STEPS	
PS	45105 STEPS	45165 STEPS	45225 STEPS	45285 STEPS	45345 STEPS	
PS	45106 STEPS	45166 STEPS	45226 STEPS	45286 STEPS	45346 STEPS	
PS	45107 STEPS	45167 STEPS	45227 STEPS	45287 STEPS	45347 STEPS	
PS	45108 STEPS	45168 STEPS	45228 STEPS	45288 STEPS	45348 STEPS	
PS	45109 STEPS	45169 STEPS	45229 STEPS	45289 STEPS	45349 STEPS	
PS	45110 STEPS	45170 STEPS	45230 STEPS	45290 STEPS	45350 STEPS	
PS	45111 STEPS	45171 STEPS	45231 STEPS	45291 STEPS	45351 STEPS	
PS	45112 STEPS	45172 STEPS	45232 STEPS	45292 STEPS	45352 STEPS	
PS	45113 STEPS	45173 STEPS	45233 STEPS	45293 STEPS	45353 STEPS	
PS	45114 STEPS	45174 STEPS	45234 STEPS	45294 STEPS	45354 STEPS	
PS	45115 STEPS	45175 STEPS	45235 STEPS	45295 STEPS	45355 STEPS	
PS	45116 STEPS	45176 STEPS	45236 STEPS	45296 STEPS	45356 STEPS	
PS	45117 STEPS	45177 STEPS	45237 STEPS	45297 STEPS	45357 STEPS	
PS	45118 STEPS	45178 STEPS	45238 STEPS	45298 STEPS	45358 STEPS	
PS	45119 STEPS	45179 STEPS	45239 STEPS	45299 STEPS	45359 STEPS	
PS	45120 STEPS	45180 STEPS	45240 STEPS	45300 STEPS	45360 STEPS	

Since 1965-1967 Buren has concentrated as both artist and theorist on applying to various grounds alternations of brightly coloured and white vertical stripes with a standard width of 8.7 cm. The execution of the stripes can vary tremendously, as can the support and the overall dimensions. For instance, the stripes may be integrated in an architectural environment. Buren usually makes his works in situ. Once he made a subtle intervention in the landscape by placing 'Buren' sails on all the boats in the vicinity; he has also added temporary stripes to the inner and outer walls of buildings, or on posters in the Paris metro. The artwork or intervention only actually means something to the artist during the process of making it and at its presentation. Tangible components can be removed afterwards, their memory captured only in the photographs, catalogues, brochures and documents on which Buren works with a like intensity. Buren has recorded his methodical way of working in myriad publications in which he further develops his ideas and theories. This has made him one of the keenest critics of contemporary art.

An artist should not concern himself with traditional matters such as style and expression, Buren feels; he sees theory and practice as a single entity. His position as an artist at the end of the sixties is illustrated by a remark made in 1969 by Joseph Beuys at the home of the art-collecting duo, Martin and Mia Visser, where Buren had made one of his works: 'We've been talking about Buren for an hour: he must be an artist.'

JP

86. from: *Photo Souvenirs, 1968-1974*

Literature: Jean Louis Maubant (ed.), *Daniel Buren. Erinnerungsphotos 1965-1988*, Wiese Verlag, Basle/Vienna 1989. Gudrun Inboden (ed.), *Daniel Buren*, Staatsgalerie Stuttgart, Stuttgart 1990. | Daniel Buren, *Les Ecrits 1965-1990*, (ed. Jean-Marc Poinsot), 3 vols., CAPC, Bordeaux 1991.

96. documents: *Kaleidoscope en reflets no. 12*, 1976-1982/1983

96. detail: *Kaleidoscope en reflets no. 12*, 1976-1982/1983

131

1. Quoted from a letter to Yvon Lambert in: Cornelia Lauf et al., *André Cadere. All Walks of Life*, The Institute for Contemporary Art, P.S.1 Museum, New York/Musée d'Art Moderne de la Ville de Paris, La Chambre Editions, Paris 1992.

As for the date of a particular piece, it's never the one on which the piece was materially manufactured, it's the date on which its index card was filled out. This is logical, because the principles of my work were determined in 1970. That was when this entire ensemble was launched, and the date of the index card indicates only when a given piece was first put into circulation. The same applies to the site, which has always been Paris, simply because the card index is in my home in Paris, and this is where I work on it.[1]

Between 1970 and 1978 an enigmatic man bearing a staff with brightly coloured stripes on his shoulder was frequently observed in and around the leading galleries and museums in Paris, Brussels, New York and elsewhere. The man was an artist of Romanian origin, who not only manifested himself in museums and galleries with his *Barres de Bois Rond* ('Round Bars of Wood'), but also at art fairs, metro stations, restaurants and on the street.

André Cadere described his round bars as 'paintings' and claimed that they had no front or back. His work was not allowed to be dependent on an exhibition space and could be shown in any space at any time, with or without permission.

The *Barres de bois rond*, varying in length from 30 cm to 2 meters, were constructed from round wooden segments in alternate colours. It was important that the sequence of colours, otherwise arranged according to mathematical per-mutations, included a deliberate mistake. Cadere said that the permutations were abstract and universal, but that he could emphasize his own personal thought and will by intro-ducing a mistake. This made every bar unique.

Cadere smuggled his bars into important exhibitions and international art events such as documenta 5, 'Prospect 68' and the Venice Biennale. There he would try to strike up dis-cussions about art and art theories with everyone, though he was rarely even invited. He sent out official invitations to his unofficial 'exhibitions' and documented them with texts and notices. He made signed certificates for his collectors.

Cadere studied exactly how the art market functioned and made an analysis of various strategies for the creation and exhibition of art. He systematically investigated a large num-ber of cultural cities in Europe, including Amsterdam and Eindhoven.

On the one hand Cadere's goal was to penetrate the heart of the avant-garde network and thus validate his existence, while on the other he wanted to question the power struc-tures in the art world.

SG

André Cadere in front of the
Palais des Beaux-Arts

Literature: *Histoire d'un Travail*, Herbert-Gewad, Ghent 1982. | *André Cadere. All Walks of Life*, The Institute for Con-temporary Art, P.S.1 Museum, New York/Musée d'Art Moderne de la Ville de Paris, La Chambre Editions, Paris 1992.

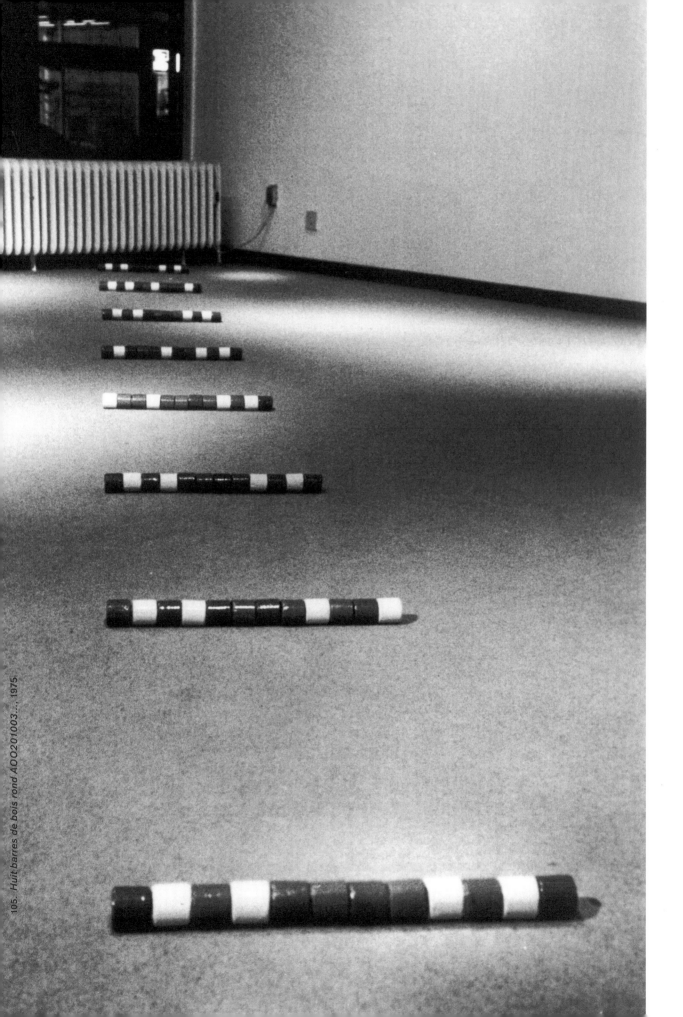

105. *Huit barres de bois rond AOO201003...., 1975.*

1. Hanne Darboven, 'Statement to Lucy Lippard [1968]'. In: A. Alberro and B. Stimson, *Conceptual Art. A Critical Anthology*, MIT Press, Cambridge (Mass.) 1999, p. 62.
2. Amine Haase, *Gespräche mit Künstlern*, Wienand, Cologne 1981, p. 48.

During her sojourn in New York (1966-1968), where the people she met included Sol LeWitt and Carl Andre, Hanne Darboven made her first *Konstruktionen*, drawings on graph paper that were created using numerical relationships. At that point it was already clear that Darboven considered the material to be subordinate to the idea. In the first place, it was the artist's intention to visualize data, rather than offering a description in the sense of ascribing meaning. Darboven switched to constructing a symbiosis between space and time in a strictly systematic way. Her system would eventually incorporate many aspects of social and cultural life. Darboven focused on calendar dates – as a representation of 'time', a concept that would become one of the most important elements in her work – but she also considered art, politics, history, music, literature and philosophy. Darboven strives to demonstrate the continuity in historical development and its relation to the present with the aid of all this data. A system proved indispensable in achieving this: 'A system became necessary; how else could I see more concentratedly, find some interest, continue at all?'[1]

On account of the seemingly complex structure of the work and the use of all sorts of different types of information, Darboven's work is often perceived as hermetic and inaccessible, which she herself repudiates: 'The assertion that people don't understand my work is unbelievable and intolerable. Because one and one is two – and in my opinion that is the only thing that everybody can really grasp. My work is by no means just the incomprehensible processing of data in the context of our computer age, but it begins with 2 = 1, 2.'[2]

SH

114. *Untitled*, 1971

Literature: Hanne Darboven, *Briefe aus New York 1966-68 zu Hause*, Ostfildern 1997. | Zdenek Felix (ed.), *Hanne Darboven. Ein Reader*, Oktagon, Cologne 1999. | Bernhard Jussen (ed.), *Schreibzeit*, Verlag der Buchhandlung Walther König, Cologne 2000.

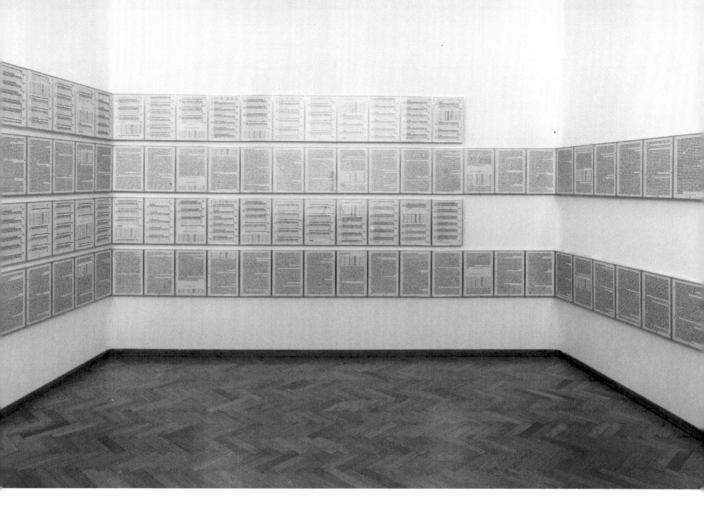

115. *1.Buch/42.Buch*, 1972

115. detail: *1.Buch/42.Buch*, 1972

1. Hans Sizoo, 'Jan Dibbets: "Als jij een grasrol maakt dan is die net zo mooi als de mijne,"' *De Nieuwe Linie*, 19 October 1968.
2. Betty van Garrel, 'Gesprek met kunstenaar Jan Dibbets', *Haagse Post*, January 12, 1972.

Dibbets received a grant to go and study at St. Martins School of Art in London in 1967. The people he encountered there included Richard Long, Barry Flanagan and George (then still without Gilbert). Initially Dibbets concentrated on forms of land art, in which he intervened in natural environments. He made works such as *Grasrol* ('Grass Roll') and *Ploegproject* ('Plough Project') at this time. This laid the foundations for what would become the core of his oeuvre: perspective correction. Dibbets created distortions, disorientations of perception, with the aid of photographic techniques: the camera positions and the forms that he superimposed on the work, which ran parallel with the frame of the work, no longer corresponded with each other. This created a tension between abstraction and reality.

Dibbets did not end up focusing on the idea above all. For him the search for the right visual form, the right image, was still essential. In doing this, Dibbets expressly focused his attention on *how* exactly that image could be created, and not on *what* was being represented. The analytical aspect won over the more experimental. 'I execute certain things because I want to offer some kind of illustration of my ideas. But I find the research much more important than the actual work... For me it is a kind of philosophy about visual art, which is not expressed in words, but in images, i.e. through the representation of your ideas.'[1]

Soon after his participation in the exhibitions 'Op losse schroeven' and 'When Attitudes Become Form' (both in 1969), Dibbets established more and more distance between himself and conceptual art. 'In that concept-art there is quite simply nothing to *see*, I simply want to see something. For me their starting point is too literary.'[2]

SH

130. *Hasebroekstraat*, 1969

Literature: *Jan Dibbets*, Walker Art Center, Minneapolis 1987. | Rudi Fuchs and Gloria Moure, *Jan Dibbets – Interior Light: Works on Architecture 1969-1990*, Rizzoli, New York 1991.

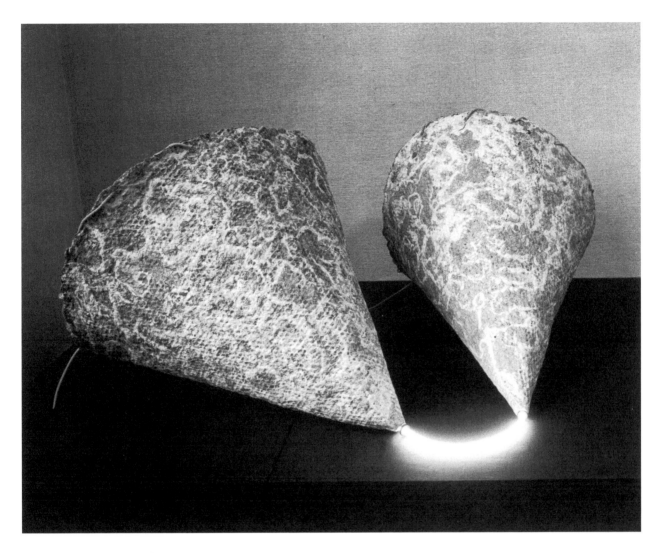

128. *Two Cones with Green Connection*, 1968

138. *Panorama - My Studio*, 1971

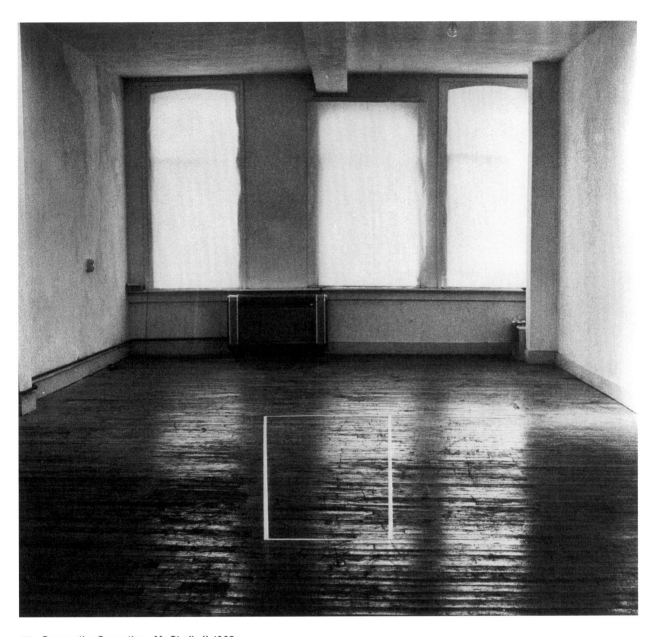

123. *Perspective Correction - My Studio II*, 1968

1. *Op het tweede gezicht: Ger van Elk*, Stedelijk Museum Amsterdam, 1979.

The components of a work of art are the idea and the material. One cannot exist independently of the other.
I choose the best possible concept and the best possible way to embody it.[1]

By the 1970s, the highly inventive and well thought-out work of Ger van Elk already encompassed sculptures, wall sculptures, assemblages, photographic works, films and paintings. Themes such as balance, equilibrium and perspective are recurring motifs in his oeuvre. Allusions to art history are also a consistent theme and Van Elk also often performs or features personally in his work. Employing a suitable dose of irony he puts expressive conventions in a new perspective and he intervenes in existing situations. During the 'Op losse schroeven' exhibition, for example, he stretched an immense canvas across the middle of the monumental staircase of the Stedelijk Museum and called it *Apparatus Scalas Dividens* (1969), the 'seemingly divided staircase'. On the occasion of this exhibition he also polished a corner of the pavement in front of the museum (*Luxurious streetcorner*), and he secured a small stone wall above one of the tables in the restaurant.

Even though Van Elk's work has always allied the idea with a specific physical visualization, it was swiftly labelled 'conceptual'. The main reason for this was the avant-garde position that Van Elk occupied in the Dutch art world at that time. From the mid-1960s he lived in Los Angeles part of the time, and his work was influenced by transatlantic movements such as Fluxus and pop art. The artists of that era developed all kinds of activities both inside and outside the museum.

By the end of the 1960s, Van Elk belonged to the core group of conceptual art protagonists in the Netherlands, along with Jan Dibbets and Marinus Boezem. Their participation in the following exhibitions marked the decisive breakthrough: 'Rassegna d'Arti Figurative 3', 'Arte Povera + Azioni Povere' in Amalfi (1968), 'Op losse schroeven' (1969), 'When Attitudes Become Form' (1969), 'Sonsbeek buiten de perken' (1971) and 'Prospect 71'.

Van Elk travelled frequently, and maintained regular contact with foreign artists. During the preparations for 'Op losse schroeven' he played a prominent role by drawing the attention of the exhibition's curators to artists who worked in 'this vein'. Van Elk also acted as the interlocutor and contact for various galleries, including Galerie Swart and Art & Project. For the latter he established contacts with British artists, including Gilbert & George, and with artists from the west coast of the United States such as Bas Jan Ader, John Baldessari and Allen Ruppersberg.

SG

141. *Net*, 1969

Literature: *Ger van Elk*, Stedelijk Museum Amsterdam, 1974-75. | Ger van Elk, *The Cadillac and the Nun*, Stedelijk Van Abbemuseum, Eindhoven/NAi Publishers, Rotterdam 1999.

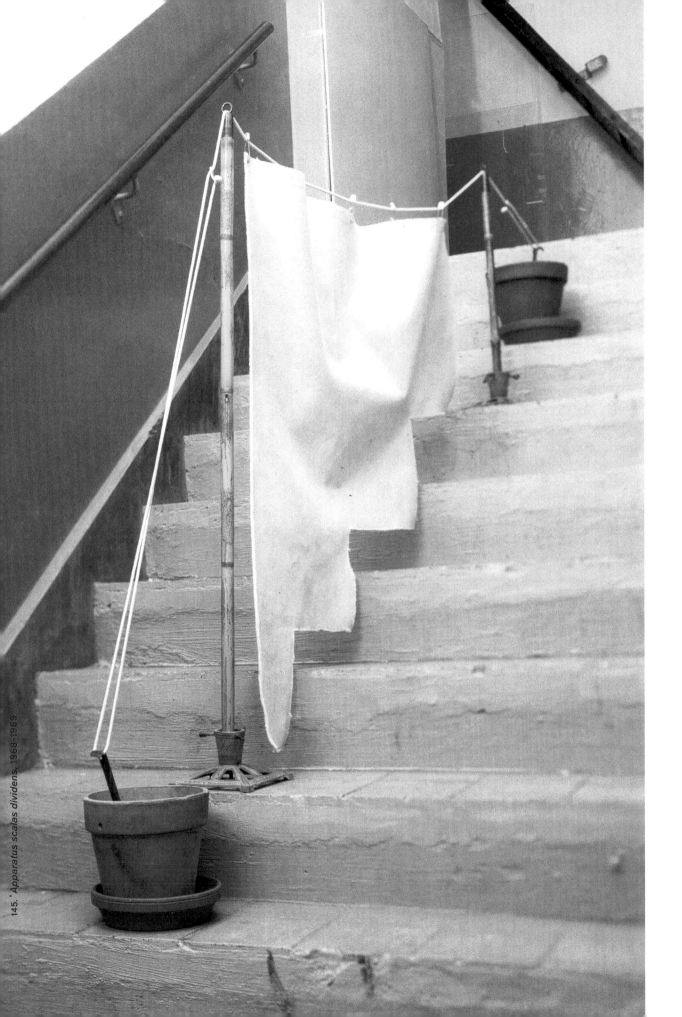

145. `Apparatus scalas dividens, 1968-1969`

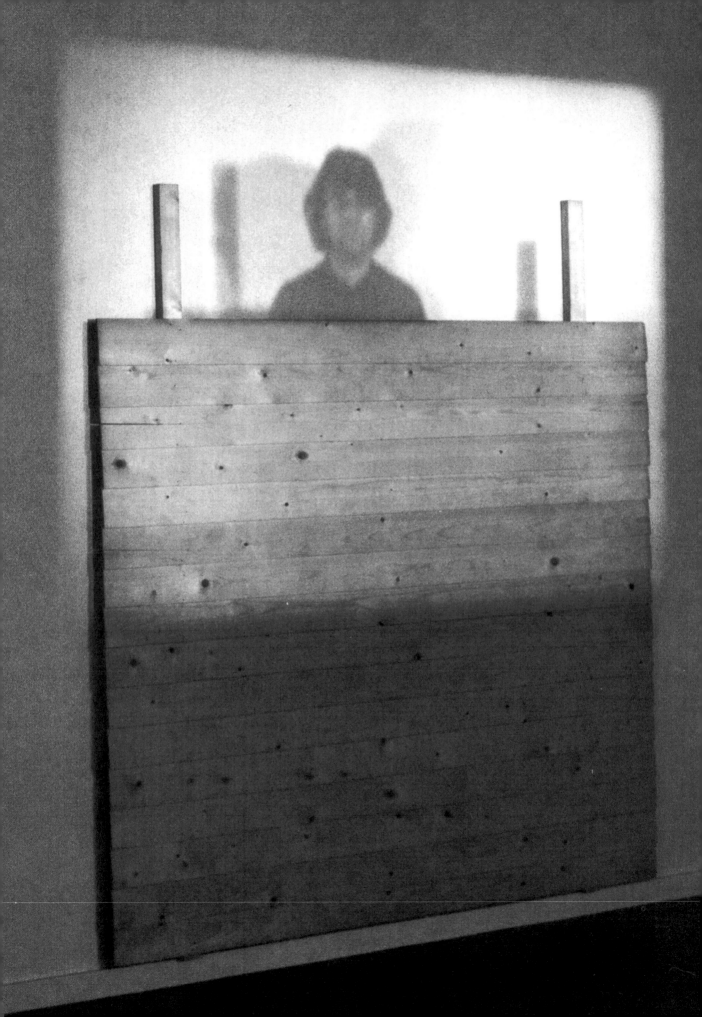

148. *The Symmetry of Diplomacy II – Peking*, 1972

1. Gilbert & George, *A Day in the Life of George & Gilbert the sculptors*, Art for All, London 1971, pp. 3, 9-10.

Gilbert & George, who both studied at St. Martin's School of Art in London, have been working together since 1968, when they started working as one artist. From 1969 they have been presenting themselves as living sculptures – a 1969 performance on the steps of the Stedelijk Museum Amsterdam marked the first of these performances. They struck an immobile pose, almost entirely covered in metallic paint, for a few hours. They 'used' their own bodies as object in order to avoid the risk of falling back on traditional and formal forms. 'Being living sculptures is our life blood, our destiny, our romance, our disaster, our light and life... Art is for all the only hope for the making way for the Modern world to enjoy the sophistication of decadent living expression. It is our strong belief that in Art there is living, and where there's life there's Hope. It is for this reason that we have dedicated our hands, legs, pens, speech and our own dear heads to progress and understanding in art.'[1]

With Gilbert & George, 'sculpture' was also given form in many other media, such as photographic works, books, videos and drawings. Thematically, the work, which is almost always humorous, also relates to 'la condition humaine', in which the duo do not fight shy of any taboo whatsoever. It thus commentates on many set habits, preconceived ideas and role patterns.

Important groups of works that Gilbert & George produced during those years included books and cards, charcoal drawings and photographic works, in which, of course, they themselves appear. The drawings in particular seem to be an allegory of the English romantic drawing tradition. These works are often enormous, as with *The Tuileries*, which fill a whole room. The photographic works from the period 1965-1975 are mostly black-and-white and consist of a number of individually-framed small photographs that are arranged into a single composition in a specific way. Here too the subject matter is the relationship between the two of them, and their relationship to their own bodies.

SH

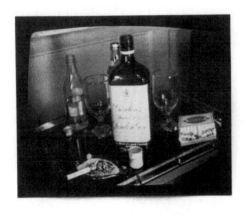

160. document: *Gordon's Makes Us Drunk*, 1972

Literature: Wolf Jahn, *The Art of Gilbert & George, or the Aesthetic of Existence*, Thames and Hudson, London 1989. | *Gilbert & George*, Musée d'Art Moderne de la Ville de Paris, Paris 1997.

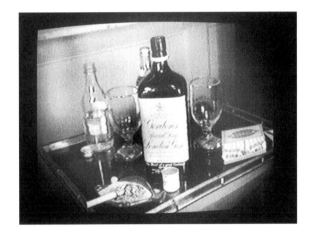

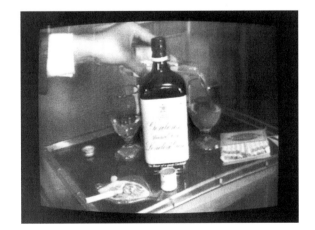

160. from: *Gordon's Makes Us Drunk*, 1972

145

154. *54 part Photo-Piece, Christmas 1971*, 1971

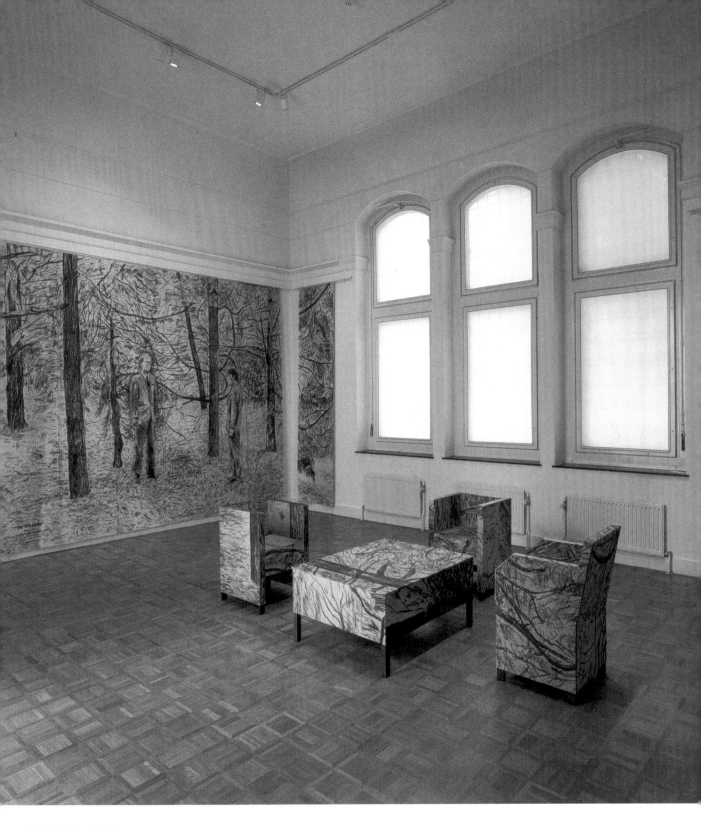

164. *The Tuileries*, 1974

147

1. *January 5-31, 1969*, Seth
Siegelaub Gallery, New York 1969,
n.p.

In November 1968, Seth Siegelaub organized an exhibition of the work of sculptor Douglas Huebler in New York. Nine 'sculptures' and four drawings could be viewed on request in Siegelaub's Madison Avenue apartment. A catalogue was sent out by post, which in fact constituted the tenth 'sculpture'. The other nine 'site sculpture projects' also existed in paper form only. 'The world is full of objects, more or less interesting. I do not wish to add any more. I prefer, simply, to state the existence of things in terms of time and/or place,' Huebler wrote shortly after the exhibition.[1]

During the ten years that followed, Huebler would produce works based on maps, drawings, descriptions and photographs. Each of his innumerable *Location*, *Duration* and *Variable Pieces* is based on a combination of photos and written statements. The photos have no unique, aesthetic value of their own but are meant as literal reflections of the procedures and operations described in the statements. In his way, Huebler gave shape to his investigation of an art without formalism, without personal style and without rules of composition.

Duration Piece #12 Amsterdam Holland consists of twelve photos and a statement. The statement explains that the photos were made with continuously duplicated intervals: thus after 0 second, 1, 2, 4, etc. Language is what explains the ratio of the working process, which in this case is based on time. The fact that the photos were made according to systematic logic rules out any personal artistic input. The photos themselves are no more and no less than pieces of evidence of a situation that the artist investigates but does not attempt to control.

HV

168. *Alternative Piece, No. 4(s)*, 1970

Literature: *Douglas Huebler*, Stedelijk Van Abbemuseum, Eindhoven 1979. | Marianne Van Leeuw and Anne Pontégnie, *Origin and Destination. Alighiero e Boetti. Douglas Huebler*, Palais des Beaux-Arts, Brussels 1997.

Duration Piece #12
Amsterdam, Holland

On January 12, 1960, at a point next to a canal in Amsterdam, 12 photographs were made in a sequence of time whereby the interval between each photograph was doubled by seconds.
(beginning at "zero time").

1. 0
2. 1 second
3. 2 seconds
4. 4 seconds
5. 8 seconds
6. 16 seconds
7. 32 seconds
8. 1 minute 4 seconds
9. 2 minutes 8 seconds
10. 4 minutes 16 seconds
11. 8 minutes 32 seconds
12. 17 minutes 4 seconds

The 12 photographs, (none identified in relationship to its place in the sequence), join with this statement to constitute the form of this piece.

Douglas Huebler
January, 1970

from: exh. cat. *Douglas Huebler*, Andover 1970

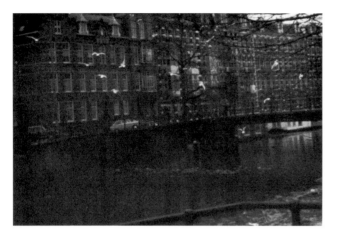
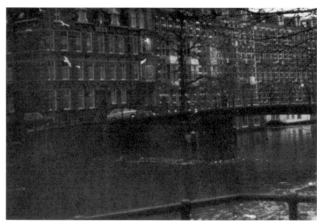
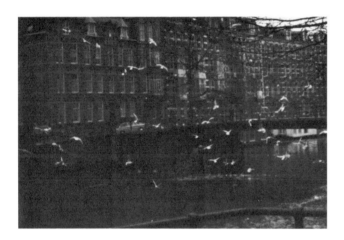

169. *Duration Piece #12*, 1970

1. Björn Springfield (ed.),
On Kawara continuity/discontinuity
1963/1979, Stockholm/Essen/
Eindhoven/Osaka 1980/1981,
pp. 3-4.

At the end of the 1950s, On Kawara left his homeland and spent the following eight years exploring the world. In 1965 the artist did finally choose New York as his permanent residence, but he would continue to travel a great deal and to devote himself to a strictly serial work pattern on a limited number of themes, some of which go all the way back to 1966. Commenting on what he hoped to accomplish with his work, On Kawara once said, 'Difference between sameness and difference is same/Sameness between difference and sameness is different.'[1] Although his working method certainly has a great deal in common with that of a number of other conceptual artists such as Stanley Brouwn and Hanne Darboven, On Kawara himself has had little contact with the conceptual group. They have propagated his work, however, and he has participated in exhibitions of conceptual art.

The themes in On Kawara's oeuvre are evident in the titles he gives his works, such as *I got up*, *I am still alive*, *One million years* and *Date-paintings*.

Postcards stamped with the text 'I got up at' followed by the time when that occurred were sent in longer or shorter series to varying groups of contacts. The same was done with the telegrams bearing the text 'I am still alive'. The *Date-paintings* have titles such as: (Stockholm:) *8JAN.1973*, *12JAN.1973* and (Halifax:) *JULY3.1973*, *JULY6.1973*, and are recorded by On Kawara in a 'Journal'. These entries are written in Esperanto or in the language of the country where the artist was staying at the time when the works were created. The date and dimensions of these paintings are also recorded, as are the subtitles and the monochrome colour used for the background. From 1966 to 1972 photos of the surrounding environment were added; in 1973 these photos consisted exclusively of black pages because the artist spent the first days of that year in Stockholm, where he became fascinated by the night sky.

JP

181. from: *I am still alive (1970-1977)*, 1978

Literature: Marianne Schmidt, Kasper König and Johannes Gachnang, *On Kawara. 1973 – Produktion eines Jahres/ One Year's Production*, Kunsthalle Bern, Bern 1974. | Björn Springfield (ed.), *On Kawara continuity/discontinuity 1963/ 1979*, Stockholm/Essen/Eindhoven/Osaka 1980-1981.

179. recto: *I got up, 25 to 31 January 1973*

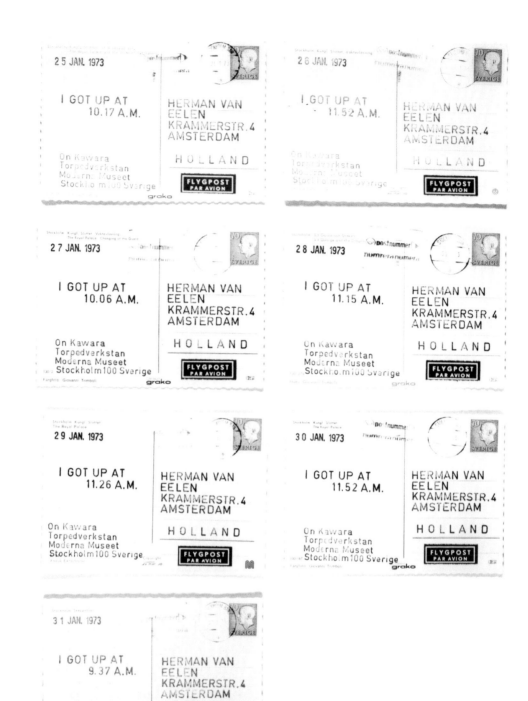

179. verso: *I got up, 25 to 31 January 1973*

In 1965 Joseph Kosuth began making *Proto-Investigations*, three-part works in which language, in addition to matter and photography, takes on an autonomous sculptural or pictorial significance. In *One and Three Glass*, one of the works, an ordinary object (in this case a glass plate), a photograph and a photographic enlargement of the dictionary definition of the object together form the work of art. The basic idea behind Kosuth's work is 'Art is the Definition of Art', as he would later write in his famous text 'Art After Philosophy' (1969). The three-part works were inspired by Marcel Duchamp's ready-mades, but they go one step further: their point of departure is not only the idea that an authority/the museum determines what art is, but also that photography and language, separated from other forms of representation, set in motion a process of imparting meaning. Another name for the *Proto-Investigations* is *Object Definitions*; as site-specific installations, the works acquire their definitive form only in a specific environment. Thus *One and Three Glass* was only actually realized a year after it was purchased in 1976.

Between 1966 and 1968, Kosuth planned to present his series *First Investigation*, in which he would exhibit only the definition of objects in the form of enlarged texts printed in white on black under the title *Art as Idea as Idea*. In this work, language was to be the only bearer of the representation, as would also be the case in the later *Investigations*. In the *Second Investigation*, Kosuth left the art world and focused on the context of the object. In the classified advertisement sections of newspapers from several countries he anonymously placed passages taken from the *Synopsis of Categories* from the thesaurus compiled by the physicist Peter Mark Roget in 1852. In later 'Investigations', existing texts were restored to the context of the visual arts. The heart of Kosuth's work has always been the fact that the aesthetic content of a work can rest on text and does not necessarily have to possess a material, physical form.

HV

188. *Teksten/Textes*, 1976

Literature: Joseph Kosuth, *Art after Philosophy and After. Collected Writings 1966-1990*, MIT Press, Cambridge (Mass.) 1991. | Joseph Kosuth, *Bedeutung von Bedeutung. Texte und Dokumentation der Investigationen über Kunst seit 1965 in Auswahl*, Staatsgalerie, Stuttgart 1981.

183. *Five Fives (to Donald Judd)*, 1965-1969

184. *One and Three glass*, 1965-1977

glass [gla:s] **I** *zn* glas(werk); **2** ra(a)m(en);
3 spiegel; **4** monocle; lens; kijker; **5** baro-
meter; **6** broeikas; **7** zandloper; —*es*, bril,
lorgnet; **II** *bn* glazen; **III** *ww* **1** weerkaatsen,
spiegelen; **2** glazig maken. ~-bell stolp.
~-case vitrine. ~-cloth **1** glazendoek; **2**
schuurlinnen. ~-dust g.-poeder. ~ eye
kunstoog. ~-house broeikas. ~-paper
schuurpapier. ~ shade glazen lampekap.
~y *bn zie* glass **II**; spiegelglad.

1. Sol LeWitt, 'Paragraphs on
Conceptual Art', *Artforum*, 5 (1967)
no. 10.

The idea itself, even if not made visual, is as much a work of art as any finished product. All intervening steps – scribbles, sketches, drawings, failed works, models, studies, thoughts, conversations – are of interest. Those that show the thought process of the artist are sometimes more interesting than the final product.[1]

Towards the end of the 1960s, the American artist Sol LeWitt was no stranger in the Netherlands. In 1967, Jean Leering and Carl Andre introduced him to the collectors Martin and Mia Visser in Bergeyk, whose collection was eventually acquired by the Kröller-Müller Museum. This initial meeting marked the start of a long friendship and many acquisitions. LeWitt's work was shown at the celebrated 'Minimal Art' group exhibition in the Gemeentemuseum Den Haag in 1968. Two years later LeWitt had his first big solo exhibition at the same museum. The exhibition catalogue, for which LeWitt took charge of the layout himself, included his theories about art, including *Paragraphs on Conceptual Art* (1967) and *Sentences on Conceptual Art* (1968). These statements established LeWitt as one of the most important theoreticians of conceptual art.
LeWitt himself uses the term 'conceptual art' to indicate that the meaning of a work of art lies more in the concept than in the material visualization. The idea is more important than the realization, which he usually entrusts to other people.
LeWitt makes spatial structures, pen and ink drawings, wall drawings, photographs, graphic work and art books. His rigorously modular structures, such as *Untitled* (1968), which are also linked with minimalist art, are based on the rectangle. LeWitt regards the square as the most neutral basic form for expressing a concept as objectively as possible. For this same reason he has been using smooth, white material since early on in his career.
LeWitt's drawings, such as *All Crossing Lines, Arcs, Straight Lines, not Straight Lines and Broken Lines* (1972), are part of an extended series and are based on a study into the essence of the notions of line and drawing. The combinations of horizontal, vertical and diagonal lines result in patterns with a particular structural density. For exhibitions he executes this kind of drawing directly onto the wall.

SG

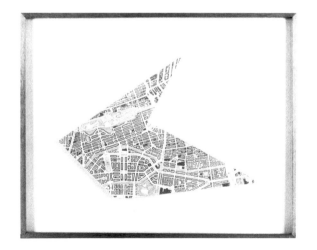

205. *Map of Amsterdam...*, 1976

Literature: *Sol LeWitt*, The Museum of Modern Art, New York 1978. | Martin Friedman, Andrea Miller-Keller, Brenda Richardson et al., *Sol LeWitt: A Retrospective*, San Francisco Museum of Modern Art, San Francisco 2000.

190. *Untitled*, 1968

201. from: *All Combinations of Arcs from Four Corners...*, 1974

196. *All Crossing Lines, Arcs, Straight Lines, not Straight Lines and Broken Lines*, 1972

1. Suzanne Wedewer, 'Reine Kunst in reiner Landschaft'. In: *Künstler. Kritisches Lexikon der Gegenwartskunst* (no. 20), Weltkunst/ Bruckmann, n.d.

While studying at the St Martin's School of Art, Richard Long made the acquaintance of Jan Dibbets. Dibbets asked him to participate in a one-evening exhibition to be held in 1967 under the title 'Dies alles Herzchen wird einmal Dir gehören' in Frankfurt a/M. Among those in attendance were artists as well as gallery owners, critics and collectors from the international avant-garde, and there the basis was laid for many contacts, exhibitions and other activities having to do with conceptual art. Richard Long was regularly involved in presentations of conceptual art because his own work demonstrates such an obvious affinity to it. An early work from 1967 (*A Line Made by Walking*) is typical of his oeuvre, in which the line (and somewhat later the circle) produced by a certain action would always play an important role. Concerning his use of the circle, Long said, 'I have to say that the first time I used a circle I had no idea why I used it. It seemed like a good idea at the time, but having made it, it looked great and seemed a very strong and powerful image, and I have used it ever since.'[1]

On the basis of his activities in natural settings, a connection is sometimes made between the work of Richard Long and land art. But unlike other artists, he never adds elements to the landscape that are alien to nature. His work is characterized by interventions in the landscape that usually disappear over time. The development of his ideas – certainly in the first decades of his oeuvre – exists only in the form of photos, sketches, artist's books and the interpretation of maps. In the latter, Long's work bears some resemblance to the map works of Richard Smithson who, like Long, brings nature into the museum in many of his works.

JP

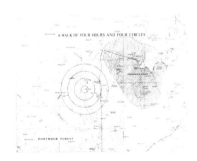

211. *A walk of four hours and four circles*, 1972

Literature: Rudi Fuchs, *Richard Long*, S.R. Guggenheim Museum, New York/Thames and Hudson, London 1986. | Anne Seymour, *Richard Long. Walking in circles*, Hayward Gallery, London 1991.

206. *Wooden sticks*, 1968

1. 'Interview with Brenda Richardson'. In: *Bruce Nauman: Neons*, Baltimore Museum of Art, Baltimore 1982, p. 20.

The use of language and the deployment of his own body have been two constants in the work of Bruce Nauman since the second half of the sixties. Generally speaking his work is characterized by a radical and astonishing unconventionality, in the terms of both methodology and of the widely varying media that he uses. Nauman began studying the form and the meaning of language early on in neon works, in which written words were given a sculptural dimension. The small changes in and additions of letters in *Eat/Death* (1962), or the exaggerated transposition of spoken language into material form as in *My Name as Though it Were Written on the Surface of the Moon* (1968), result in totally new meanings. The neon works resemble advertisements, of course, but they have absolutely no sales function. In an interview in 1982, Nauman spoke about the background of these works: 'I had an idea, that I could make art that would kind of disappear – an art that was supposed not quite to look like art. In that case, you wouldn't really notice it until you paid attention. Then, when you read it, you would have to think about it.'[1]

Of great significance for Nauman's ideas about language were the philosopher Wittgenstein's notions on the functioning of language and word play. The content of Nauman's alludes strongly to the human condition, to the human being as a social creature. In the videos from the period around 1970, which were made in his own studio, subjectivity and a growing awareness of one's own body play an important role. Bruce Nauman devises activities that he also performs himself. Works such as *Wall Floor Positions* (1968), *Walk with Contraposto* (1969) and *Pacing upside Down* (1969) possess a tight, repetitive rhythm and are characterized by a kind of obsessive monomania. Later on, Nauman would have others (an actor, a mime artist, a clown) perform the activities he had prescribed and would also integrate the viewer in the work in a very direct way.

HV

227. from: *Pursuit*, 1975

Literature: *Bruce Nauman*, Hayward Gallery, London 1988. | Joan Simon, Janet Jenkins and Toby Kamps, *Bruce Nauman*, Walker Art Center, Minneapolis 1994.

218. *My Name as Though It Were Written on the Surface of the Moon*, 1968

224. *Untitled* ('Design for a Space'), 1971

225. *Untitled* ('Positive and Negative'), 1971

Edward Ruscha

(Omaha, Nebraska 1937)

1. Edward Ruscha in: A.D. Coleman, 'I'm Not Really a Photographer', *The New York Times*, 10 September 1972, p. 235. Quoted in: Ann Goldstein and Anne Rorimer (eds.), *Reconsidering the Object of Art: 1965-1975*, MoCA, Los Angeles 1995, p. 209.

As early as the late fifties, painter Ed Ruscha began introducing linguistic elements in his paintings. He drew his inspiration for the contents of his work from comic strips and advertisements – pop art's source of inspiration (to which his work was then related). Besides this work, Ruscha produced seventeen books between 1963 and 1972. The first was *Twentysix Gasoline Stations* and consisted of photographs of roadside petrol stations between Los Angeles and Oklahoma City. Almost all these books, including *Every Building on the Sunset Strip* (1966) and *Thirty-four Parking Lots in Los Angeles* (1967), record typical aspects of the architecture and culture of Los Angeles. The book *Dutch Details*, published in May 1971 for 'Sonsbeek buiten de perken', transfers this vision to the average Dutch residential area. The photos themselves are strictly functional shots without the use of any special angles or aesthetic interventions. As Ruscha told critic Eddie Coleman in an interview, 'I never take pictures just for the taking of pictures; I'm not interested in that at all... It [photography] is strictly a medium to use or to not use... I use it to do a job, which is to make a book.'[1] These are artist's books insofar as they are entirely devised and published by Ruscha himself. The fact that, apart from the first book, they were not published in a limited, numbered edition and were periodically reprinted indicates a radically new notion of what up until then was the ever so exclusive 'livre d'artiste'. These simple little books, quite cheap at that time, did not have to be handled as valuable works of art but were accessible to everyone. In 1969, Ruscha published the book *Stains* in which he used organic materials for the first time. The 75 sheets of paper that constitute the publication are coloured (stained) by a variety of materials including tap water, male semen and soft drinks. Ruscha soon began using these kinds of materials in silkscreen prints and as paint on his silk text paintings, such as *Pure Ecstasy* from 1972.

HV

240. from: *Dutch Details*, 1971

Literature: Neal Benezra, Kerry Brougher, *Ed Ruscha*, Hirschhorn Museum and Sculpture Garden, Washington D.C. 2000. | Siri Engberg, Clive Philpot, *Ed Ruscha 1959-1999, Catalogue Raisonné*, Walker Art Center, Minneapolis 1999.

SAND

IN THE

VASELINE

246. *Sand in the Vaseline*, 1974

1. David Bellman, *On the Threshold of the Future: Robert Ryman + Ian Wilson*, Genesta (CA) 1996, p. 1.

Robert Ryman started painting in about 1955 and almost immediately found his own style in the making of square and monochrome paintings. He would remain faithful to the square and the use of monochrome throughout his entire oeuvre owing to their neutrality and their fundamental and direct quality. One of the artist's well-known statements about painting is: 'A painter is only limited by his degree of perception. Painting is only limited by the known.'[1] Although there has been a tendency to regard Ryman's work from the first half of the sixties as minimal art on the basis of his close contact with certain artists, it is actually not possible to classify him within any particular school. This is due to the strictly personal background from which his works emerge, and to Ryman's way of working, which is both rational and intuitive. Despite the artist's desire to make his work look simple and very direct, there's still a great deal of brainwork behind the production of each painting. At the same time, a work is only interesting for him if something unexpected and new emerges as it is being painted.

In the years before 1970, Ryman carried out a study of the characteristics of various paints and surfaces. This led to a small series of works in 1968 that have not been mounted or do not have a permanent surface, but are to be applied directly to the wall. In these works – *Orrin* (1967), for example – Ryman used what for him were new materials such as wax paper, adhesive tape and carpenter's chalk. Ryman himself regards this group, as well as a few works that immediately follow them, as 'conceptual' due to the fact that they can always be executed anew and with different materials, if desired. For this reason, says the artist, he made handwritten instructions to accompany these works, which, however, have gone missing in the intervening years.

JP

248. document: *Orrin* (2001)

Literature: *Robert Ryman*, Stedelijk Museum Amsterdam, 1974. │ *Robert Ryman*, Museo Nacional Centro de Arte Reina Sofia, Madrid 1993.

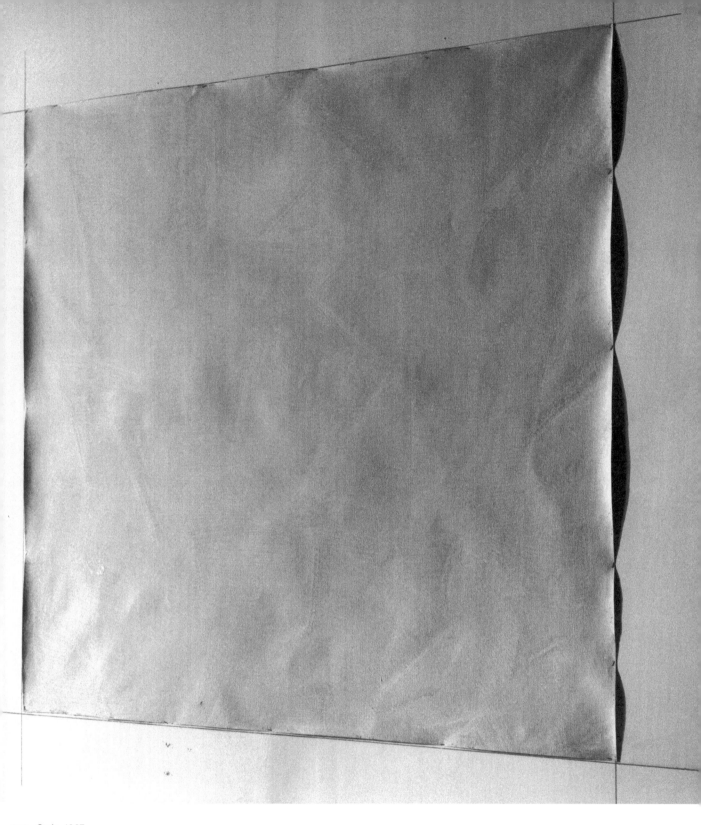

248. *Orrin*, 1967

171

Gerry Schum, a filmmaker who had studied at the Berlin Film Academy, wanted to give art a more important place on television. Initially he did this the traditional way: he showed works of art to the public and provided it with a commentary. The activities of avant-garde artists such as Jan Dibbets and Ger van Elk, with whom he was friends, set him off in a different direction. Schum became directly involved with movements like conceptual art and land art. He came up with the idea of no longer making films about art, but films that actually consist of works of art. With this goal in mind, he established his *Fernsehgalerie* ('Television Gallery') in 1969. He invited eight artists to create an artwork specially for television. He acted as cameraman and was responsible for the production. On April 15, 1969, he broadcast the first television exhibition on *Sender Freies Berlin* under the title 'Land Art'.

The films in 'Land Art' were about abstract concepts like space and time. Some artists, including Robert Smithson, Dennis Oppenheim and Walter De Maria, created footage of projects that had previously been documented in photographs. Barry, Flanagan and Boezem gave a framework to the natural movement processes of the tides and the wind respectively. The press generally reacted favourably to Schum's radical new initiative. However, for the wider public the works were still incomprehensible.

Nonetheless, Schum succeeded in broadcasting his second television exhibition, 'Identifications', in 1970. This time he showed the work of 20 artists from the international avant-garde. Van Elk shaved a cactus clean with an electric shaver and Reiner Ruthenbeck made balls of paper. As with 'Land Art', clarity and the simplicity of camera work and lighting were the first priority.

After 'Identifications', Schum was no longer able to get his foot in the door at any television station. Disheartened, he went in search of an alternative. Video equipment, still a novelty at the time, seemed to offer a way forward. His television gallery became a video gallery, and invited the artists with whom he had worked in 'Identifications', among others, to make a video (recording). The gallery was based in Dusseldorf. Schum and his video gallery were represented at practically all the leading exhibitions, such as documenta 5, 'Sonsbeek 71' and 'Prospect 71'.

SG

in Gerry Schum's video gallery

Literature: *Gerry Schum*, Stedelijk Museum Amsterdam, 1979-1980. | Christiane Fricke, *'Dies alles Herzchen wird einmal Dir gehören.' Die Fernsehgalerie Gerry Schum 1968-1970 und die Produktionen der Videogalerie Schum 1970-1973*, Peter Lang Verlag, Bern/Berlin/Frankfurt a.M./New York 1996.

249. *Land Art. Fernsehausstellung I*, 1969 250. *Identifications. Fernsehausstellung II*, 1970

1. See: Ted Castle, 'Robert Smithson rolls over in his grave', *Art Monthly*, no. 58 (1982), pp. 6-8.

Richard Smithson began his artistic career in around 1957, initially painting in an abstract expressionistic style. His meetings in the early sixties with figures such as Carl Andre, Allan Kaprov, Sol LeWitt and Richard Long, who inspired him to create minimalistic metal sculpture, were important for his further development. His work is also related to land art on account of its interventions in the landscape (whether fictitious or not), and his installations often consist of a combination of elements from both land art and minimal art.

In the Netherlands, Robert Smithson is mainly known for the works *Spiral Hill* and *Broken Circle*, interventions in the landscape near Emmen which he executed in 1971 as part of 'Sonsbeek buiten de perken'. Smithson carried out a number of similar permanent landscape interventions. Often this portion of his work consisted of temporary, alienating procedures in or with a landscape, as occurred in 1969 near Heerlen with the placing of mirrors. The resulting effect was recorded in photographs that were shown that same year at the exhibition 'Op losse schroeven' in the Stedelijk Museum. He also transferred elements from one particular landscape ('site') to an exhibition area ('non-site') in the form of an installation. Regarding this, Smithson said, 'Instead of putting a work of art on some land, some land is put into the work of art.'[1] Smithson is mainly conceptual in the sense that his ideas do not actually have to be carried out. They are also expressed in both his sketches and drawings as well as in his poems and theoretical and critical writings.

JP

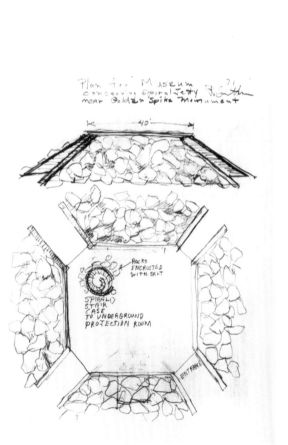

254b. *Plan for a Museum Concerning Spiral Jetty*, 1971

Literature: Nancy Holt (ed.), *The Writings of Robert Smithson*, New York University Press, New York 1979. | Robert Hobbs, *Robert Smithson: a retrospective view*, 40th Venice Biennale/United States Pavilion, Ithaca (N.Y.) 1982. | Eugenie Tsai, *Robert Smithson Unearthed. Drawings, Collages, Writings*, Colombia University Press, New York 1991. | Jack Flam (ed.), *Robert Smithson: the collected writings*, University of California Press, Berkeley/Los Angeles/London 1996.

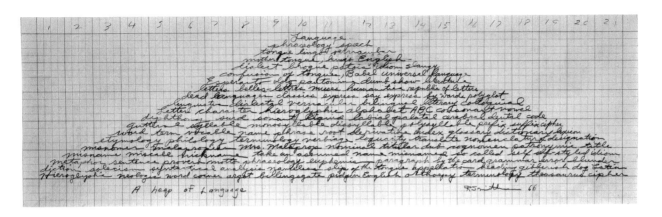

251. *A heap of Language*, 1966

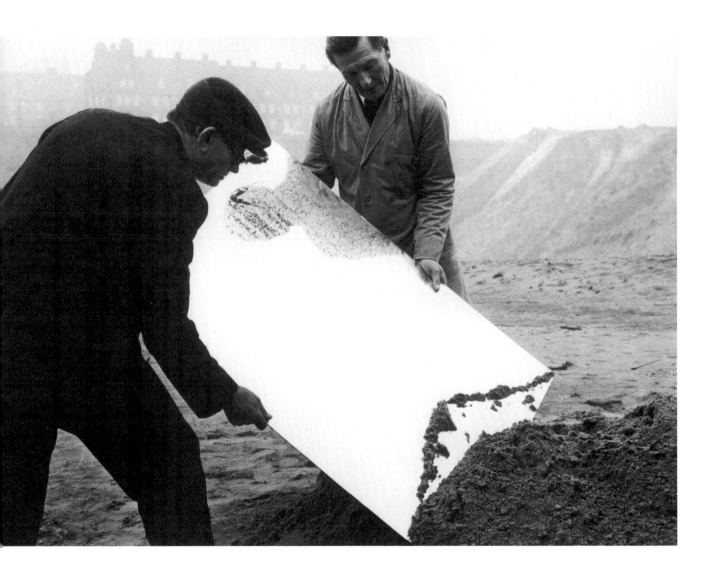

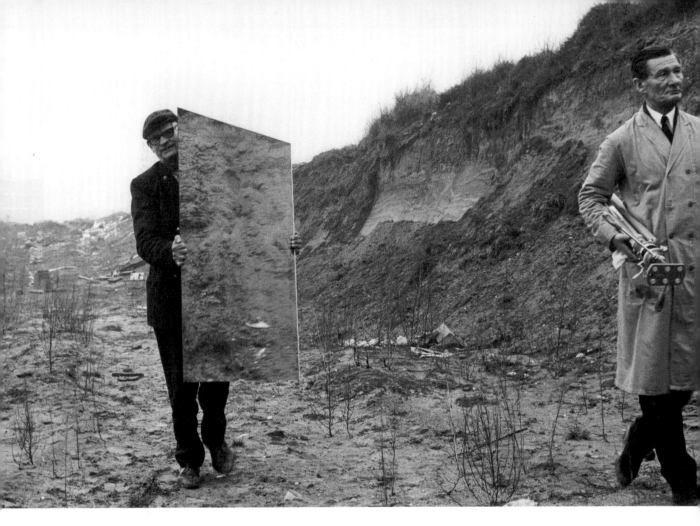

project *Yellow earth with mirrors*, near Heerlen (NL), 1969

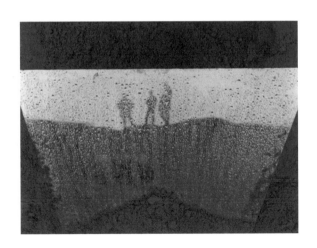

In late 1968, an unusual exhibition was held in the progressive New York gallery of Seth Siegelaub. The exhibition *Statements* involved nothing more than a book in which Lawrence Weiner made 28 general and specific statements about realizable situations, such as:

a plate of triplex affixed to the wall or the floor

one litre of green outdoor paint thrown at a brick wall

Though Weiner initially sprayed his paint directly onto the floor or threw it against the wall, he quickly decided that these acts would still be understood as unique works of art to too great an extent. From 1969 he upheld three conditions for the possible existence of the work:

1. The artist may construct the piece
2. The piece may be fabricated
3. The piece need not to be built
Each being equal and consistent with the intent of the artist, the decision as to condition rests with the receiver upon the occasion of receivership.

From 1969 onwards Weiner's work consisted to a large extent of language rather than tangible objects. Weiner came to the conclusion that an artist does not have to realize a work. It is sufficient for it to exist linguistically as a statement. One and the same work can be executed at any location whatsoever, if necessary at different places simultaneously. Weiner executed his statements on the walls of exhibition spaces, and on invitations and posters for his exhibitions. Along with a number of other artists of his generation, Weiner also belonged to the first group of artists who experimented with alternative forms of presentation, such as advertising products, posters, stickers and match boxes. In the end, he posted adverts and placed texts on gramophone records, tape and film.

Weiner, who soon came to be regarded as one of the most important founders of conceptual art, bought a houseboat in Amsterdam in 1970. From then on he alternated between living in Amsterdam and New York. Although in 1979 he himself claimed that he was not involved with the art world in Amsterdam, in 1969 he took part in 'Op losse schroeven' and over the years he has exhibited at Art & Project on various occasions.

SG

STATEMENTS
Lawrence Weiner

$1.95

255. from: *Statements*, 1968

Literature: *Lawrence Weiner*, Stedelijk Museum Amsterdam, 1988. | Alexander Alberro et al., *Lawrence Weiner*, Phaidon Press, London 1998.

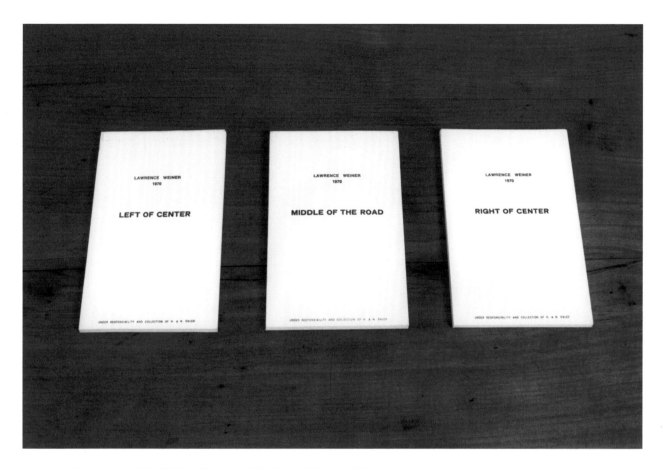

259-261. *Left of Center*, 1970, *Middle of the Road*, 1970, *Right of Center*, 1970

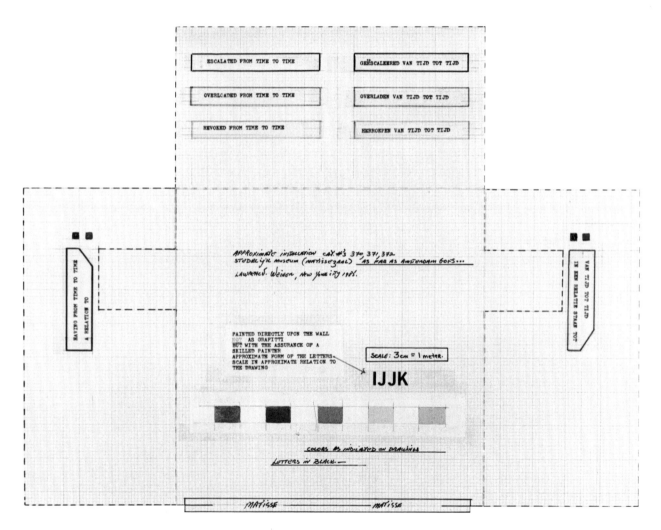

269. document: *Escalated from time to time*, 1973-1985

ESCALATED FROM TIME TO TIME

GEËSCALEERD VAN TIJD TOT TIJD

OVERLOADED FROM TIME TO TIME

OVERLADEN VAN TIJD TOT TIJD

REVOKED FROM TIME TO TIME

HERROEPEN VAN TIJD TOT TIJD

269. from: *Escalated from time to time*, 1973-1975

269. from: *Escalated from time to time*, 1973-1975

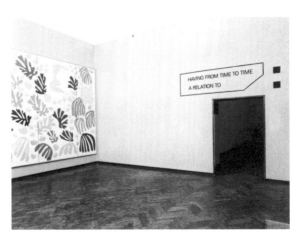

1. Ian Wilson, 'Conceptual Art',
Artforum, February 1984, p. 61.
2. 'Time: A Panel Discussion', *Art International*, November 1969, p. 23.

Since 1968, the year in which he created the *Circle on the floor*, a circle drawn in chalk on a floor with a diameter of almost two metres, Wilson has done no more painting or given his art any other physical, material form whatsoever. The concrete art object no longer offered Wilson any perspective for his further development. Since then he has directed his attention to 'oral communication': discussions with visitors to galleries and museums, at home with private collectors or with fellow artists. Wilson regards these discussions, which address the abstraction of ideas, 'the formless abstractions of language. Infinite and formless',[1] as a form of sculpture. 'I'm not a poet and I'm considering oral communication as a sculpture. Because… if you take a cube, someone has said you imagine the other side because it's so simple. And you can take the ideas further by saying you can imagine the whole thing without its physical presence. So now immediately you've transcended the idea of an object that was a cube into a word, without its physical presence. And you still have the essential features of the object at your disposal. So now, if you just advance a little, you end up where you can take up a word like time and you have the specific features of the word "time." You are just moving the idea of taking a primary structure and focusing attention on it.'[2]

The discussions are not taped, jotted down, or recorded in any other form; they are not objects that are meant to be looked at. It is about the moment, the participation of the protagonists in the process and the personal contact. The only material elements are the announcement of the discussion, with the date and place, and the document that subsequently serves as proof of the fact that the discussion took place.

SH

277. *Discussion, 23 January 1972*

Literature: Ian Wilson, 'Conceptual Art', *Artforum*, February 1984. | David Bellman, *On the Threshold of the Future: Robert Ryman + Ian Wilson*, London 1996.

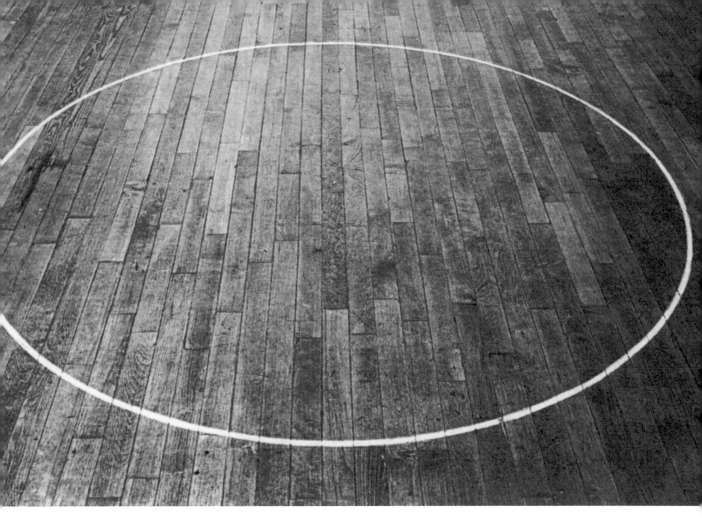

275. *Circle on the Floor*, 1968-1985

catalogue numbers marked
with * indicate artists' books

documentation included in the
exhibition is from the archives
of Nicole Verstraeten, Brussels

Bas Jan Ader

1 ———— *Fall I (Los Angeles),* 1970
16 mm silent black-and-white film
34"
Museum Boijmans Van Beuningen,
Rotterdam

* 2 ———— *Fall*
Los Angeles, Bas Jan Ader, 1970
19 x 19 cm
Stedelijk Museum Amsterdam

3 ———— *Fall II, (Amsterdam),* 1970
16 mm silent black-and-white film
13"
Museum Boijmans Van Beuningen,
Rotterdam

4 ———— *Broken Fall (Geometric),*
Westkapelle Holland, 1971
16 mm silent black-and-white film
1'50"
Museum Boijmans Van Beuningen,
Rotterdam

5 ———— *I'm too sad to tell you,* 1971
16 mm silent black-and-white film
2'5"
Museum Boijmans Van Beuningen,
Rotterdam

6 ———— *I'm too sad to tell you,* 1970
black-and-white photo
49 x 59 cm
Museum Boijmans Van Beuningen,
Rotterdam

7 ———— *Nightfall,* 1971
16 mm silent black-and-white film
4'11"
Museum Boijmans Van Beuningen,
Rotterdam

8 ———— *Broken Fall (Organic)*
Amsterdamse Bos, Holland, 1971
16 mm silent black-and-white film
1'30"
Museum Boijmans Van Beuningen,
Rotterdam

Carl Andre

9 ———— from: *Words,* 1958-1972
ink and typescript on paper
various formats
Stedelijk Museum Amsterdam

10 ———— *Dutch Poem,* 1967
ink on paper
29.5 x 20.5 cm
Kröller-Müller Museum, Otterlo
(formerly in the Visser collection)

11 ———— *10 x 10 Altstadt Lead*
Square, 1967/1976
lead plates + document, each:
1 x 50 x 50 cm, total size: 1 x 500 x 500 cm
Stedelijk Museum Amsterdam

* 12 ———— *Xerox Book*
New York, Siegelaub/Wendler, 1968
[with Barry, Huebler, Kosuth, LeWitt,
Weiner, et al.]
28 x 21.4 cm
Stedelijk Museum Amsterdam

* 13 ———— *Carl Andre*
Mönchengladbach, Städtisches
Museum Abteiberg, 1968
21 x 17 cm
Stedelijk Museum Amsterdam

14 ———— *Jonas Piece,* 1968
4 steel plates + document
each: 2.5 x 15.5 x 15.5 cm
Coll. Herman and Henriëtte van Eelen,
Amsterdam

15 ———— *Jonas Piece,* 1968
4 aluminium plates + document
each: 2.5 x 15.5 x 15.5 cm
Collection Herman and Henriëtte
van Eelen, Amsterdam

16 ———— *64 Bent nailrun,* 1969
64 nails + documents
various formats
Collection Herman and Henriëtte
van Eelen, Amsterdam

* 17 ———— *One Month, March 1969*
New York, Seth Siegelaub, 1969
[with Barry, Huebler, Kawara, Kosuth,
LeWitt, Long, Nauman, Ruscha,
Smithson, Weiner, Wilson, et al.]
21.5 x 17.5 cm
Stedelijk Museum Amsterdam

* 18 ———— *July, August, September 1969*
New York, Seth Siegelaub, 1969
[with Barry, Buren, Dibbets, Huebler,
Kosuth, LeWitt, Long, Smithson,
Weiner, et al.]
27.7 x 21.3 cm
Stedelijk Museum Amsterdam

* 19 ———— *144 Blocks & Stones Portland*
Ore: for Robert Smithson
Portland, Portland Center for the
Visual Arts, 1973
20.3 x 20.3 cm
Stedelijk Museum Amsterdam

*20 —————— *Quincy Book*
Andover, Addison Gallery of
American Art, 1973
20.5 x 20.5 cm
Stedelijk Museum Amsterdam

Art & Language

21 —————— *Index 2 (II) (Hayward Index),*
1972
4 card-index boxes with texts and
320 index cards on the wall
various formats
Collection Herbert, Ghent

22 —————— *Matrix for an Index,* 1972
pencil on paper
140 x 120 cm
Collection Herbert, Ghent

*23 —————— *Art-Language, The Journal
of conceptual art*
Vol. 1, nos. 1, 2 & 4; Vol. 2, nos. 1 & 4;
Vol. 3, no. 1, Coventry… Warwickshire,
Art & Language Press, (1969-1974)
various formats
Stedelijk Museum Amsterdam

John Baldessari

24 —————— *Folding Hat,* 1971
black-and-white PAL videotape, sound
30'
Stedelijk Museum Amsterdam

*25 —————— *Ingres and other parables*
London, Studio International, 1972
27 x 30.7 cm
Stedelijk Museum Amsterdam

*26 —————— *Choosing: green beans*
Milano, Galleria Toselli, 1972
29.7 x 21 cm
Stedelijk Museum Amsterdam

*27 —————— *Throwing Three Balls
in the Air to get a Straight Line
(best of Thirty-six Attempts)*
Milano, Giampaolo Prearo, Galleria
Toselli, 1973
25 x 33 cm
Stedelijk Museum Amsterdam

*28 —————— *Four Events and
Reactions*
Florence, Centro Di, 1975
12.5 x 18 cm
Stedelijk Museum Amsterdam

*29 —————— *Throwing a Ball Once
to Get Three Melodies and
Fifteen Chords*
Irvine, Art Gallery University of
California, 1975
20.3 x 25.2 cm
Stedelijk Museum Amsterdam

30 —————— *Five pickles (with fingerprints),
in the shape of a hand,* 1975
[from the folio *Artists & Photographs,*
New York, Multiples Inc., 1975]
colour photocollage, limited edition
51.1 x 61.3 cm
Stedelijk Museum Amsterdam

*31 —————— *Brutus killed Caesar*
Akron, Emily H. Davis Art Gallery of the
University of Akron, [1976]
10 x 27.5 cm
Stedelijk Museum Amsterdam

Robert Barry

32 —————— *Konzeption - Conception…*
Köln/Opladen, Westdeutscher Verlag, 1969
corrections in ink
19.9 x 21 cm
Collection Herman and Henriëtte
van Eelen, Amsterdam

33 —————— *10° # 2,* 1968
ink on graphic paper
11 works in a book, each: 28 x 21 cm
Collection Daled, Brussels

34 —————— *Radiation Piece, barium 133,*
1968-1969
black-and-white photo
17.2 x 25 cm
Siegelaub Collection & Archives at the
Stichting Egress Foundation, Amsterdam

*35 —————— *January 5-31,* 1969
New York, Seth Siegelaub, 1969
[with Huebler, Kosuth, Weiner]
20.8 x 18 cm
Stedelijk Museum Amsterdam

*36 —————— *Art & Project bulletin 17:
Robert Barry*
Amsterdam, Art & Project, 1969
29.5 x 21 cm
Netherlands Institute for Art
History (Archive Art & Project),
The Hague

*37 —————— *Robert Barry*
Torino, Sperone, 1970
17 x 11.5 cm
Stedelijk Museum Amsterdam

38 —————— *Agreement of original
transfer of work of art,* 1971
typescript document
3 parts, each 29.7 x 42 cm
Collection Daled, Brussels

*39 —————— *Two pieces*
Torino, Sperone, 1971
17.2 x 11.5 cm
Stedelijk Museum Amsterdam

*40 —————— *Something which is very
near in place and time, but not
yet known to me*
Köln, Gerd de Vries/Paul Maenz, 1971
29.6 x 21 cm
Stedelijk Museum Amsterdam

*41 —————— *It is… it isn't…*
Paris, Yvon Lambert, 1972
17 x 11 cm
Stedelijk Museum Amsterdam

42 —————— *Invitation Piece,* 1972-1973
invitation cards
8 parts, various formats
Collection Herbert, Ghent

*43 —————— *January 1973*
Warszawa, Galeria Foksal, 1973
30 x 21 cm
Stedelijk Museum Amsterdam

44 —————— *One Hundred Words,* 1973
letterpress on paper
10 parts, each: 66 x 51 cm
Stedelijk Van Abbemuseum,
Eindhoven

45 —————— *16th Century,* 1974
projection of 80 slides
Stedelijk Van Abbemuseum,
Eindhoven

*46 —————— *All the things I know…*
Amsterdam, Stedelijk Museum, 1974
27.5 x 20.5 cm
Stedelijk Museum Amsterdam

*47 —————— *Robert Barry*
Amsterdam, Art & Project, 1974
21 x 10 cm
Stedelijk Museum Amsterdam

*48 —————— *Belmont 1967*
Eindhoven, Stedelijk Van
Abbemuseum/Essen, Museum
Folkwang, 1977
21 x 28 cm
Stedelijk Museum Amsterdam

Marinus Boezem

49 —— *Window*, 1968
wood, glass and cloth
250 x 95 x 30 cm
De Vleeshal/Stichting Beeldende
Kunst Middelburg

50 —— *Weather map, Thursday 26
September 1968*
manipulated weather map
34.3 x 24.6 cm
Coll. L.A. Dosi Delfini, Amsterdam

51 —— *Signing the Sky above
the Port of Amsterdam by an
Aeroplane*, 1969
photos
3 parts, each: 42.3 x 60 cm
Stedelijk Van Abbemuseum, Eindhoven
(on permanent loan from the Netherlands
Institute for Cultural Heritage)

*52 —— *Paper Events*
Multi-Art Press, 1970
30 x 21.5 cm
Stedelijk Museum Amsterdam

Marcel Broodthaers

53 —— *Carte du Monde Poétique*, 1968
modified map of the world on canvas
115.5 x 181 cm
Collection Herbert, Ghent

54 —— *Une Echelle de Briques*, 1969
wood, bricks and cement
201 x 169 x 57 cm
Caldic Collection, Rotterdam

55 —— *La Signature Série 1*, 1969
screen print on white tracing paper
55 x 75 cm
Collection Herman and Henriëtte
van Eelen, Amsterdam

*56 —— *Der Adler vom Oligozän bis
heute : …Musée d'Art Moderne,
Département des Aigles, Section
des Figures*
Düsseldorf, Städtische Kunsthalle, 1972
2 parts, each: 21 x 14.7 cm
Stedelijk Museum Amsterdam

*57 —— *La Porte est Ouverte*
Köln, Galerie Werner, 1972
21 x 14.5 cm
Stedelijk Museum Amsterdam

*58 —— *Jeter du Poisson sur le
Marché de Cologne*
Köln, Galerie Werner, 1973
20.9 x 14.5 cm
Stedelijk Museum Amsterdam

59 —— *L'Entrée de l'Exposition*,
1974
paintings, photos, graphics and
indoor palms
various formats
Bonnefantenmuseum, Maastricht

60 —— *Réclame pour la Mer
du Nord*, 1974
offset print and screen print
104 x 66 cm
Stedelijk Museum Amsterdam

*61 —— *A Voyage on the North Sea*
London, Petersburg Press, 1974
15 x 17.8 cm
Stedelijk Museum Amsterdam

*62 —— *Marcel Broodthaers:
catalogue*
Bruxelles, Palais des Beaux-Arts, 1974
30 x 23 cm
Stedelijk Museum Amsterdam

63 —— *La Soupe de Daguerre*, 1975
[from the folio Artists & Photographs,
New York, Multiples Inc., 1975]
colour photos and screen print on
cardboard, limited edition
52.5 x 51.4 cm
Stedelijk Museum Amsterdam

*64 —— *L'Angelus de Daumier*
Paris, Centre National d'Art et de
Culture Georges Pompidou, 1975
2 parts: each: 25.4 x 20.3 cm
Stedelijk Museum Amsterdam

Stanley Brouwn

65 —— *Steps*, 1970
black-and-white photo, plan, text
3 parts: various formats
Collection VB/VR

66 —— *Walks from x to y*, 1970
red felt-tip on collotypes
8 parts: various formats
Stedelijk Museum Amsterdam

67 —— *If three different paths
go from x to y*, 1970
red felt-tip on collotype
2 parts, each: 81 x 101 cm
Stedelijk Museum Amsterdam

68 —— *43°*, 1970
city map modified with red ballpoint pen
city map
81 x 101 cm
Stedelijk Museum Amsterdam

69 —— *100°*, 1970
city map modified with red ballpoint pen
city map
81 x 101 cm
Stedelijk Museum Amsterdam

*70 —— *La Paz*
Schiedam, Stedelijk Museum
Schiedam, 1970
19.5 x 19.7 cm
Stedelijk Museum Amsterdam

*71 —— *Tatvan*
München, Aktionsraum 1, 1970
15 x 21.4 cm
Stedelijk Museum Amsterdam

72 —— *This way Brouwn*, 1970
black-and-white photo on document
33 x 20 cm
Collection Herman and Henriëtte
van Eelen, Amsterdam

73 —— *Position of the Lumeystraat
in relation to the…*, 1970
collage
5 parts, each: 75 x 100 cm
Stedelijk Museum Amsterdam

74 —— *Position 1; 1a; 1b; 1c; 1d*, 1971
collage, ballpoint pen and pencil
5 parts, each: 75 x 100 cm
Stedelijk Museum Amsterdam

*75 —— *Steps*
Amsterdam, Stedelijk Museum, 1971
13.7 x 20.8 cm
Stedelijk Museum Amsterdam

*76 —— *One step 1x - 100x*
Brussel, Gallery MTL, 1971
15.7 x 16 cm
Stedelijk Museum Amsterdam

*77 —— *This way Brouwn,
25-2-61 26-2-61*
Köln/New York, König, 1971
24 x 20.2 cm
Stedelijk Museum Amsterdam

*78 —— *1 step - 100000 steps*
Utrecht, De Utrechtse Kring/
Amsterdam, Art & Project, 1972
27 x 20.6 cm
Stedelijk Museum Amsterdam

79 ——— *Constructed Walk*, 1972
2 boxes of unlined card indexes with
printed text
30.5 x 19.8 x 39.5 cm
Stedelijk Museum Amsterdam

* 80 ——— *100.000 mm.*
Brussels, Gallery MTL, 1975
15.5 x 16 cm
Stedelijk Museum Amsterdam

* 81 ——— *1 step on 4000 mm.*
Amsterdam, Stanley Brouwn, 1975
31.7 x 37.4 cm
Stedelijk Museum Amsterdam

82 ——— *1 Step on 1 m*
(=1.000.000 mm), 1975
ink and pencil on paper
116 x 118 cm
Kröller-Müller Museum, Otterlo
(formerly in the Visser collection)

83 ——— *A 1 step 1:1/2;*
B 1 step 1:8, 1976
ink and pencil on paper
175 x 50 cm
Kröller-Müller Museum, Otterlo
(formerly in the Visser collection)

84 ——— *100 km*, 1976
1000 drawings in printing ink in
10 portfolios on trestle tables
drawings, each: 123.8 x 88 cm,
total size: 75 x 130 x 335
Museum Boijmans Van Beuningen,
Rotterdam

85 ——— *1 km (1000 m) 1:400*, 1976
pencil and ink on paper
288 x 31.6 cm
Stedelijk Museum Amsterdam

Daniel Buren

86 ——— *Photo Souvenirs*, 1968-1974
black-and-white photos
15 parts, various formats
Kröller-Müller Museum, Otterlo
(formerly in the Visser collection)

87 ——— *Tissu rayé de bandes*
blanches et bleues, 1969
acrylic on canvas
188 x 284 cm
Collection Herbert, Ghent

* 88 ——— *MTL Art/Critique Mensuel*
magazine, July 1970
29.1 x 20.3 cm
Stedelijk Museum Amsterdam

* 89 ——— *5 texts*
New York, John Weber Gallery/
London, Jack Wendler Gallery, 1973
22.9 x 15.7 cm
Stedelijk Museum Amsterdam

* 90 ——— *Halifax*
Paris, Multiplicata/Halifax, Lithography
Workshop of N.S.C.A.D., 1974
11.1 x 16.3 cm
Stedelijk Museum Amsterdam

* 91 ——— *Projekt für ADA2*
Berlin, Neuer Berliner Kunstverein, 1974
20.9 x 29.5 cm
Stedelijk Museum Amsterdam

92 ——— *Peinture-angulaire*, 1975
acrylic on canvas
200 x 140 cm
Stedelijk Van Abbemuseum, Eindhoven

* 93 ——— *Pour donner la parole,*
je substitue POUR aux pages qui
me sont attribuées
Bruxelles, POUR écrire la liberté, 1975
29.5 x 20.9 cm
Stedelijk Museum Amsterdam

* 94 ——— *Voile/Toile, Toile/Voile*
Berlin, Akademie der Künste, 1975
26 x 19.2 cm
Stedelijk Museum Amsterdam

* 95 ——— *Seven Ballets in Manhattan*
New York, John Weber Gallery, 1975
21.7 x 14 cm
Stedelijk Museum Amsterdam

96 ——— *Kaleidoscope en reflets*
no. 12, 1976-1982/1983
Intervention in the lower and upper
lobbies of the Stedelijk Museum with
painted plexiglas panels, the colours
derived from *La Perruche et la Sirène*
by Henri Matisse + documents
50 parts, each: 64.5 x 63 cm
Stedelijk Museum Amsterdam

* 97 ——— *Hier/Ici*
Amsterdam, Stedelijk Museum, 1976
27.5 x 20.7 cm
Stedelijk Museum Amsterdam

* 98 ——— *Ailleurs/Elders*
Eindhoven, Stedelijk Van
Abbemuseum, 1976
26.8 x 20.9 cm
Stedelijk Museum Amsterdam

* 99 ——— *From*
Otterlo, Rijksmuseum Kröller-
Müller, 1976
29.2 x 20.4 cm
Stedelijk Museum Amsterdam

* 100 ——— *Notes sur le travail par*
rapport aux lieux où il s'inscrit,
prises entre 1967 et 1975 et dont
certaines sont spécialement
récapitulées ici
Genève, Adelina von Fürstenberg, 1976
20 x 14.4 cm
Stedelijk Museum Amsterdam

* 101 ——— *The Cube, the White,*
the Idealism (1967-1975)
New York, Leo Castelli Gallery/
John Weber Gallery, 1976
28.4 x 22.8 cm
Stedelijk Museum Amsterdam

* 102 ——— *Reboundings*
Brussels, Daled & Gevaert, 1977
20.4 x 12.9 cm
Stedelijk Museum Amsterdam

* 103 ——— *Les Écrits (1965-1990)*
Bordeaux, capcMusée d'art
contemporain, 1991
3 parts, each: 22.5 x 14 cm
Stedelijk Museum Amsterdam

André Cadere

104 ——— *Bâton*, 1974
white, orange and red lacquer
on wood + document
h. 119 cm, Ø 2 cm
Collection Daled, Brussels

105 ——— *Huit barres de bois rond*
AOO201003 (huit pièces différentes
uniquement par l'erreur), 1975
various colours of lacquer
on wood + document
8 parts, each: h. 41.5 cm, Ø 3.5 cm
Collection Herbert, Ghent

* 106 ——— *Présentation d'un travail.*
Utilisation d'un travail
Hamburg, Hossmann/Bruxelles,
Gallery MTL, 1975
23.9 x 15.4 cm
Stedelijk Museum Amsterdam

107 ——— *Bâton*, 1977
blue, yellow, green and white
lacquer on wood + document
h. 83 cm, Ø 4 cm
Collection Daled, Brussels

108 ——— *Histoire d'un travail*
Gent, Herbert/Gewad, 1982
29.5 x 21.1 cm
Stedelijk Museum Amsterdam

Hanne Darboven

109 ——— *Drawing links*, 1966
ink on graphic paper
54.5 x 42.5 cm
Kröller-Müller Museum, Otterlo
(formerly in the Visser collection)

110 ——— *Drawing Plan*, 1968
ink and pencil on paper
60 x 43.5 cm
Kröller-Müller Museum, Otterlo
(formerly in the Visser collection)

111 ——— *Drawing*, 1968
ink on graphic paper + document
70 x 360 cm
Kröller-Müller Museum, Otterlo
(formerly in the Visser collection)

112 ——— *Drawing*, 1968
ink on graph paper
75.5 x 76 cm
Kröller-Müller Museum, Otterlo
(formerly in the Visser collection)

113 ——— *Number drawings*, 1970
ink on paper
29.5 x 21 cm
Kröller-Müller Museum, Otterlo
(formerly in the Visser collection)

114 ——— *Untitled*, 1971
typescript on paper
4 parts, each: 29.5 x 21 cm
Collection Herman and Henriëtte
van Eelen, Amsterdam

115 ——— *1.Buch/42.Buch*, 1972
ink on paper
86 panels, each: 42.5 x 30.1 cm
total size: 175 x 788.5 cm
Stedelijk Museum Amsterdam

116 ——— *El Lissitzky Kunst und
Pangeometrie*
Brussel, Daled/Yves Gevaert/
Hamburg, Hossmann, 1973
30.5 x 22.5 cm
Stedelijk Museum Amsterdam

* 117 ——— *Hanne Darboven*
Milano, Flash Art, 1973
20.9 x 29.5 cm
Stedelijk Museum Amsterdam

* 118 ——— *60 arbeiten à 1 arbeit*
Düsseldorf, Konrad Fischer, 1975
20.8 x 14.7 cm
Stedelijk Museum Amsterdam

* 119 ——— *Textes de Charles
Baudelaire, Texte von Heinrich
Heine, texto de Enrique Santos
Discepolo (...) ausgewählt und
zitiert von Hanne Darboven*
Bruxelles, POUR écrire la liberté, 1975
35 x 27.5 cm
Stedelijk Museum Amsterdam

* 120 ——— *1975*
Hamburg, Hanne Darboven, 1976
29.5 x 21 cm
Stedelijk Museum Amsterdam

* 121 ——— *Briefe aus New York
1966-68 an zu Hause*
Ostfildern, Cantz, 1997
22 x 16.8 cm
Stedelijk Museum Amsterdam

Jan Dibbets

122 ——— *Field with narrow,
fairly shallow furrows*, 1967
modified image
21.5 x 27.3 cm
Collection Daled, Brussels

123 ——— *Perspective Correction –
My Studio II*, 1968
black-and-white photo on canvas
115 x 115 cm
Stedelijk Museum Amsterdam

124 ——— *Perspective correction –
Big square*, 1968
black-and-white photo on canvas
115.5 x 115.5 cm
Collection Herman and Henriëtte
van Eelen, Amsterdam

125 ——— *3 water-puddles
with mud. Water/taperecorder
with blub-sound*, 1968
ink on squared paper
33.2 x 21.2 cm
Coll. L.A. Dosi Delfini, Amsterdam

126 ——— *Two Cones with Green
Connection*, 1968
papier-mâché, neon tube, iron wire
gauze and sailcloth
84 x 175 x 130 cm
Stedelijk Museum Amsterdam

127 ——— *12 hours tide object at
the Dutch Coast*, 1968-1969
ink on paper
42 x 33 cm
Collection Herman and Henriëtte
van Eelen, Amsterdam

128 ——— *Hasebroekstraat*, 1969
postcard
13 x 18 cm
Collection Herman and Henriëtte
van Eelen, Amsterdam

129 ——— *Project for Art & Project*,
1969
4 maps and 4 files with documents
various formats
Collection Herman and Henriëtte
van Eelen, Amsterdam

130 ——— *3 roads in the
Netherlands*, 1969
collage and drawing on paper
3 parts, total size: 65.5 x 50 cm
Collection Herman and Henriëtte
van Eelen, Amsterdam

131 ——— *The shadows in my
studio as they were at 27-7-69
from 8.40-14.10 photographed
every 10 minutes*, 1969
photos
34 parts, each: 23 x 29 cm,
total size: 23 x 103.5 cm
Collection Herbert, Ghent

132 ——— *Postcard of bridge*, 1970
modified postcard
13 x 18 cm
Collection Herman and Henriëtte
van Eelen, Amsterdam

* 133 ——— *Robin Redbreast's
Territory/Sculpture 1969*
Köln, König/New York, Siegelaub, 1970
18.4 x 12 cm
Stedelijk Museum Amsterdam

134 ——— *Flut/Holland*, 1969-1970
photos modified with ink
total size: 20 x 200 cm
Collection Herman and Henriëtte
van Eelen, Amsterdam

* 135 ——— *Study for Merwede*, 1970
black-and-white photos, map,
text in pencil
42 x 63.5 cm
Kröller-Müller Museum, Otterlo
(formerly in the Visser collection)

*136 ———— *Artists & Photographs*
[with Huebler, Kosuth, LeWitt, Long,
Nauman, Ruscha, Smithson, et al.]
New York, Multiples Inc., 1970
33.7 x 33.7 cm
Stedelijk Museum Amsterdam

137 ———— *Panorama – Haags
Gemeentemuseum*, 1971
black-and-white photo and pencil on paper
75 x 100 cm
Gemeentemuseum Den Haag, The Hague

138 ———— *Panorama – My Studio*, 1971
black-and-white photo and pencil on paper
66.5 x 96 cm
Stedelijk Museum Amsterdam

139 ———— *4-Points O-135°*, 1972
10 black-and-white photos and pencil
on paper
74 x 99 cm
Stedelijk Museum Amsterdam

Ger van Elk

140 ———— *Jugend Style Plint Piece*, 1968
wood, metal and cloth
17 x 178 x 25 cm
Stedelijk Museum Amsterdam

141 ———— *Net*, 1969
wood, iron, cloth and rope
120 x 180 x 80 cm
Stedelijk Museum Amsterdam

142 ———— *Self-portrait Behind a
Wooden Fence*, 1969
16 mm colour film projected on
a wooden fence
Collection Becht, Naarden

143 ———— *Luxurious street corner*, 1969
photo and red felt-tip pen, text in pencil
41 x 36 cm
Collection Daled, Brussels

144 ———— *La Cuisine Hollandaise /
Colonial-style*, 1969
coffeepot, hot plate, aquarium with
water on table
80 x 75 x 35 cm
Collection Becht, Naarden

145 ———— *Apparatus scalas dividens*,
1968-1969
tent canvas, bamboo canes,
flower pots, herrings, cast-iron holders,
guy ropes, safety pins
238 x 20 x 113 cm
Collection of the artist, Amsterdam

146 ———— *La Pièce*, 1971
wood, enamel paint in plexiglas box
2.1 x 9.5 x 7.7 cm
Collection of the artist, Amsterdam

147 ———— *The Co-Founder of
the Word OK*, 1971
colour photos
3 parts, each: 50.8 x 40 cm
Collection Daled, Brussels

148 ———— *The Symmetry of Diplomacy II -
Peking*, 1972
retouched colour photos
2 parts, each: 65 x 65 cm
Stedelijk Museum voor Aktuele Kunst,
Ghent

149 ———— *The well shaven cactus (1969)
Paul Klee um den Fisch (1970)
The co-founder of the word OK (1971)
The discovery of the sardines (1971)
The symmetry of diplomacy (1971)*
Amsterdam, Art & Project, 1972
21.3 x 10 cm
Stedelijk Museum Amsterdam

Gilbert & George

150 ———— *Gilbert by George and George
by Gilbert*, 1970
file with 2 drawings + dictation tape
total size: 63 x 37.5 cm
Collection Herman and Henriëtte
van Eelen, Amsterdam

*151 ———— *The Pencil on Paper
Descriptive Works of
Gilbert & George the sculptors*
London, Art for All, 1970
20.2 x 12.6 cm
Stedelijk Museum Amsterdam

*152 ———— *To be with art is all we ask*
London, Art for All, 1970
19.9 x 20.9 cm
Stedelijk Museum Amsterdam

*153 ———— *Art Notes and Thoughts*
Amsterdam, Art & Project, 1970
25.2 x 17.7 cm
Stedelijk Museum Amsterdam

154 ———— *54 part Photo-Piece,
Christmas 1971*, 1971
black-and-white photos
total size: 130 x 180 cm
Collection Becht, Naarden

*155 ———— *'The Paintings' (with Us
in Nature) of Gilbert & George
the human sculptors*
Düsseldorf, Kunstverein für die
Rheinlande und Westfalen/
Amsterdam, Stedelijk Museum,
1971
20.8 x 14.3 cm
Stedelijk Museum Amsterdam

*156 ———— *A day in the life of
Gilbert & George the sculptors*
London, Art for All, 1971
20 x 12.6 cm
Stedelijk Museum Amsterdam

*157 ———— *Side by side*
London, Art for All, 1971
19.5 x 13.5 cm
Stedelijk Museum Amsterdam

158 ———— *In the Bush*, 1972
black-and-white PAL videotape, sound
17'
Stedelijk Museum Amsterdam

159 ———— *A Portrait of the Artists
as Young Men*, 1972
black-and-white PAL videotape, sound
7'15"
Stedelijk Museum Amsterdam

160 ———— *Gordon's Makes Us
Drunk*, 1972
black-and-white videotape Scotch/
open reel, sound
12'
Stedelijk Museum Amsterdam

*161 ———— *'Oh, the Grand old
Duke of York' : Gilbert & George
the sculptors*
Luzern, Kunstmuseum Luzern, 1972
29.1 x 20,6 cm
Stedelijk Museum Amsterdam

*162 ———— *Pink Elephants
(London Dry, The Majors Port,
Dom Perignon, The Majors Port,
Bristol Cream, Bristol Cream)*
London, 1973
20.2 x 12.2 cm
Stedelijk Museum Amsterdam

*163 ———— *Gilbert & George the
living sculptors, catalogue for
their Australian visit*
London, Art for All, 1973
17.2 x 17.5 cm
Stedelijk Museum Amsterdam

* 192 ——— *49 Three-part Variations using Three Different Kinds of Cubes / 1967-68*
Zürich, Bruno Bischofberger, 1969
17 x 35.5 cm
Stedelijk Museum Amsterdam

* 193 ——— *Four basic Kinds of Straight Lines and their Combinations*
London, Studio International, 1969
20 x 20.1 cm
Stedelijk Museum Amsterdam

* 194 ——— *Four basic Kinds of Lines & Colour*
London, Lisson Gallery/New York, Studio International/Paul David Press, 1971
19.9 x 20 cm
Stedelijk Museum Amsterdam

195 ——— *Lines & Lines, Arcs & Arcs*, 1972
ink on paper
29.5 x 41.7 cm
Stedelijk Museum Amsterdam

196 ——— *All Crossing Lines, Arcs, Straight Lines, not Straight Lines and Broken Lines*, 1972
ink on paper
27.8 x 21.5 cm
Stedelijk Museum Amsterdam

* 197 ——— *Arcs, Circles & Grids*
Bern, Kunsthalle Bern, 1972
20.5 x 20.5 cm
Stedelijk Museum Amsterdam

198 ——— *Lines 10 Centimeter long / Lines from and to certain Points*, 1974
ink on paper
36 x 36 cm
Collection Herbert, Ghent

* 199 ——— *La posizione di tre figure geometriche. Tre disegni su parete*
Torino, Sperone, 1974
19 x 13 cm
Stedelijk Museum Amsterdam

* 200 ——— *Squares with Sides and Corners torn off*
Brussels, Gallery MTL, 1974
14.5 x 14.5 cm
Stedelijk Museum Amsterdam

* 201 ——— *All Combinations of Arcs from Four Corners, Arcs from Four Sides, Straight Lines, Not-Straight Lines, and Broken Lines*
Lausanne, Editions des Massons, 1974
20.5 x 20.5 cm
Stedelijk Museum Amsterdam

* 202 ——— *The Location of Lines*
London, Lisson Gallery, 1974
20.2 x 20.5 cm
Stedelijk Museum Amsterdam

* 203 ——— *Incomplete open Cubes*
New York, John Weber Gallery, 1974
20.1 x 20.2 cm
Stedelijk Museum Amsterdam

204 ——— *Map of Amsterdam without the Amstel River. R 657*, 1976
modified city map
87 x 104 cm
Stedelijk Museum Amsterdam

205 ——— *Map of Amsterdam between the Stedelijk Museum, Julianapark, Strawinskylaan, the corner of Hillegomstraat and Duinstraat and Koninklijk Paleis*, 1976
cut-out city map
54.7 x 69.9 cm
Collection L.A. Dosi Delfini, Amsterdam

Richard Long

206 ——— *Wooden sticks*, 1968
twigs
89 parts: various sizes
Collection Herman and Henriëtte van Eelen, Amsterdam

207 ——— *Guggenheim Piece*, 1971
photo, pencil and chalk on paper behind glass
39 x 39 cm
Stedelijk Museum Amsterdam

208 ——— *From along a river-bank*, 1971
collage of leaves + booklet
3 parts, each: 20 x 60 cm
Collection Herman and Henriëtte van Eelen, Amsterdam

* 209 ——— *Two sheepdogs cross in and out of the passing shadows. The clouds drift over the hill with a storm*
London, Lisson Publications, 1971
book + manuscript
28.1 x 18.4 cm
Collection Daled, Brussels

210 ——— *On This Hillside*, 1972
black-and-white photo and text
32 x 24 cm
Collection Daled, Brussels

211 ——— *A walk of four hours and four circles*, 1972
modified map
32 x 24 cm
Collection Daled, Brussels

* 212 ——— *South America*
Düsseldorf, Konrad Fischer, 1972
12.8 x 13 cm
Stedelijk Museum Amsterdam

213 ——— *A Rolling Stone, Resting Places along a Journey*, 1973
chalk and photocollage on paper
11 parts, each: 42 x 56.5 cm
Stedelijk Museum Amsterdam

* 214 ——— *Richard Long*
Amsterdam, Stedelijk Museum, 1973
20.7 x 29.7 cm
Stedelijk Museum Amsterdam

* 215 ——— *From around a Lake*
Amsterdam, Art & Project, 1973
21.1 x 9.8 cm
Stedelijk Museum Amsterdam

* 216 ——— *Inca Rock, Campfire Ash*
London, Robert Self Publications, 1974
43.8 x 29.3 cm
Stedelijk Museum Amsterdam

Bruce Nauman

217 ——— *Wall/Floor Positions*, 1968
black-and-white NTSC videotape, sound
60'
Stedelijk Museum Amsterdam

218 ——— *My Name as Though It Were Written on the Surface of the Moon*, 1968
neon tube
8 parts, total size: 30 x 549 x 7 cm
Stedelijk Museum Amsterdam

219 ——— *Walk with Contraposto*, 1969
black-and-white NTSC videotape, sound
KCA 60
60'
Stedelijk Museum Amsterdam

220 ——— *Lip Sync*, 1969
black-and-white NTSC videotape, sound
60'
Stedelijk Museum Amsterdam

221 ——— *Revolving Upside Down*, 1969
black-and-white NTSC videotape, sound
UCA 60
55'
Stedelijk Museum Amsterdam

222 ——— *Pacing Upside Down*, 1969
black-and-white NTSC videotape, sound
55'
Stedelijk Museum Amsterdam

223 ——— *Holograms*, 1970
photolithographs
5 parts, each: 66 x 66 cm
Stedelijk Museum Amsterdam

224 ——— *Untitled*
(*'Design for a Space'*), 1971
pencil on paper
33.5 x 40 cm
Collection Herman and Henriëtte
van Eelen, Amsterdam

225 ——— *Untitled*
(*'Positive and Negative'*), 1971
pencil on paper
33.5 x 40 cm
Collection Herman and Henriëtte
van Eelen, Amsterdam

226 ——— *Tony Sinking into the*
Floor Face Up and Face Down, 1974
colour NTSC videotape
60'
Stedelijk Museum Amsterdam

227 ——— *Pursuit*, 1975
16 mm colour film, sound
28'
Stedelijk Museum Amsterdam

Edward Ruscha

228 ——— *Some Los Angeles*
Apartments
Hollywood, Heavy Industry
Publications, 1965-1970
17.8 x 14.1 cm
Stedelijk Museum Amsterdam

229 ——— *Every Building on*
the Sunset Strip
Hollywood, Heavy Industry
Publications, 1966
18.6 x 14.7 cm
Stedelijk Museum Amsterdam

230 ——— *Royal Road Test*
Los Angeles, Patrick Blackwell, Edward
Ruscha, Mason Williams, 1967
23.7 x 16.4 cm
Stedelijk Museum Amsterdam

231 ——— *Thirtyfour Parking Lots*
in Los Angeles
[Hollywood, Heavy Industry
Publications], 1967
25.4 x 20.4 cm
Stedelijk Museum Amsterdam

*232 ——— *Nine Swimming Pools*
and a Broken Glass
[Hollywood, Heavy Industry
Publications], 1968
17.8 x 14.1 cm
Stedelijk Museum Amsterdam

*233 ——— *Business Cards*
[Hollywood, Heavy Industry
Publications], 1968
22.3 x 14.5 cm
Stedelijk Museum Amsterdam

*234 ——— *Twentysix Gasoline*
Stations
[Hollywood, Heavy Industry
Publications], 1969
17.9 x 14.1 cm
Stedelijk Museum Amsterdam

*235 ——— *Crackers*
Hollywood, Heavy Industry
Publications, 1969
22.3 x 15.1 cm
Stedelijk Museum Amsterdam

*236 ——— *Babycakes with Weights*
New York, Multiples Inc., 1970
19.1 x 15.3 cm
Stedelijk Museum Amsterdam

*237 ——— *Various Small Fires*
and Milk
[Hollywood, Heavy Industry
Publications], 1970
17.8 x 14 cm
Stedelijk Museum Amsterdam

*238 ——— *Real Estate Opportunities*
Hollywood, Heavy Industry
Publications, 1970
18 x 14.1 cm
Stedelijk Museum Amsterdam

*239 ——— *Records*
Hollywood, Heavy Industry
Publications, 1971
17.9 x 14 cm
Stedelijk Museum Amsterdam

*240 ——— *Dutch Details*
Deventer, Stichting Octopus, 1971
11.1 x 38 cm
Stedelijk Museum Amsterdam

*241 ——— *A Few Palm Trees*
Hollywood, Heavy Industry
Publications, 1971
17.8 x 14 cm
Stedelijk Museum Amsterdam

242 ——— *Babycakes Suspended*, 1972
gunpowder and pastel on paper
58.7 x 74 cm
Stedelijk Museum Amsterdam

*243 ——— *Colored People*
Hollywood, Heavy Industry
Publications, 1972
18 x 14.2 cm
Stedelijk Museum Amsterdam

*244 ——— *Edward Ruscha (Ed-werd*
Rew-Shay) young artist
Minneapolis, Minneapolis Institute
of Arts, 1972
11.5 x 9.5 cm
Stedelijk Museum Amsterdam

245 ——— *Pure Ecstasy*, 1974
tea on moiré silk
91 x 102 cm
Stedelijk Van Abbemuseum, Eindhoven

246 ——— *Sand in the Vaseline*, 1974
egg yolk on silk
91 x 102 cm
Stedelijk Van Abbemuseum, Eindhoven

247 ——— *Make up Dept*, 1975
[from map: Artists & Photographs,
New York, Multiples Inc., 1975]
colour photo on transparent plastic
40.6 x 50.7 cm
Stedelijk Museum Amsterdam

Robert Ryman

248 ——— *Orrin*, 1967
paper, blue chalk + document
157.5 x 157.5 cm
Coll. Herman and Henriëtte van Eelen,
Amsterdam

Gerry Schum

249 ——— *Land Art.*
Fernsehausstellung I, 1969
[projects with Marinus Boezem,
Jan Dibbets, Richard Long,
Robert Smithson, et al.]
videotape
32'5"
Stedelijk Museum Amsterdam

250 ——— *Identifications.*
Fernsehausstellung II, 1970
[projects with Stanley Brouwn,
Ger van Elk, Gilbert & George,
Lawrence Weiner, et al.]
videotape
33'30"
Stedelijk Museum Amsterdam

Robert Smithson

251 ——— *A heap of Language*, 1966
pencil on paper
16.7 x 56.2 cm
The Over Holland Collection

252 ——— *The Museum of the Void*, 1967
pencil on paper
47.9 x 61.1 cm
The Over Holland Collection

253 ——— *Non-site (name of site in Germany)*, 1968
pencil on paper
19 x 56 cm
Kröller-Müller Museum, Otterlo
(formerly in the Visser collection)

254 ——— a *Museum Plan, Utah*
b *Plan for a Museum concerning Spiral Jetty*
c *Underground Projection Room*, 1971
pencil
3 parts, each: 9 x 12 inches
Collection Herbert, Ghent

Lawrence Weiner

* 255 ——— *Statements*
New York, Seth Siegelaub, 1968
17.8 x 10.2 cm
Stedelijk Museum Amsterdam

256 ——— *A turbulence induced within a body of water*, 1969
ink on paper + document
21 x 26 cm
Collection Herman and Henriëtte van Eelen, Amsterdam

* 257 ——— *Lawrence Weiner*
Aachen, Gegenverkehr, Zentrum für aktuelle Kunst, 1970
19.9 x 21 cm
Stedelijk Museum Amsterdam

* 258 ——— *Tracce/Traces*
Torino, Sperone, 1970
17 x 11.3 cm
Stedelijk Museum Amsterdam

259 ——— *Middle of the Road*, 1970
offset print + document
16.8 x 10.5 cm
Collection Daled, Brussels

260 ——— *Left of Center*, 1970
offset print + document
16.8 x 10.5 cm
Collection Daled, Brussels

261 ——— *Right of Center*, 1970
offset print + document
16.8 x 10.5 cm
Collection Daled, Brussels

* 262 ——— *Casuality.
Affected and/or effected New York*
Leo Castelli Gallery, 1971
16.5 x 11 cm
Stedelijk Museum Amsterdam

* 263 ——— *10 Works*
Paris, Yvon Lambert, 1971
17 x 11 cm
Stedelijk Museum Amsterdam

* 264 ——— *Perhaps when removed*
Amsterdam, Art & Project, 1971
21 x 10 cm
Stedelijk Museum Amsterdam

* 265 ——— *[Quizás cuando removido]*
Buenos Aires, Centro de Arte y Comunicación, 1971
21.5 x 16.7 cm
Stedelijk Museum Amsterdam

* 266 ——— *And/or : green as well as blue as well as red*
London, Jack Wendler, 1972
17.1 x 12.1 cm
Stedelijk Museum Amsterdam

* 267 ——— *Having been done at.
Having been done to*
Torino, Sperone, 1972
17 x 11.2 cm
Stedelijk Museum Amsterdam

* 268 ——— *A primer*
Kassel, Documenta, 1972
14.8 x 10.5 cm
Stedelijk Museum Amsterdam

269 ——— *Escalated from time to time*, 1973-1985
Texts painted on the walls, the colours derived from *La Perruche et la Sirène* by Henri Matisse, executed on the occasion of the exhibition 'As far as Amsterdam goes…', Stedelijk Museum Amsterdam 1985-1986 + document
Stedelijk Museum Amsterdam

* 270 ——— *Having from time to time a relation to: escalation-overloading-revocation*
Amsterdam, Art & Project, 1973
21 x 10 cm
Stedelijk Museum Amsterdam

* 271 ——— *Once upon a time*
Milano, Franco Toselli, 1973
16.9 x 12 cm
Stedelijk Museum Amsterdam

272 ——— *On a Rough – being within the context of [a] place*, 1975
language
Stedelijk Van Abbemuseum, Eindhoven

273 ——— *Nothing To Lose - Niets aan Verloren*, 1976
gramophone record
Stedelijk Museum Amsterdam

274 ——— *Bent over backward(s) in a point of order Bent over forward(s) in a point of order*, 1976
ink on paper
29.5 x 21 cm
Private collection, Amsterdam

Ian Wilson

275 ——— *Circle on the Floor*, 1968-1985
chalk
Ø 183 cm
Stedelijk Van Abbemuseum, Eindhoven

* 276 ——— *Section 1*, 1971
typescript
29 x 23 cm
Stedelijk Museum Amsterdam

277 ——— *Discussion, 23 January 1972*
document + bill
29.5 x 21 cm
Collection Daled, Brussels

278 ——— *Discussion, 10 September 1972*
document
29.5 x 21 cm
Collection Daled, Brussels

* 279 ——— *Working notes: section 8*, 1975
typescript
29 x 23 cm
Stedelijk Museum Amsterdam

* 280 ——— *Section 35*, n.d.
typescript
29 x 23 cm
Stedelijk Museum Amsterdam

For extended bibliographies see:

Goldstein, Ann and Anne Rorimer (eds.),
 Reconsidering the Object of Art:
 1965-1975, (exh. cat.), Los Angeles:
 The Museum of Contemporary
 Art/Cambridge, Massachussetts:
 The MIT Press, 1995
Global Conceptualism: Points of
 Origin, 1950s-1980s, (exh. cat.),
 New York: Queens Museum of Art/
 DAP/Distributed Publishers, 1999

Alberro, Alexander, *Deprivileging Art.*
 Seth Siegelaub and the Politics of
 Conceptual Art, Ph.D. , Evanston,
 Illinois: Northwestern University, 1996
 (Dissertations Abstracts International:
 Order no. AAC9714538)
Alberro, Alberro and Patricia Norvell,
 Recording Conceptual Art. Early
 Interviews with Barry, Huebler,
 Kaltenbach, LeWitt, Morris, Oppenheim,
 Siegelaub, Smithson, and Weiner
 by Patricia Norvell, Berkeley:
 University of California Press, 2001
Alberro, Alexander and Blake
 Stimson (eds.), *Conceptual Art.*
 A Critical Anthology, Cambridge,
 Massachussetts: The MIT Press, 1999
Art & Project bulletin, no. 1 t/m 94,
 (1968-1975), Art&Project, Amsterdam
L'art conceptuel, une perspective,
 (exh. cat.), Paris: Musée d'Art Moderne
 de la Ville de Paris, 1989
Ausstellungen bei Konrad Fischer,
 Düsseldorf Oktober 1967 –
 Oktober 1992, Bielefeld: Edition
 Marzona, 1993
Bois, Yve-Alain and Rosalind E. Krauss,
 Formless: A User's Guide [translation
 from the French], New York: Zone Books,
 1997 [orig. published as exh. cat.
 L'informe. Mode d'emploi, Centre
 Georges Pompidou, Paris, 22 May-
 26 August, 1996]
Conception. Conceptual Documents
 1968 to 1972, (exh. cat.), Norwich
 Gallery, Norwich School of Art and
 Design/Article Press, 2001
documenta 4 (exh. cat.), Kassel:
 Documenta/Druck + Verlag, 1968
documenta 5 (exh. cat.),
 Kassel: Documenta/Verlagsgruppe
 Bertelsmann, 1972
Godfrey, Tony, *Conceptual Art*, London:
 Phaidon Press Ltd, 1998
The Impossible Document. Photo-
 graphy and Conceptual Art in
 Britain 1966-1976, (exh. cat.),
 London: Camerawork, 1997
Lippard, Lucy R., *Six Years. The*
 Dematerialization of the Art Object
 from 1962 to 1972, Berkeley/
 Los Angeles: University of
 California Press, (1973) 1997

Live in Your Head. Concept and
 Experiment in Britain 1965-75,
 (exh. cat.), London: Whitechapel Art
 Gallery, 2000
Live in Your Head. When Attitudes
 Become Form. Works – Concepts –
 Processes – Situations –
 Information, (exh. cat.), Bern:
 Kunsthalle, 1969
Minola, Anne e.a., *Gian Enzo Sperone,*
 Torino–Roma–New York: 35 Anni di
 Mostra tra Europa e America, 2 vols.
 Turin: Hopefulmonster Editore, 2000
Mollet-Viéville, Ghislain,
 Art minimal et conceptuel, Genève:
 Editions SKIRA, 1995
Morgan, Robert C., *Art into ideas.*
 Essays on Conceptual Art, New York:
 Cambridge University Press, 1996
Morgan, Robert C., *Between Modernism*
 and Conceptual Art. A Critical
 Response, Jefferson, NC:
 McFarland & Co., 1997
Museumjournaal, 1965-1975 (Stichting
 Kunstpublicaties)
Newman, Michael and Jon Bird (eds.),
 Rewriting Conceptual Art, London:
 Reaktion Books, 1999
Op losse schroeven. Situaties en
 cryptostructuren, (exh. cat.),
 Amsterdam: Stedelijk Museum, 1969
Prospect 68, (exh. cat.), Dusseldorf:
 Städtische Kunsthalle, 1968
Prospect 69, (exh. cat.), Dusseldorf:
 Städtische Kunsthalle, 1969
Rorimer, Anne, *New Art in the 60s*
 and 70s. Redefining Reality, London:
 Thames & Hudson, 2001
Sonsbeek 71. Sonsbeek buiten
 de perken, (exh. cat.), Arnhem:
 [Stichting Sonsbeek (?)], 1971
Stiles, Kristine and Peter Selz (eds.),
 Theories and Documents of
 Contemporary Art. A Sourcebook of
 Artist's Writings, Berkeley/Los Angeles:
 University of California Press, 1996
Tragatschnig, Ulrich, *Konzeptuelle Kunst.*
 Interpretationsparadigmen: Ein
 Propädeutikum, Berlin: Reimer
 Verlag, 1996
Wide White Space, 1966-1976,
 (exh. cat.), Brussels: Palais des
 Beaux-Arts, 1994

photographic credits

(where not indicated in photo caption)
— John Baldessari
— Bonnefantenmuseum Maastricht
— Peter Cox, Eindhoven (for The Over
Holland Collection)
— H. & H. van Eelen, Amsterdam
— Engels
— Tom Haartsen, Ouderkerk a/d Amstel
(for Museum Boijmans Van Beuningen
Rotterdam and for Kröller-Müller
Museum Otterlo)
— Piet Isabie
— R. Klein Gotink (for Rijksmuseum
Twenthe Enschede)
— Maranzano
— Cary Markerink, Amsterdam
(for Kröller-Müller Museum Otterlo)
— Museum Boijmans Van Beuningen
Rotterdam
— Dirk Pauwels, Ghent (for Stedelijk
Museum voor Aktuele Kunst Gent)
— Nathan Rabin
— Wim Riemens, Middelburg
(for Marinus Boezem)
— Frits Rotgans, Amsterdam
— Stedelijk Museum Amsterdam (Karin
Balog, Dennis Hogers, Rob Versluys)
— Stedelijk Van Abbemuseum
Eindhoven
— Dick Wolters, Overzande
(for Museum Boijmans Van Beuningen)

translations

— Nancy Forest-Flier, Alkmaar
(Ader, Brouwn, Huebler, Kosuth, Nauman,
Kawara, Long, Ruscha,
Ryman, Smithson)
— John Kirkpatrick, Rotterdam
(Art & Language, Baldessari, Boezem,
Buren)
— Peter Mason, Amsterdam
(Foreword, Introduction, Blotkamp)
— Andrew May, Amsterdam
(Van Winkel, Introduction Sentences,
Andre, Barry, Broodthaers, Cadere,
Darboven, Dibbets, Van Elk, Gilbert &
George, Schum, LeWitt, Weiner, Wilson)
— Arthur Payman, Bussum
(chronicle)

Available in North, South and Central America through D.A.P./Distributed Art Publishers Inc, 155 Sixth Avenue 2nd Floor, New York, NY 10013-1507, Tel. 212 6271999, Fax 212 6279484.

Available in the United Kingdom and Ireland through Art Data, 12 Bell Industrial Estate, 50 Cunnington Street, London W4 5HB, Tel. 181 7471061, Fax 181 7422319.

NAi Publishers is an internationally orientated publisher specialized in developing, producing and distributing books on architecture, visual arts and related disciplines.

NAi Publishers, Mauritsweg 23, 3012 JR Rotterdam, info@naipublishers.nl, www.naipublishers.nl

Printed and bound in the Netherlands